"WHEN YOU NEED TO STOP AN ASTEROID, YOU GET SUPERMAN. WHEN YOU NEED TO SOLVE A MYSTERY, YOU CALL IN BATMAN. BUT WHEN YOU NEED TO END A WAR, YOU GET WONDER WOMAN."

—GAIL SIMONE

WONDER WOMAN

AMBASSADOR OF TRUTH

SIGNE BERGSTROM
FOREWORD BY LYNDA CARTER

ORIGINAL INTERVIEWS CONDUCTED BY TARA BENNETT

HARPER
DESIGN
An Imprint of HarperCollins Publishers

Published in 2017 by Harper Design
An Imprint of HarperCollins*Publishers*
195 Broadway
New York, NY 10007
Tel: (212) 207-7000
Fax: (855) 746-6023
harperdesign@harpercollins.com
www.hc.com

Distributed throughout the world by
HarperCollins Publishers
195 Broadway
New York, NY 10007

Produced by becker&mayer! an imprint of The Quarto Group

Author: Signe Bergstrom
Designer: Rosebud Eustace
Editor: Paul Ruditis
Image Researchers: Farley Bookout and Chip Carter
Production Coordinators: Olivia Holmes and Jennifer Lim

Library of Congress Cataloging in Publication Data is available upon request.

ISBN: 978-0-06-269293-1

First Printing, 2017

Printed and bound in China

Wonder Woman was created by William Moulton Marston

CONTENTS

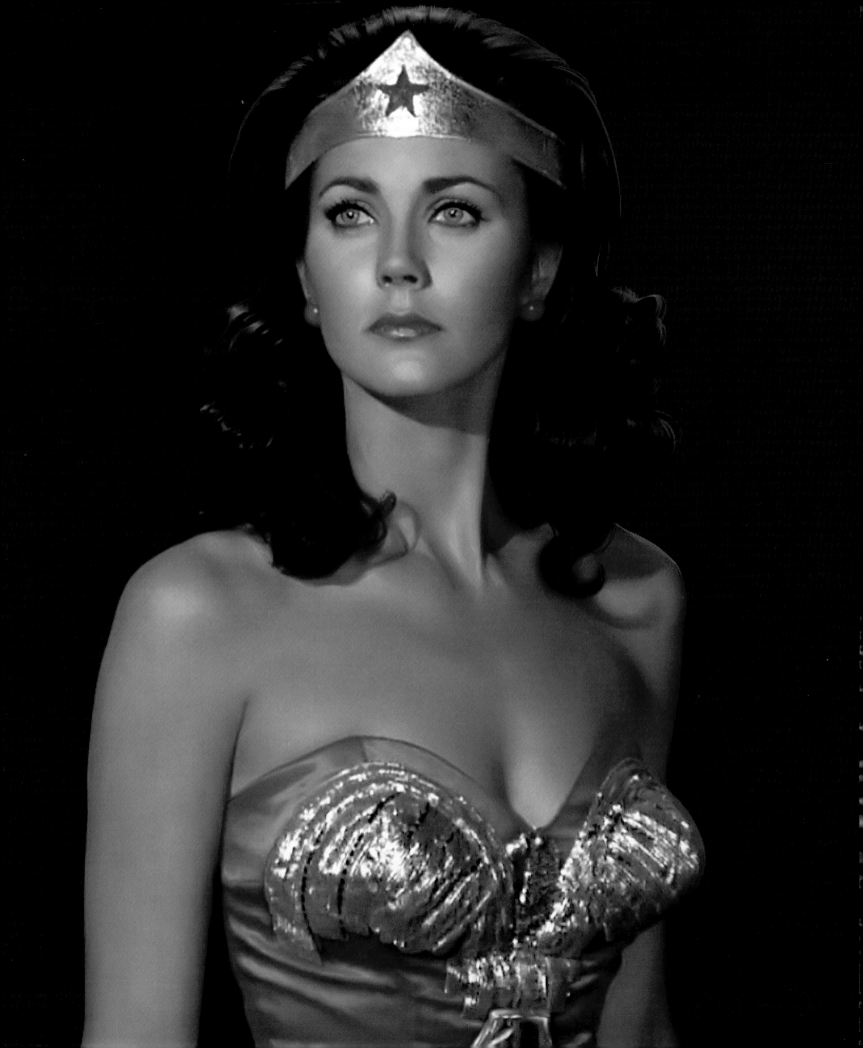

FOREWORD BY
LYNDA CARTER

Taking off that iconic red, white, blue, and gold outfit when filming the last *Wonder Woman* episode was personally moving. But it was over. Our story had run its course. I was lucky: I got to play one of the strongest, smartest, most heroic women ever on television. It was an honor, and now it was time to move on. Of course, I had no idea that I'd still be talking about that incredible character decades later.

It was rare in the seventies for a woman to be the lead character in a television drama. I guess the part had to be a superhero for it to happen. Wonder Woman was my first major role on television, and launched my acting career. Actually, it was two roles. My Wonder Woman role was as much Diana Prince as super hero, and I was able to interpret the character and leave her mark through a woman's eyes. To show her intelligence, kindness and emotional strength in addition to her superpowers. And even though filming ended years ago, Wonder Woman has stayed with me for the rest of my life. After all the many other exciting things I've done and enjoyed in my career since then—acting, singing, dancing, modeling—nothing will surpass Wonder Woman for me.

Some actors try to distance themselves from the characters they've played. They fear being type-cast. Not me. I have embraced the character. Wonder Woman was created as a feminist ideal. She has survived for decades when other characters—men and women—have burst onto the scene and disappeared. Wonder Woman has not only survived, she has thrived. Seeing the impact she's had—and has—on so many women and girls around the world, has been awe-inspiring. So today, I couldn't be more thrilled that Wonder Woman has become a world-wide phenomenon again. How fantastic!

The crowd at the premiere of the *Wonder Woman* film directed by the brilliant, gifted Patty Jenkins was electric. At the time, I said that I was thrilled to pass the torch to a new Wonder Woman, the beautiful actress Gal Gadot. The lasso of truth is in good hands. But in a larger sense, I wasn't really passing anything on to anyone. I was sharing a legacy with Gal, in the way she and I share Wonder Woman with all women and girls in the world. And as we share her with the men who stand with her and with us.

For over forty years, women around the globe have been telling me what Wonder Woman means to them. I've looked into tear-filled eyes of incredible women who saw something great in this character, and found something stronger in themselves because of her. Somewhere along the way, *she* became *we*. And now there are even more of us. As it says in the opening of this book, Wonder Woman is having a moment. But it's not her moment, and it's not mine. It doesn't belong to the director, or the actor, or the producers. It's our moment. Together. Wonder Woman belongs to you.

OPPOSITE | Lynda Carter in costume as *Wonder Woman* (1975).

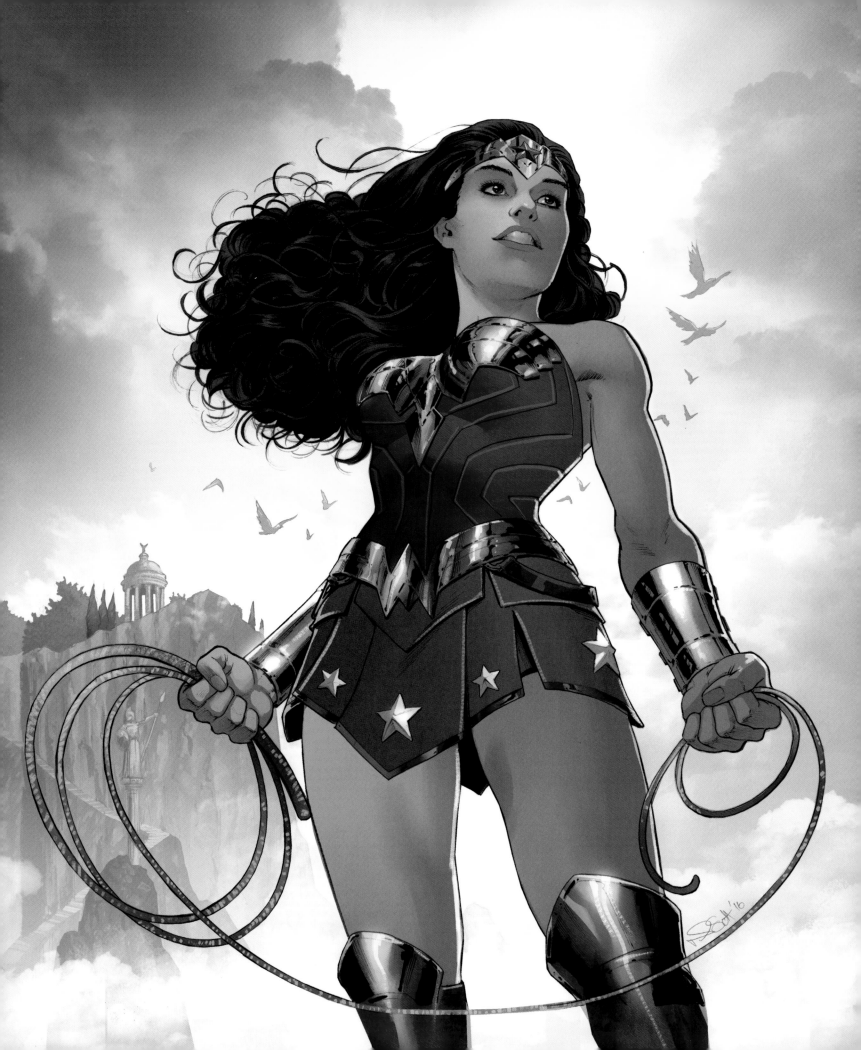

INTRODUCTION
A TIME OF WONDER

Even after seven decades as a pop culture icon, Wonder Woman is having a moment. Her comic books continue to sit comfortably on the bestsellers' lists, but her reach has expanded far beyond the printed page. Today, she's everywhere: her visage graces everything from collectible figurines and LEGO minfigures to coffee mugs and T-shirts. From the moment Lynda Carter spun into action as Wonder Woman in the hit 1970s television show, the Amazon Princess has been a mainstay of the small screen, appearing in live-action and animated shows, a direct-to-DVD movie, and in DC Comics spin-offs of popular properties. She's even crossed over to the world of video gaming, a far cry from her humble origins as an old-school comic book gal.

Her adventures have been published by DC Comics continuously for the past seventy-five years—only Superman and Batman can boast similar longevity —and she continues to hold the attention of comic book reading audiences worldwide. Different audiences, and each new generation, know Wonder Woman from any one of her multimedia adaptations. While her character has been revised and relaunched multiple times, and her costume and superhuman powers have undergone significant changes over the years, through it all Wonder Woman has emerged, time and time again, as an indelible cultural presence. From her origins as an Amazon Princess to a warrior fighting for

OPPOSITE | Cover art by Nicola Scott *Wonder Woman Vol.5 #4* (October 2016).

the good of mankind to her more stately incarnation as an ambassador for peace, Wonder Woman is a uniquely complicated symbol of feminine power, and with the 2017 release of *Wonder Woman*, her full-length feature film, her popularity shows no sign of abating.

When audiences were first introduced to Gal Gadot as Wonder Woman in director Zack Snyder's 2016 blockbuster film *Batman v Superman: Dawn of Justice*, they knew they were witnessing a seismic shift in the super hero genre. Wonder Woman's familiar red-white-and-blue Vargas-like costume was replaced by Greek-inspired armor that looked battle tested, hard-core. Her tiara, its point edged between her eyebrows, appeared to be both shield and weapon, and served as a tacit reminder of her Amazonian heritage. Wonder Woman's footwear of choice—thigh-high sandals—made her fleet of foot, nimble, and able to torpedo into the sky, sword and shield in hand. One look and mainstream audiences got what comic book readers had known for years: Wonder Woman is a woman warrior in the world of man. She's fearless, powerful, relentless in spirit and heart, and she's in charge.

For longtime Wonder Woman fans, *Batman v Superman* provided the pinnacle moment they'd waited decades to see. Wonder Woman burst onto the screen armed with sword and shield in hand. As she battled fiercely alongside Batman and Superman to save mankind, audiences witnessed the incredible warrior in action, yet her backstory was left largely untold. In 2017, director Patty Jenkins changed that with her awe-inspiring film *Wonder Woman*. For the first time in cinematic history, audiences stepped full throttle into the immersive world of Wonder Woman, witnessing her life as Princess Diana, the island girl who lives beneath the armor, and reveling in the personally transformative experiences that led her to become the one, the only Wonder Woman. The film made over $100 million in its opening weekend, and Patty Jenkins became the first female director to cross that big-budget threshold.

As the world's predominant female super hero, Wonder Woman has undergone significant changes in her character, costume, and story lines. It's understood, however, by audiences worldwide that Wonder Woman is, at heart, a looming, larger-than-life entity. She's a stand-in for the values we, as a society, hold most dear: peace, justice, truth, and compassion. In her, we recognize our potential everyday heroism, and we remember why it's important to fight against those who threaten our values and our innate sense of goodness. Prior to the film's release, Jenkins said, "It's been incredible to make something about a super hero that stands for a message of fighting for a loving, thoughtful government, especially in this current climate. . . . There's going to be a lot of conversation about her being a woman in these times, but I think the greatest part about the character is that she's so much bigger than all of that." Since the film's release, there has been a lot of conversation about Wonder Woman being a woman, but that dialogue hasn't been unique to the modern age. Wonder Woman has been stirring up controversy from the moment she arrived on the scene and, as always, she's risen above the chatter and the distraction, proving herself worthy of our attention time and time again.

Jenkins's film represents a watershed moment in the canon of *Wonder Woman*, a history that stretches back to the summer of 1941, when Wonder Woman made her comic book debut in *All-Star Comics #8* (December-January 1941–1942), followed quickly by *Sensation Comics #1* (January 1942). Both comic books were published by Maxwell Charles Gaines and credited to "Charles Moulton," a mashed-up pseudonym comprised of both Maxwell's middle name and author Dr. William Moulton Marston's middle name. Though Wonder Woman was birthed alongside Superman and Batman, two characters who have seen more than their fair share of films, television series, video games, and aisles of related merchandise, it's taken Wonder Woman a good deal longer to get her moment in the cinematic sun. No matter. Here's the deal with heroes: They come when you need them most, and Wonder Woman, an ambassador of truth, is *exactly* the heroine we need now, today more than ever. She arrived right on time.

OPPOSITE | Actress Gal Gadot as *Wonder Woman* (2017).

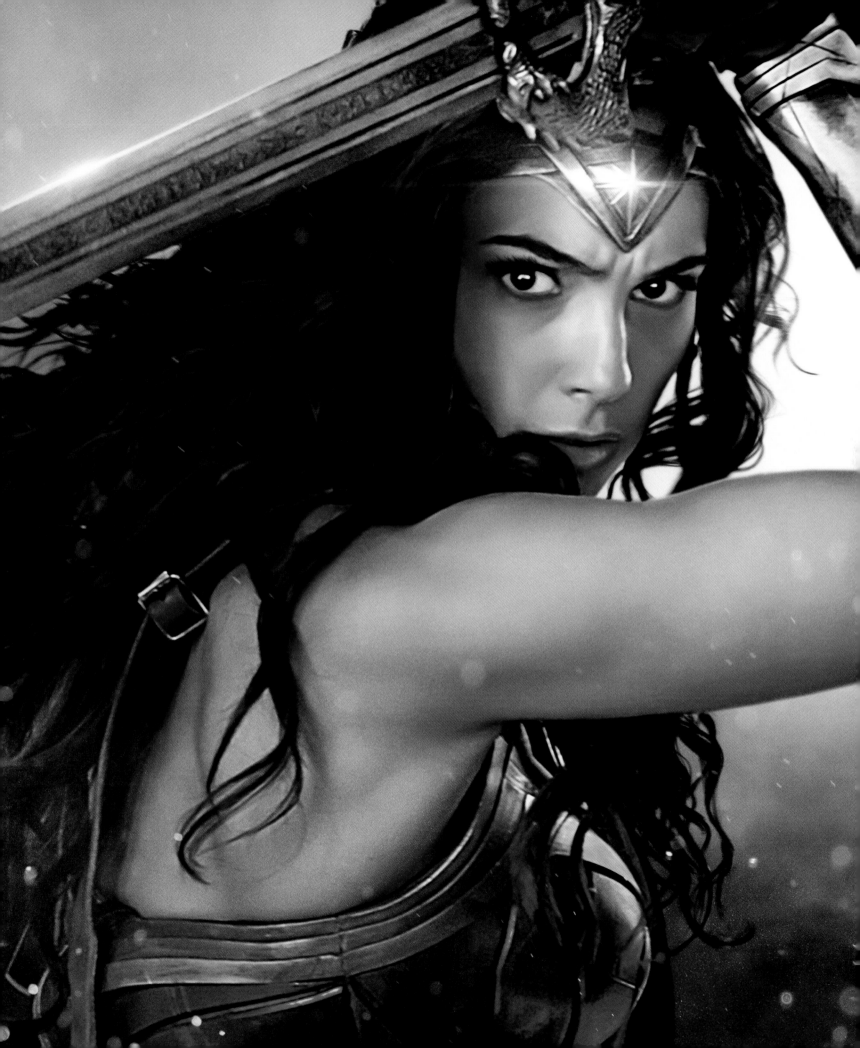

PRELUDE

THE AGE OF WOMAN

PREVIOUS SPREAD |
Interior panel artwork by Ric
Estrada, *Wonder Woman Vol. 1
#208* (November 1973).

OPPOSITE | Cover art by
Liam Sharp, *Wonder Woman
Vol.5 # 1* (August 2016).

As the most popular female comic book super hero in history, Wonder Woman has been around the block a few times. When talking about full-fledged female heroes, she was the biggest game in town for years. Sure, there have been other heroines, but Wonder Woman's been the gold standard: she's never gone out of print, her worldwide fans number in the millions, and she's been a mainstay of the small screen, with the cult favorite television show in the 1970s as well as appearing in several animated series since then. More recently, she's accomplished forays into the video gaming world and, of course, made her big-screen debut. Those are decent stats, especially considering that, in true comic book fashion, Wonder Woman's been subjected to some eyebrow-raising narrative arcs and multiple character reboots by an ever-growing list of writers, editors, and artists over her seventy-five-plus-year history. Nevertheless, she persisted.

The longstanding cycle of the American comic book is write-establish-reboot-repeat. As each new editor and creative team comes on board with their own ideas about who Wonder Woman is, previous story lines are abandoned at will. Sometimes there are over-the-top, even bizarre imaginings, and characters who have been killed off are suddenly brought back to life. Wonder Woman gets married and has kids, until that story line is discarded in the next issue. Diana Prince, Wonder Woman's alter ego, changes jobs—and her wardrobe—faster than you can say, "Suffering Sappho!" Most fans accept superficial changes as long as the fundamentals of Wonder Woman's heroism—her sense of compassion; her strength as a woke woman; her badass, take-no-prisoners attitude—remain her

core, undaunted and fierce. Luckily, each time her characterization drifts from her core strengths, fans and fellow artists-slash-heroes—Greg Rucka, George Pérez, Gail Simone, John Byrne, Phil Jimenez, Roy Thomas, Jodi Picoult, and Trina Robbins, to name a few—rise up as the vanguards of truth and justice to set her back on course.

While characters and story lines can change on a yearly or even monthly basis, the comics industry as a whole consistently makes periodic large-scale transformations to the overall tone and style of mainstream comics. These periods of great change are referred to as "ages" and, in Wonder Woman's tenure, she's lived through a host of them, including, in chronological order, the Golden Age, the Silver Age, the Bronze Age, and the Modern Age. Because the continuity of Wonder Woman's character has changed so much over the years, these ages help contextualize her evolution within the larger framework of the American comic book.

LEFT | Cover art by Adam Hughes, *Wonder Woman Vol. 2 #184* (October 2002).

OPPOSITE | Cover art by H. G. Peter, *Sensation Comics #1* (January 1942).

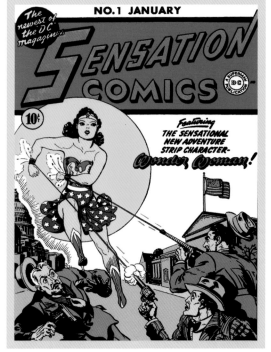

While exact sales figures are difficult to track from the 1940s, it's widely held that *Wonder Woman* pulled her own weight just fine as the lead feature in *Sensation Comics*. She also appeared regularly in *All-Star Comics* as well as in the quarterly *Comic Cavalcade*, in which she was on *every* cover; hers was the lead story in *every* issue. What made Wonder Woman truly sensational, however, was the fact that she was one of the first female super heroes in a world dominated by super-strong men. Though her creator was also a man, Dr. William Moulton Marston's *Wonder Woman* was certainly influenced by the women in his life as well as by the women's movement. His Golden Age version of the Amazon Princess is one that readers return to again and again, and whom several writers, creators, and players in future *Wonder Woman* projects would reference in their own work. Marston created an original when he made *Wonder Woman*, and struck gold—good thing, too, because he needed to hit one out of the ballpark after suffering a long string of professional setbacks.

A jack-of-all-trades, Marston had tried his hand at a number of occupations before making his splash on the pages of *Wonder Woman*. Among other job titles, he was the inventor of the systolic blood pressure test, which was a crucial component of the popular-yet-controversial lie detector test; psychology professor at Tufts University; author of various academic papers and books, including *Emotions of Normal People*; and psychology consultant to some of Hollywood's biggest film studios, such as Universal, who hired him to analyze and evaluate the effect of various plot points on audiences. A man with outsize appetite and ambition, Marston was on track to create his own motion picture company—Equitable Pictures Corporation—until its fate and Marston's fortune and cinematic future plunged along with the 1929 stock market. Following that setback, Marston went back to his bread and butter—writing.

Before committing pen to paper to create *Wonder Woman*, Marston wrote and published *Try Living*, a book that explored the psychological benefits and happiness that come from doing what you love. In 1937, Marston went on a press junket for the book and, in a story picked up by the Associated Press, issued a seemingly unrelated and, at the time, revolutionary idea: women would one day rule the world. The *Chicago Tribune* ran with the headline, "Women Will Rule 1,000 Years Hence!" The *Los Angeles Times* was more certain in their declaration: "Feminine Rule Declared Fact!" Marston also declared feminist Margaret Sanger's contributions to humanity second only to Henry Ford's. Clearly, here was a man who, for reasons both deeply personal and political, was ready to expound on the wonders of women.

Marston got into the comic book biz the same way he entered most professions: he talked his way into it as a psychology consultant. The story goes that

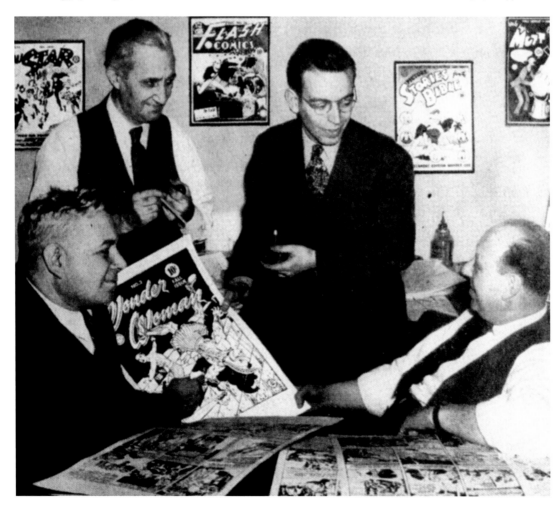

Superman's publisher, Charles Gaines, read a *Family Circle* article written by his paramour, Olive Byrne, in which she interviewed Marston for his thoughts on the possible dangers of comic books for America's impressionable youth. At the time, comics were getting a bad rap for their violence and possible political persuasions, among other issues. Jill Lepore, author of *The Secret History of Wonder Woman,* writes, "As a consulting psychologist, Marston convinced Gaines that what he really needed to counter the attacks on comics was a female super hero." To win Gaines over, Marston pleaded his case in an argument that would become the foundation and psychological motivation behind the creation of Wonder Woman's character. He wrote:

A male hero, at best, lacks the qualities of maternal love and tenderness, which are as essential to a normal child as the breath of life. Suppose

LEFT | William Moulton Marston, H. G. Peter, Sheldon Mayer, and Max Gaines, 1942.

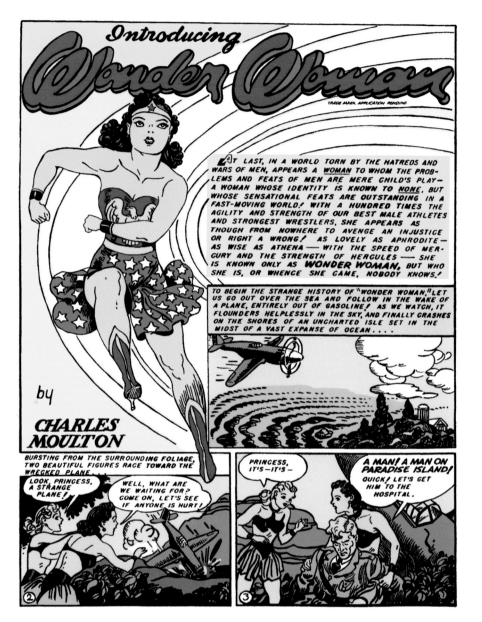

your child's ideal becomes a superman who uses his extraordinary power to help the weak. The most important ingredient in the human happiness recipe is still missing—love. It's smart to be strong. It's big to be generous. But it's sissified, according to exclusively masculine rules, to be tender, loving, affectionate, and alluring. "Aw, that's girl's stuff!" snorts our comics' reader. "Who wants to be a girl?" And that's the point; not even girls want to be girls so long as our feminine archetype lacks force, strength, power. Not wanting to be girls they don't want to be tender, submissive, peace-loving as good women are. Women's strong qualities have become despised because of their weak ones. The obvious remedy is to create a feminine character with all the strength of Superman plus all the allure of a good and beautiful woman.

Marston sold the idea of *Wonder Woman* to Gaines with his typical showmanship-like flair. His stance was peppered with sentiments popular among 1940s first-wave feminists, tweaked to his unique brand of psychology. Gaines decided to green-light *Wonder Woman*, figuring he could drop it if it flopped. The version of *Wonder Woman* that Marston created, along with help from his crack team—editor Sheldon Mayer, who also edited *Superman*, and artist Harry G. Peter (better known as H.G. Peter)—was heavy on exploring themes that reflected the power dynamics implicit in gender roles. Wonder Woman was often subjected to men's symbolic, and often literal, tyrannical chains, from which she tirelessly freed herself again and again, displaying her awesome power, strength, and courage. Whether intentional or not, the simple fact that a woman could be the starring protagonist of her own life inverted the traditional assumptions about a woman's place in the world . . . and she's a super hero? Game on.

THE BRONZE AGE
1970–1985

At the moment *Wonder Woman* was getting back in the game, DC canceled the majority of their other super hero titles—save *Wonder Woman, Superman,* and *Batman*—due to poor sales and performance. The early 1970s comic book audiences had had their fill of flying men with mutant strength and craved more variety. Publishers delivered westerns, horror and monster stories, and pulp, with heavy plotlines that dealt with real issues of the day—drug and alcohol abuse, discrimination and racism, urban poverty, and environmental concerns. By the mid-1970s, however, audiences had reverted to their core: super heroes. Publishers, eager to connect with a new generation of audiences, began to embrace franchising opportunities with comics based on films and television shows.

With Lynda Carter leading the charge, *Wonder Woman* hit her stride during the mid-1970s. Though the television show was on air for only three seasons, its impact was immense, and brought Wonder Woman

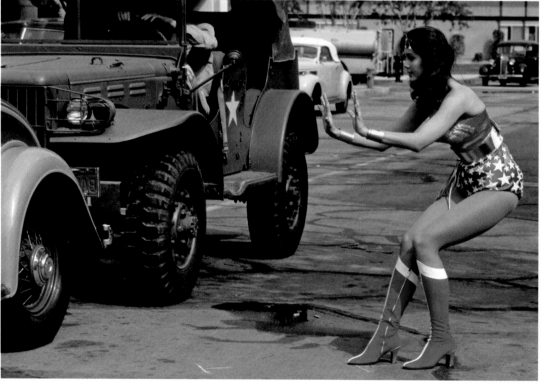

TOP | Cover art by Jose Delbo, *Wonder Woman Vol. 1 #228* (February 1977).

BOTTOM AND OPPOSITE | Lynda Carter as Wonder Woman in the 1970s TV series.

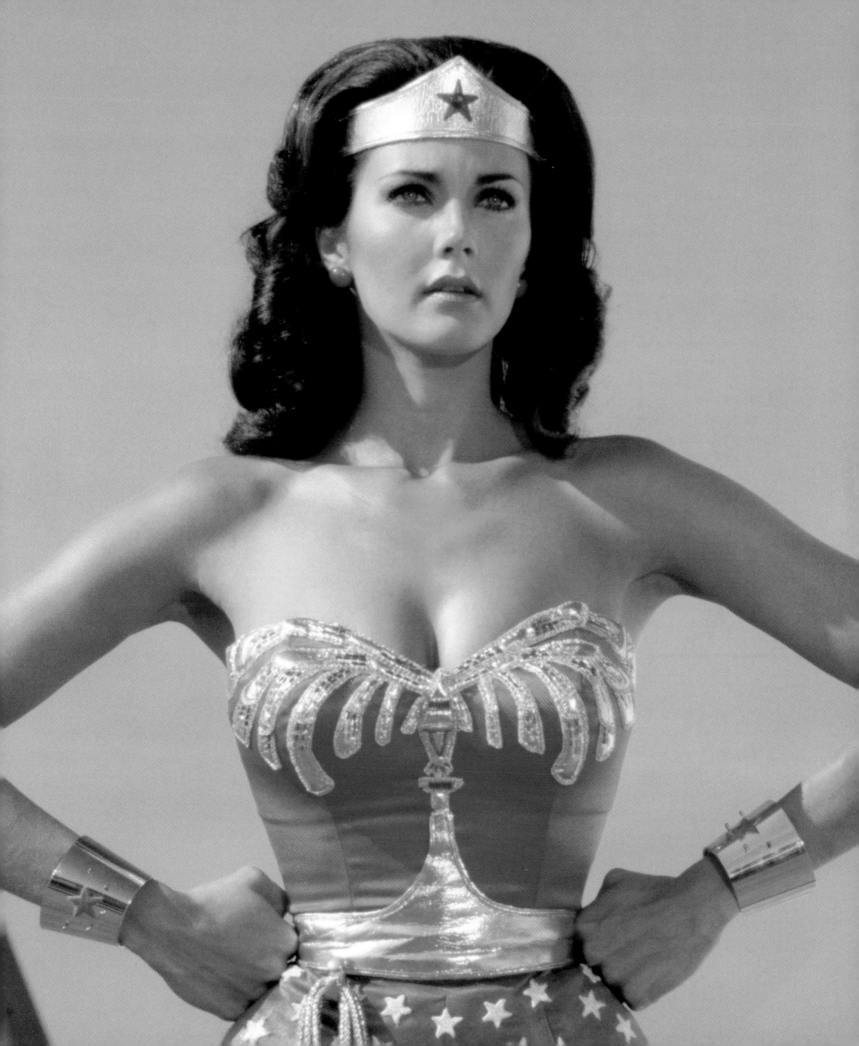

worldwide recognition. Given the popularity of the television show, *Wonder Woman #228* (February 1977) was set during World War II to match the first season of the series. The fifteen-issue run took place on Earth-2, where Wonder Woman was a member of the Justice Society of America. Later that same year, her character made an appearance as a backup feature in *World's Finest*; in this iteration, Wonder Woman's adventures were set in the present day. Following *World's Finest*, she showed up in five issues of *Adventure Comics*. Suddenly, Wonder Woman was everywhere all at once, and seemingly spanning the time continuum.

> DC CONTINUITY WAS SO CONFUSING, NO NEW READER COULD EASILY UNDERSTAND IT, WHILE OLDER READERS HAD TO KEEP MILES-LONG LISTS TO SET THINGS STRAIGHT. AND THE WRITERS . . . WELL, WE WERE ALWAYS STUMBLING OVER EACH OTHER TRYING TO FIGURE OUT SIMPLE ANSWERS TO DIFFICULT QUESTIONS.
>
> —MARV WOLFMAN

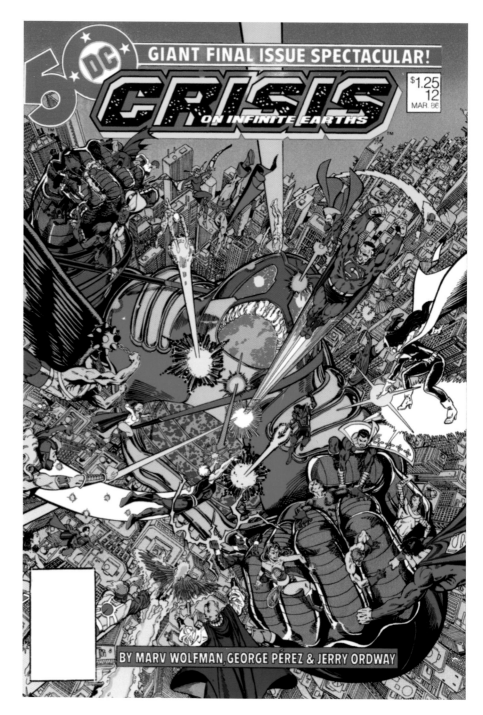

The 1980s ushered in tremendous change at DC Comics when the company attempted to address the multiple continuity issues it had with several of their characters and properties. By creating a limited twelve-issue series from 1985 to 1986 called *Crisis on Infinite Earths*, the overarching story merged the multiple "Earths" and time periods of various DC Comics's properties into a single Earth. Written by Marv Wolfman and illustrated by George Pérez, it offered a simplified narrative to explain the various discrepancies of DC's fifty years of

continuity issues by dividing the DC Universe into pre-*Crisis* and post-*Crisis* periods. For non-comic-book readers, the differentiation was in itself fairly confusing, but for the initiated, *Crisis on Infinite Earths* was a godsend; it essentially connected the loose threads that had been slowly unraveling the DC Universe for years.

ABOVE | Cover art by George Pérez, *Crisis on Infinite Earths #12* (March 1986).

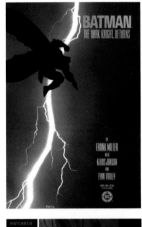

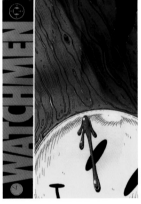

TOP | Cover art by Frank Miller, *Batman: The Dark Knight Returns #1* (February 1986).

BOTTOM | Cover art by Dave Gibbons, *Watchmen #1* (September 1986).

RIGHT | Interior panel art by George Pérez, *Who's Who in the DC Universe* (June 2005).

THE MODERN AGE
1986–PRESENT DAY

The Modern Age of DC Comics started with a bang, namely the seminal publication of *The Dark Knight Returns* and *Watchmen*. Both stories represented a trend among mainstream comics to go darker. Audiences wanted their heroes conflicted, outliers to a corrupt social system. This trend was reflected in other creative mediums, too: *Die Hard*, *Lethal Weapon*, and the *Rambo* series were at the top of the box office while grunge music and its sonic apathy simultaneously ricocheted across the country. Angst and internal conflict were big sellers, and comic book publishers took note.

The Post-*Crisis* DC reflected a time in the company's history when comic books emphasized realism: characters were believable and story lines were experimental, with the intention of grabbing a new generation of readers. DC turned its lens on Wonder Woman and dispatched its own team—editor Karen Berger, writer/illustrator George Pérez, and writers Greg Potter and Len Wein—to breathe some new life into the series. Wonder Woman returned to her feminist roots, and Pérez grounded the character in Greek mythology; Diana Prince was dropped altogether, leaving Wonder Woman free to live her life

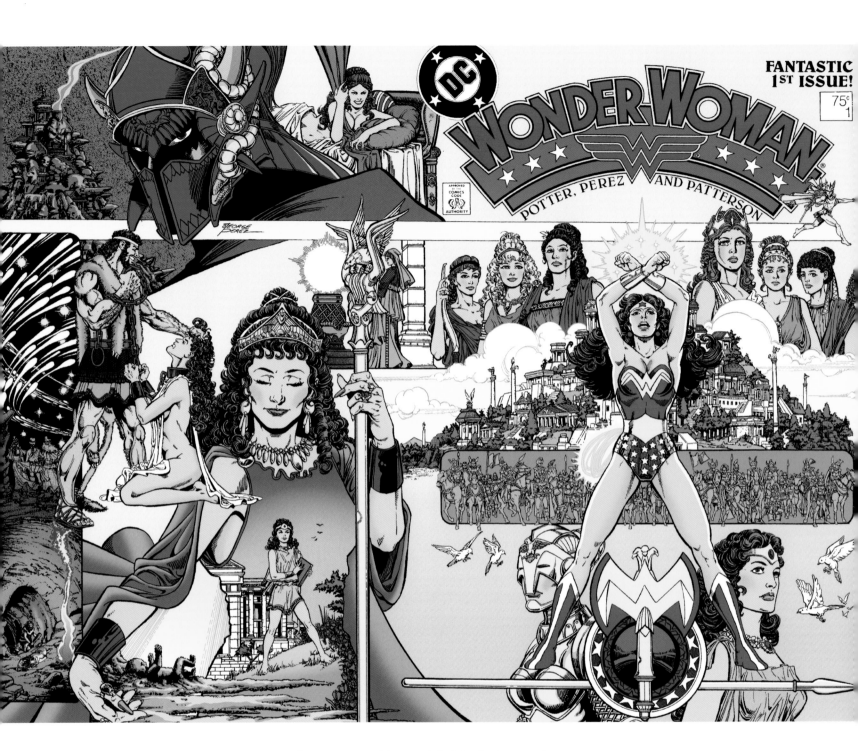

in the open as an Amazon Princess. Her title was relaunched with a new #1 (Volume 2) that focused on her mythological background and stressed the importance of her ambassador-like qualities as they related to the Amazonian ideals of peace, equality, and love. The redevelopment would largely fall to Pérez, who worked on the series in a variety of roles for five years. At a time when the rest of the

world went dark, Wonder Woman became more principled . . . at least until someone pulled a gun or a sword and she had to throw down.

Pérez, having taken a successful turn as writer on *Wonder Woman*, stayed on until issue #62, at which point William Messner-Loebs took over as writer, paired with editor Paul Kupperberg. Wonder Woman had long been defined by her goodness and

ABOVE | Cover art by George Pérez, *Wonder Woman Vol. 2 #1* (February 1987).

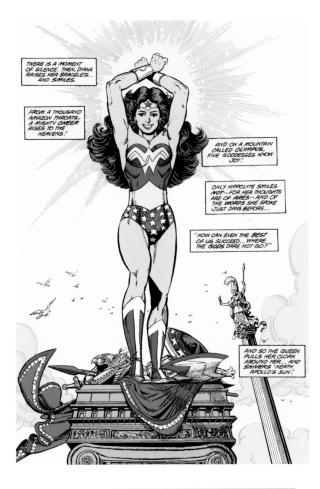

OH, GODS OF OLYMPUS! THOUGH I LOVE PARADISE, I YEARN FOR MORE FROM MY LIFE. I YEARN FOR PURPOSE!

—WONDER WOMAN, *WONDER WOMAN VOL. 2 #1*

ABOVE | Interior panel art by George Pérez, *Wonder Woman Vol. 2 #1* (February 1987).

RIGHT | Interior panel art by Mike Deodato Jr., *Wonder Woman Vol. 2 #93* (January 1995).

sense of moral purity, and Messner-Loebs struggled with bringing her to the dark side. How does a good girl like Wonder Woman go bad? She doesn't. But in Messner-Loebs's hands, she did end up being more violent and forcefully aggressive than ever before and, thanks to the line drawings of Brazilian artist Mike Deodato Jr., even more scantily clad. Wonder Woman's costume had always been a little risqué

but in Deodato's version, it shrank to a tiny thong while the rest of her assumed epically curvaceous proportions. By the end of the 1990s, *Wonder Woman* experienced two additional cycles of writers—first John Byrne and then Eric Luke.

In 2001, new blood arrived in the form of writer/artist Phil Jimenez, who picked up where the game-changing Pérez had left off. Every writer,

artist, and editor who touches *Wonder Woman* inevitably leaves his or her mark on the character, but few are as universally respected as Jimenez for his authentic, respectful portrayal of the super heroine. Fan favorite and critic-approved Gail Simone cites Jimenez as one of her favorite writers and sources of inspiration for all things *Wonder Woman*—along with John Byrne, Trina Robbins, Kurt Busiek, and Pérez, among others. A special high note from Jimenez's tenure (2000–2003) is an issue in which Lois Lane interviews Wonder Woman, an ultimate girl-power moment.

Jimenez was first introduced to Wonder Woman via the 1970s Lynda Carter television show. As a young boy, the show—and Carter—made a lasting impression on him. He explains, saying, "It goes without saying that Lynda Carter—and her perfect embodiment of that character on the *Wonder Woman* TV series of the 1970s at a time when I was young and incredibly impressionable—has everything to do with what I love about Wonder Woman and what appeals to me about her (at least as I interpret her) . . . She embodied qualities that I long to have and have longed to see spread throughout the world." Not surprising, much of Jimenez's artwork during his run, which began with #64 (January 2001), incorporated visual elements from the Carter television show. For observant fans, these sly references trafficked in nostalgia and connected the Wonder Woman of the Modern Age with an earlier version whom many fans, like Jimenez himself, knew first as a television star. Jimenez restored Wonder Woman's feminine power without making her a sexbomb. He explains, saying:

> *I love that Wonder Woman's a woman. What that means to different people (especially to actual women) might be vastly different. But being raised by a single mother; being particularly attuned, for various reasons, to feminine energy (although, admittedly, not always female); and being fascinated by the sex and gender politics that permeate the character and her world, all make Wonder Woman's "womanness" interesting to me. It's also what I think makes this character less interesting or troublesome to many comic*

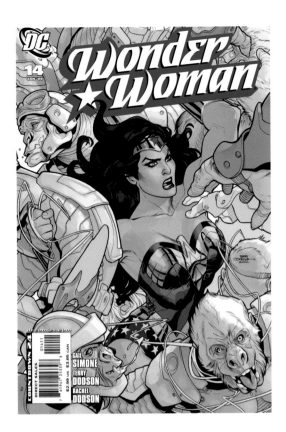

> *readers. I actually think many creators who try to "fix" her do so by trying to make her more masculine and more male—one of the guys as it were—instead of embracing her female-ness and celebrating it.*

Following Jimenez, Wonder Woman once again lost her powers in a six-issue series written by Walt Simonson. Greg Rucka took over the helm with issue #195 and introduced a new rogue—the ruthless and calculating businesswoman Veronica Cale. By the time Gail Simone picked up writing duties, DC had undergone yet another massive relaunch, this time in 2006. *Wonder Woman* started fresh—once again—with issue #1 (June 2006), the publication of which was timed to coincide with DC's "One Year Later" crossover story line. Simone made her debut with issue #14, following writing rotations by Allan Heinberg and novelist Jodi Picoult, who won critical acclaim for her contribution. Simone would go on to write five story arcs: *The Circle, Ends of the Earth, Rise of the Olympian, Warkiller,* and *Contagion.* Simone is the longest-running female writer on the property, a fact that has endeared her

OPPOSITE | Cover art by Adam Hughes, *Wonder Woman Vol. 2 #170* (July 2001).

RIGHT | Cover art by Terry Dodson, *Wonder Woman Vol. 3 #14* (January 2008).

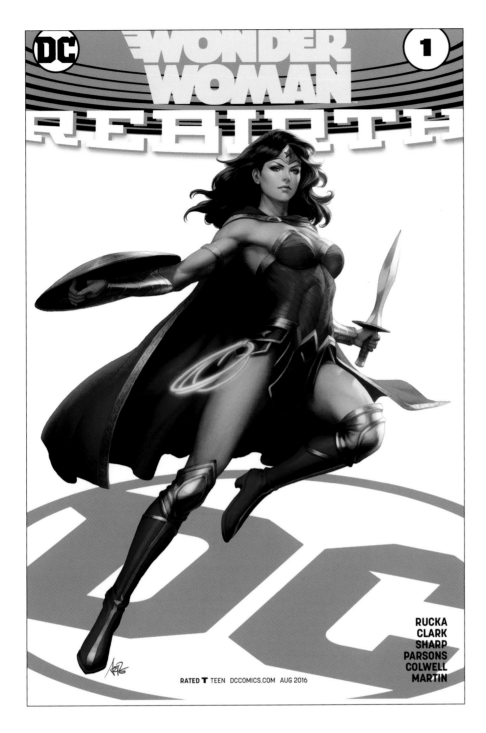

WONDER WOMAN REBIRTH 1

RUCKA
CLARK
SHARP
PARSONS
COLWELL
MARTIN

RATED T TEEN DCCOMICS.COM AUG 2016

Wonder Woman is truly awe-inspiring. A warrior in every sense—mental, physical, and emotional—she wields her weapons with newfound energy; even the golden lasso becomes something to fear. Marston would have been proud.

The 2006 relaunch was followed by another in 2011 in which the entire DC Comics line of ongoing monthly titles was revamped in what was branded the *New 52*. The first issue of Wonder Woman in this new universe was written by Brian Azzarello and illustrated by Cliff Chiang. Azzarello has described his version of *Wonder Woman* as being darker than dark: a "horror" book. Despite the violence that permeates each page, Azzarello was also interested in horror's flipside and created a story line with it that featured Wonder Woman exploring the idea of mercy. Even

> DIANA IS OFTEN WRITTEN AS MORE OF A CONCEPT THAN A CHARACTER. IF PEOPLE LOOK AT DIANA AND KNOW *EXACTLY* WHO SHE IS AND WHY SHE DOES WHAT SHE DOES, THAT WILL BE THE ULTIMATE SUCCESS.
>
> —GAIL SIMONE

when Wonder Woman takes a walk on the dark side, she can't stay there for very long.

In 2016, Greg Rucka and artists Liam Sharp, Matthew Clark, and Nicola Scott produced a new *Wonder Woman* series in conjunction with the end of the *New 52* period that led into an era of "Rebirth." During this story line Wonder Woman once again returned to her roots, with Rucka exploring the depth of what it means to leave paradise for the world of man. She faced her most notable foes and showed them that love out would always win out over hate. And she reunited with Steve Trevor, following a ill-fated romance with none other than Superman.

OPPOSITE | Cover art by Terry & Rachel Dodson, *Wonder Woman Vol. 3 #16* (March 2008).

ABOVE | Variant cover art by Stanley Lau, *Wonder Woman Vol. 5 #1* (August 2016).

to countless fans eager for *Wonder Woman* to have an authentically female voice.

During her run, Simone says she was focused on "letting the tiger loose. Wonder Woman's slightly untamed, and she's the greatest warrior the Earth has ever known, period. She fights for right, she wants peace. But woe betide despots and those who harm innocents in her presence." In Simone's hands,

PART ONE
PRINCESS

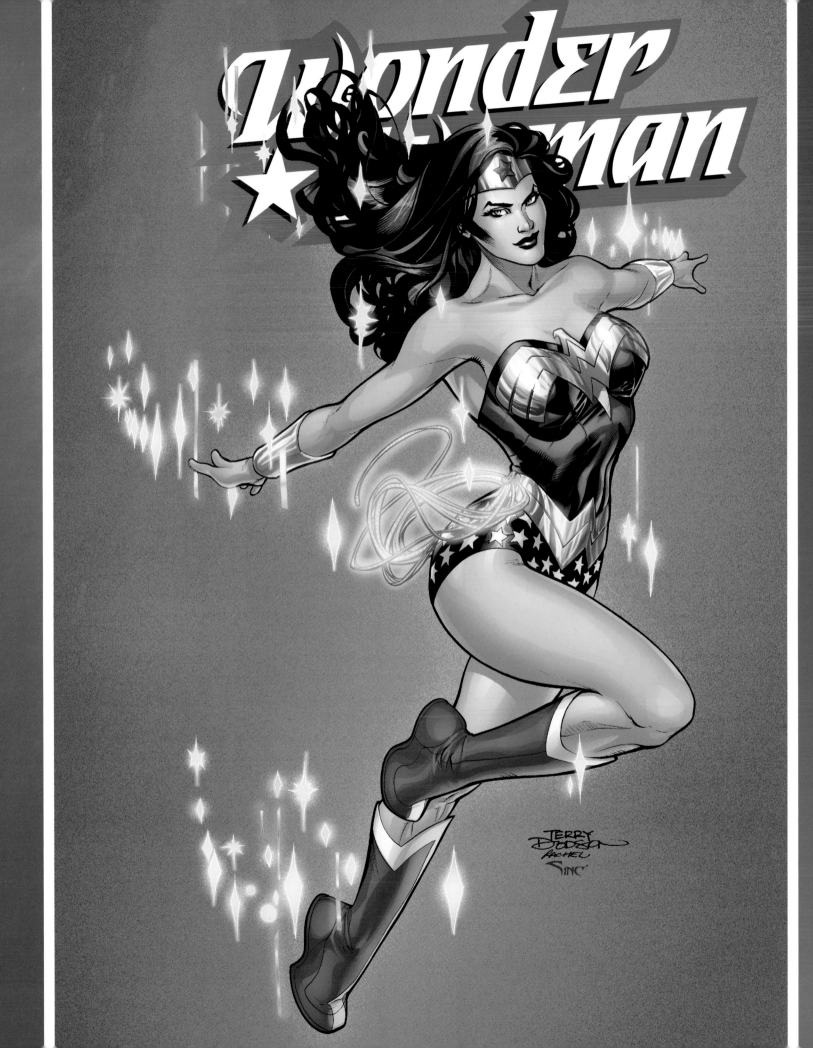

COURAGE & SISTERHOOD

While Wonder Woman acquired her superhuman powers in distinctly different ways, depending on the writer telling her story, one element of her origin story has largely remained the same: Wonder Woman lived in a world apart from man and, as such, abides by a different set of rules. According to Marston's origin story, Princess Diana was birthed on Paradise Island from clay sculpted by her mother, Queen Hippolyta. Life was breathed into her by Aphrodite, the goddess of love. Born a princess, Diana was nonetheless destined for a fate bigger than twirling around in gauzy, fairy-tale dresses. (Admittedly, though, the twirling would come later.)

That Wonder Woman's formative years were spent surrounded by a family of women is telling and not at all surprising, given that Marston himself was a vocal advocate of the first-wave feminism of the 1940s women's movement, and surrounded himself with his own family of women. Paradise Island—as a fictional device—and the early women's movement both championed the idea of women's moral superiority over men, and Marston believed Wonder Woman's core sense of empathy and compassion, coupled with her innate ability to treat fellow human beings with love, kindness, and respect, were uniquely feminine characteristics. To transpose that idea more fully, Marston put womanhood on a pedestal and made Diana a princess and her mother, a queen. It was only a matter of time, however, before the little girl, the princess, became a woman and, called into action, faced the world of man head-on.

PREVIOUS SPREAD | Interior panel artwork by George Pérez, *Wonder Woman Vol. 2 #1* (February 1987).

OPPOSITE | Cover art by Terry & Rachel Dodson, *Wonder Woman Vol. 3 #5* (May 2007).

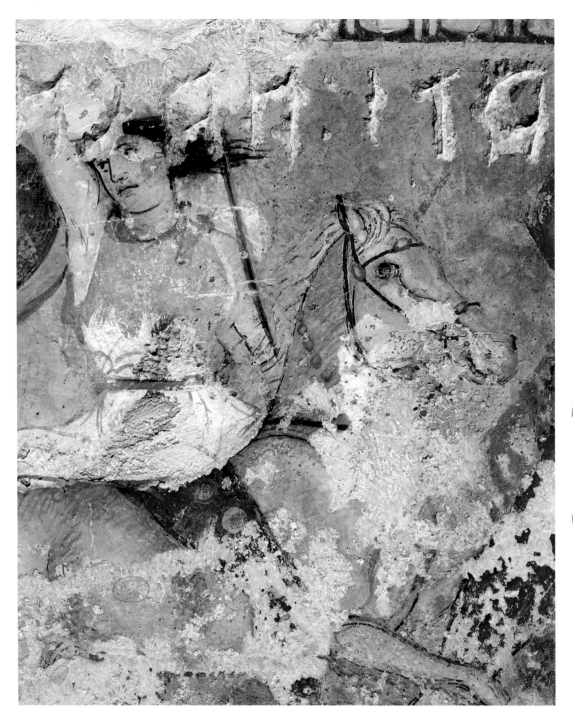

Amazons have long fascinated the general public. In the *Iliad*, Homer described Amazons as warrior women who lived apart from the world of man. The word itself is taken from the Greek term *amazoi*, meaning "breastless"; legend held it that Amazonian women removed their right breasts as young girls to better facilitate the drawing of the bow, the bow and arrow being their main weapon of defense. Much of

Wonder Woman's courage comes from her sense of sisterhood with other women and her Amazonian upbringing. Just as a princess or a queen rallies her subjects to action, Wonder Woman is able to summon other women (and men) to join her in battle and to claim ownership of their own strengths. A general could do no better gearing up his army.

LEFT | The Sarcophagus of the Amazons, detail of a rider, from Tarquinia (tempera on alabaster), Greek, (4th century BC).

ABOVE | Interior panel art by Mike Sekowsky *Wonder Woman Vol. 1 #183* (August 1969).

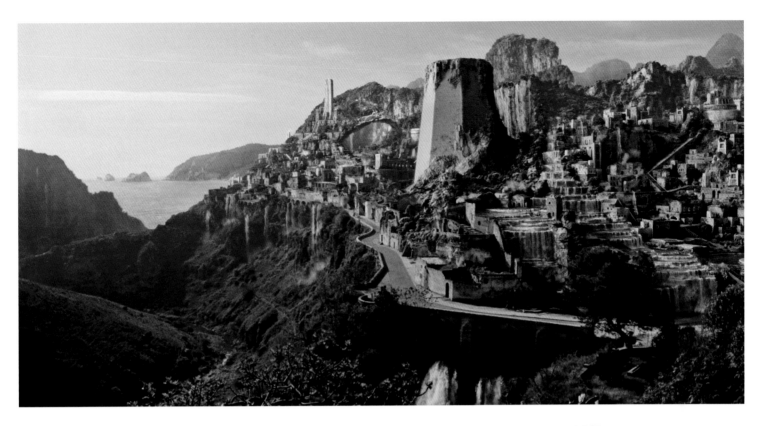

PARADISE ISLAND
THEMYSCIRA: UNCHARTED LAND

Before there was a Diana Prince or a Wonder Woman, there was a young, ambitious, and curious girl named Princess Diana, who lived on an island ruled by women. In order for this girl to become a comic book heroine, she had to conceal herself, in this case from the queen, her mother, in order to compete in a strenuous competition. The reward for this show of skill and strength would secure her title as Wonder Woman, take her far from home and into the complicated world of man. In that new, patriarchal society, she concealed herself again, changing her identity from princess to Diana Prince. Hers is a disguise within a disguise. Once Queen Hippolyta saw her daughter as the contest's victor, however, she knew there was no one else suitable for the task at hand, for the strengths the young girl possessed had been passed down to her by her own mother: compassion, athleticism, fearlessness, and, above all else, the determination to continually fight the good fight.

ABOVE | Themyscira as the island appeared in *Wonder Woman* (2017).

According to the Pre-*Crisis* era of DC Comics (1941–1985), Wonder Woman, along with her mother, Queen Hippolyte, ruled Paradise Island, a secret isle inhabited entirely by women. As William Moulton Marston's origin story went, Queen Hippolyte defeated Hercules, the world's strongest man, and in retaliation, he stole her magic girdle, which had been given to the queen by Aphrodite, goddess of love and beauty. Without her girdle, Hippolyte lost her powers and, unable to protect her people, the Amazons were captured, bound in chains, and made slaves to men. They escaped their gruesome fate by agreeing to live a world apart from man, and traveled across the ocean until they found an uncharted land, naming it Paradise Island. Marston called this isle of women "paradise" for good reason: It backed up his characterization of the peace and harmony inherent, he believed, in an all-female civilization. In Marston's comic book world, women, guided by Aphrodite, countered the

violence and aggression of men, who were ruled by Mars, the god of war.

Paradise Island, whether understood from Marston's perspective or from that of another writer of *Wonder Woman*, has always been a fantastical place far removed from the everyday trials and tribulations that Wonder Woman faces in the world of man. Robert Kanigher, who took over writing duties on the *Wonder Woman* comic books from 1947 to 1967, wrote Paradise Island into a number of issues, due to its popularity. Largely written for a female teenage readership, Kanigher's stories—at least those that centered on Paradise Island—bordered on the stuff of fairy tales. Readers got a revelatory look into Wonder Woman's personal life as she learned dressmaking, played musical instruments, partook in sports, and tried her hand at cooking, and they were introduced to younger versions of her in Wonder Girl and Wonder Tot. Of course, she also battled mythical monsters and beasts like genies, giants, and mer-people with her mother.

The actual location of Paradise Island has moved around: First assumed to be somewhere in the Pacific

Ocean, its position changed to the Bermuda Triangle in the 1970s television show with Lynda Carter. In first-season episode "The Feminum Mystique, Part 2," Paradise Island's coordinates are shown on-screen as 30° 22' N, 64° 47'W, confirming that location in the Atlantic. In 2009's animated film *Wonder Woman*, starring Keri Russell as the voice of the Amazon Princess, the island's location shifted to the Aegean Sea. When DC Comics relaunched the Wonder Woman character in 1987—the beginning of the comics' so-called Post-*Crisis* period—Paradise Island got a top-to-bottom makeover, starting with a name change. In *Wonder Woman (Vol. 2) #1*, the island is called Themyscira in

ABOVE | Interior panel art by Mike Sekowsky, *Wonder Woman Vol. 1 #183* (August 1969).

OPPOSITE (TOP) | *Wonder Woman: Spirit of Truth* artwork by Alex Ross.

OPPOSITE (BOTTOM) | Interior panel by Yanick Paquette, *Wonder Woman: Earth One* (June 2016).

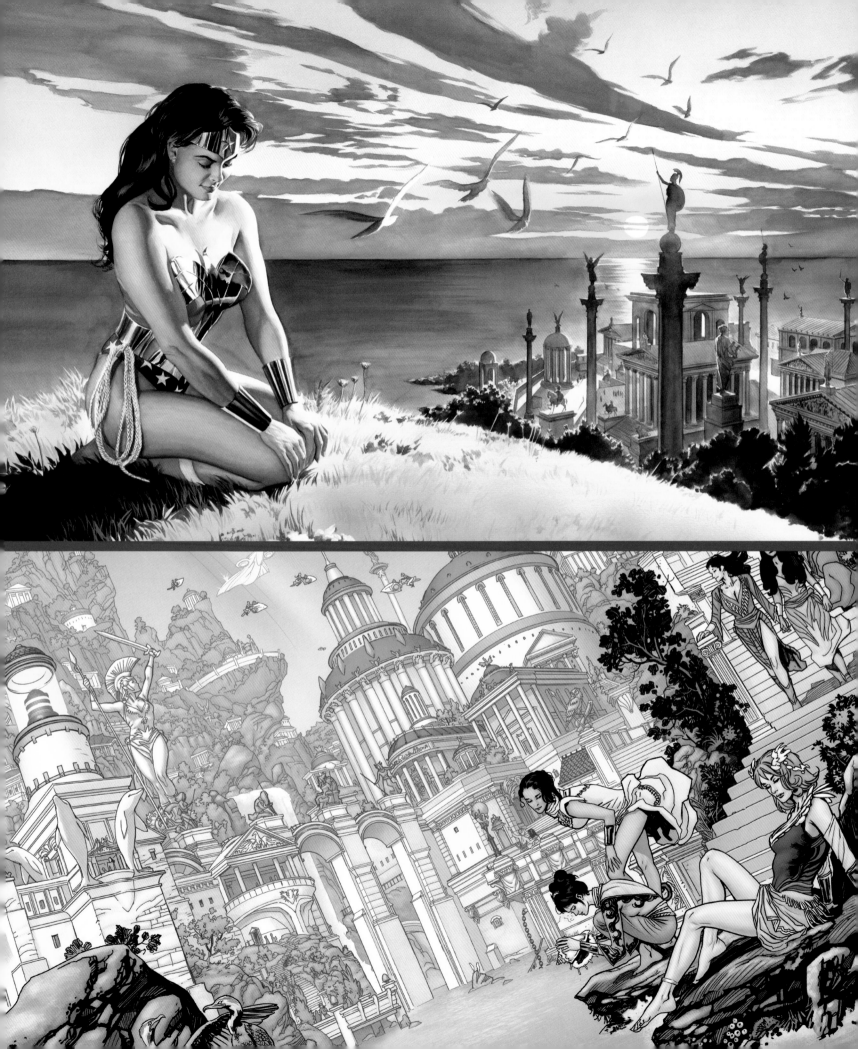

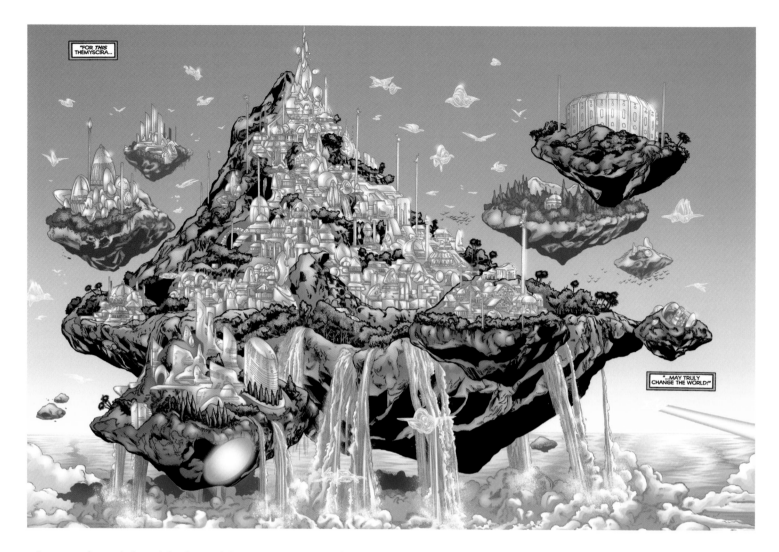

reference to the mythological Greek city of Themiscyra, which, in the Post-*Crisis* world of *Wonder Woman*, was the Amazons' original home.

The Post-*Crisis* version of Wonder Woman's homeland is a far cry from Marston's Pre-*Crisis* tale, though it hits on similar themes: ruled by the sisters Hippolyta and Antiope, Themiscyra is attacked by Ares, the god of war, and his brother, who take the Amazons as their slaves. Athena agrees to help the Amazons on one condition: they must not take revenge. Once freed, however, the Amazons wreak havoc and wage war on their captors. Hippolyta (who also underwent a slight name change decades earlier from the original spelling, Hippolyte) ushers the surviving Amazons to an uncharted island that they name Themyscira, and they endeavor to start their lives anew. As punishment, however,

for failing to heed Athena's words of wisdom, the island is literally positioned over a vortex called Doom's Doorway, and the Amazons must remain ever vigilant, guarding against possible demons and monsters. In this version, Themyscira is, once again, located in the Bermuda Triangle but can magically transport itself to any location or time period. After the island was destroyed in 2001's "Our Worlds at War," writer/artist Phil Jimenez updated the island and made it a heavenly, futuristic-looking, floating citadel, complete with never-ending, crystal-blue waterfalls and lush greenery: Themyscira 2.0.

Call it what you want—Themyscira or Paradise Island—and drop it in any ocean, sea, or time period, Wonder Woman's tranquil hometown is, by most accounts, graced with stunning vistas and fertile land, and populated with beautiful, strong women free to

TOP | Interior panel art by Phil Jimenez, *Wonder Woman Vol. 2 #177* (February 2017).

BOTTOM | Still from *Wonder Woman* animated film, 2009.

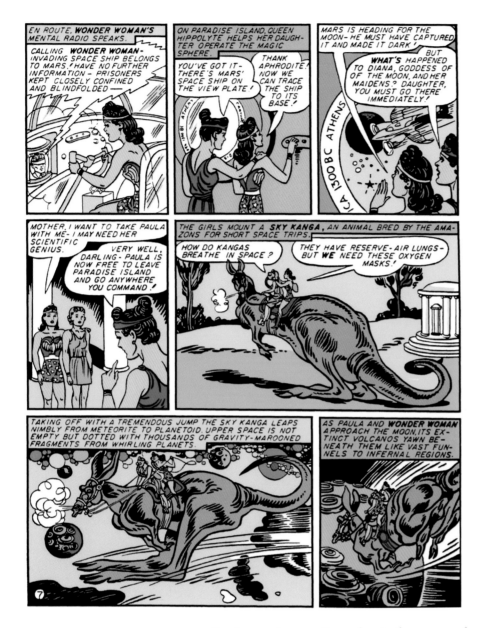

live, love, and govern themselves in the manner of their choosing. Not bad for an island getaway.

ISLAND FAUNA: KANGAS, PEGASUS, AND GRIFFINS

In Marston's Pre-*Crisis* version, Paradise Island was home to creatures called kangas, which were similar to real-life, modern-day kangaroos. The Amazons rode these beasts like horses. Princess Diana's kanga was named Jumpa. Smaller, rabbit-like creatures also inhabited the isle. By the time Paradise Island transitioned to the Post-*Crisis* Themyscira, the creatures themselves had changed, too. Common woodland

animals like deer, horse, and fish remained, but the waters surrounding the island got mythical, and were populated with water nymphs called Naiads. Forests, too, were crowded with tree nymphs called Dryads. Phil Jimenez featured the kangas during his writing tenure while having them share the island with dinosaurs. Greg Rucka and Eric Luke went back to the basics of Greek mythology, with Rucka installing a second Pegasus on the island; Luke, in 1999, had introduced the island to its first all-white Pegasus. Rucka's Pegasus was gleaming black and possessed red eyes. Luke made Themyscira a virtual animal sanctuary for exotic creatures: centaur, Chiron, dragon, chimera, and sphinx called Themyscira home. Gail Simone introduced the idea that Hippolyta cared for griffins in the island's stables. In *Rise of the Olympian,* Simone also created the island of Thalarion, home to winged horses and winged lions both, creatures tamed by the Gargareans, an all-male tribe of warriors who integrated themselves into the Amazons' lives and presumably brought their animals to Themyscira, too.

UNWANTED GUESTS: MEN, WAR, AND DEMONS

Since Steve Trevor crash-landed on the island, paradise has gotten more than its share of visitors, conquerors, and plunderers, and that's not counting the demons that live beneath the island's secret vortex, Doom's Doorway. Writer George Pérez had the Amazons slaughtered on their home base; Phil Jimenez introduced a full-on, all-island tribal war over the island's ownership; and Walt Simonson had a Hydra turn the Amazons to stone. In fact, Themyscira's been host to so many epic battles that the island's buildings have been demolished,

rebuilt, and demolished again so many times, it's a wonder the Amazons are still willing to call it home. (In one version, the island is rebuilt with the help of alien technology.) For a place originally created as a beautiful refuge and safe haven from the ravages of man and the modern world, Themyscira can get a bit unruly. Then again: Where's the fun in creating women warriors who don't fight? This Amazonian spirit is a significant trait in Wonder Woman's history, with Paradise Island and all that it represents at the core of her character, providing her motivation through stories tracing all the way back to her very creation.

ABOVE | Interior panel artwork by Phil Jimenez, *Infinite Crisis #2* (January 2006).

OPPOSITE | Interior panel artwork by Phil Jimenez, *Wonder Woman Vol. 2 #177* (February 2002).

SENSATIONAL FACTS AND ALL-STAR NEWS

"NOW, GO, MY DAUGHTERS. HENCEFORTH, YOU SHALL FORM A SACRED SISTERHOOD. HENCEFORTH, YOU SHALL BE AMAZONS. AND NONE MAY RESIST YOUR POWER."

—HIPPOLYTA, *WONDER WOMAN, VOL. 2, #35*

• Themyscira makes several appearances in the television series *Justice League* and *Justice League Unlimited* as Wonder Woman's homeland. The island has been featured in several animated films, including *Justice League: The New Frontier* (2008), *Wonder Woman* (2009), and *Superman/Batman: Apocalypse* (2010). It's also a playable stage in the video game *Mortal Kombat vs. DC Universe* (2008) and *Injustice: Gods Among Us* (2013).

• In Post-*Crisis Wonder Woman* comic books, Amazons are the reincarnated souls of women slain throughout history by men. Each year they celebrate their creation in a ritual called the Feast of Five, in which they honor the goddesses who brought them to life: Artemis, Athena, Aphrodite, Demeter, and Hestia.

In Matt Wagner's 2003 comic book series *Batman/ Superman/Wonder Woman: Trinity*, the island is defended by giant birds who die fighting.

• In the 2007/2008 comic book series *Countdown to Final Crisis*, the waters surrounding the island are swarming with megalodons, ancient mammoth sharks.

• As a child, Julia Kapatelis, a fictional character created by George Pérez during the 1987 *Wonder Woman* comic book reboot, fell into the Ionian Sea and was rescued from drowning by the goddess Thetis, who brought the child to Themyscira to heal. As an adult, Kapatelis became dean of the Department of History and Geology at Harvard University. She would go on to help design and build a new Themyscira, along with help from Steve Trevor, among others, after the island was destroyed by the evil character Imperiex.

• In the 2017 *Wonder Woman* film, the island of Themyscira was largely filmed on location in Southern Italy, with CGI enhancements to give a more mystical quality to the land.

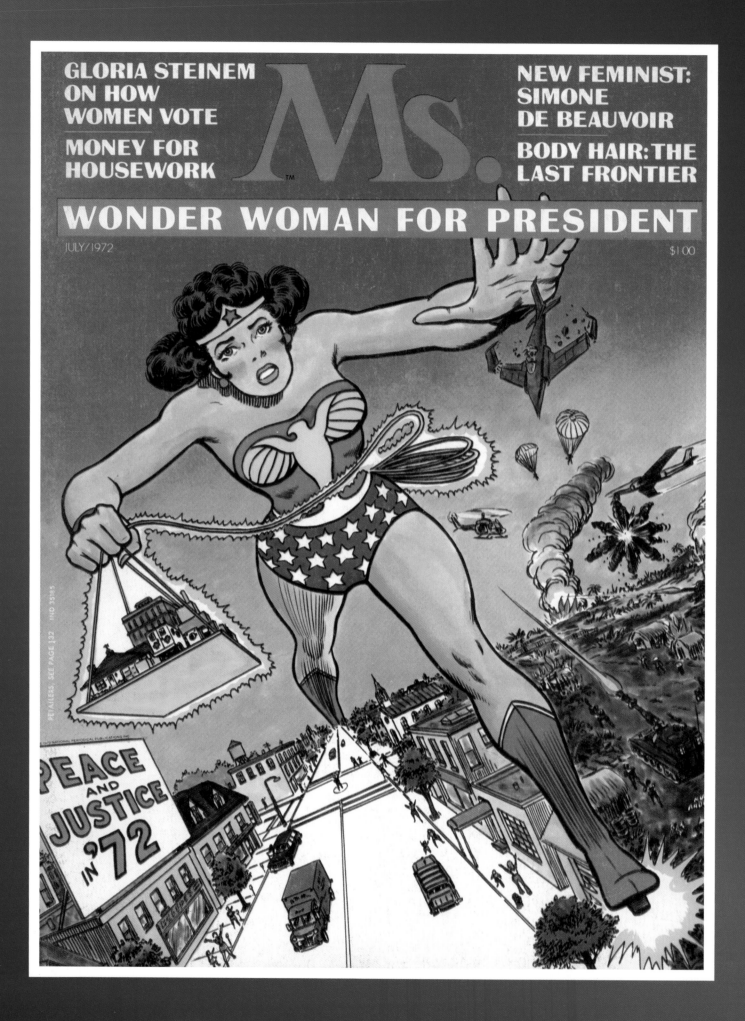

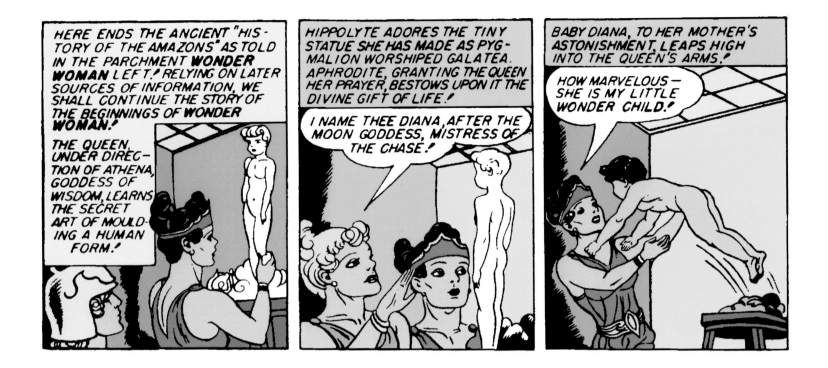

ORIGIN STORIES

OPPOSITE | *Ms.* magazine cover (July 1972).

ABOVE | Interior panel art by H.G. Peter, *Wonder Woman #1* (July 1942).

In 1972, *Ms.* magazine featured Wonder Woman on the front cover of its first regular issue. For Gloria Steinem, longtime feminist and one of the magazine's cofounders, Wonder Woman bridged the gap between feminism's first wave and its second wave of the 1960s to early 1980s. In her introduction to a collection of thirteen original Marston *Wonder Woman* stories organized by the magazine and published in conjunction with National Periodical Publications (DC Comics), Steinem wrote:

> Wonder Woman symbolizes many of the values of the women's culture that feminists are now trying to introduce into the mainstream: strength and self-reliance for women; sisterhood and mutual support among women; peacefulness and esteem for human life; a diminishment both of 'masculine' aggression and the belief that violence is the only way of solving conflicts.

The message was clear: Wonder Woman had become feminism's adopted mascot. It's no wonder that the Amazonian super heroine was a favorite icon. After all, she was born that way.

Creator Dr. William Moulton Marston intentionally created the character of Wonder Woman to address feminist issues, writing in a 1942 press release: "The only hope for civilization is the greater freedom, development and equality of women." Wonder Woman was always intended to be an allegorical example of feminine power and what happens when her strength is subjected to man's aggression or, worse, his domination. According to Marston, Wonder Woman was conceived, in part, "to combat the idea that women are inferior to men, and to inspire girls to self-confidence and achievement in athletics, occupations, and professions monopolized by men."

Marston had long held to these beliefs. In a 1937 press conference—a couple of years before Wonder Woman made her comic book debut—the good doctor doubled down on his opinions, stating, "Women have twice the emotional development, the ability to love, than man has. And as they develop as much ability for worldly success as they already have ability for love, they will clearly come to rule business and the nation and the world." Suffragists had advanced a similar

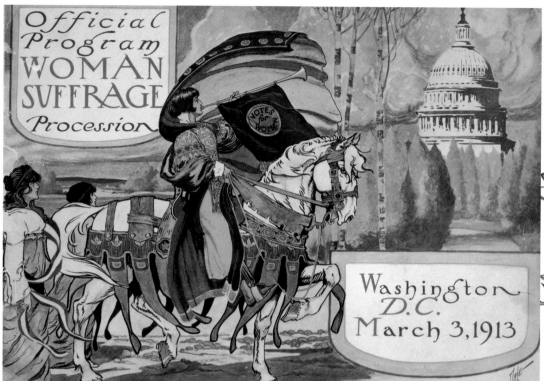

> **LOOKING BACK NOW AT THESE WONDER WOMAN STORIES FROM THE FORTIES, I AM AMAZED BY THE STRENGTH OF THEIR FEMINIST MESSAGE.**
>
> —GLORIA STEINEM

argument while trying to secure the vote for women.

As it stood, Marston himself had several key connections to the early women's movement, notwithstanding first and foremost that his wife, Elizabeth Holloway, had been an outspoken suffragist during her years at Mount Holyoke College. Additionally, Olive Byrne, the mother of two of Marston's children, was the daughter of Ethel Byrne, who, in 1917, went on a much-publicized hunger strike after she and her sister, Margaret Sanger, were arrested for opening the nation's first birth control clinic. At the very least, Marston was a man who understood that questions surrounding women's issues would become more and more entrenched in American life—and Wonder Woman was his answer to the call. She may have been born on an island paradise, but she was built to fight in the trenches.

TOP | 1913 Cover of official program for the National American Women's Suffrage Association procession, March 3, 1913.

BOTTOM | Cover art by H.G. Peter, *Wonder Woman #1* (July 1942).

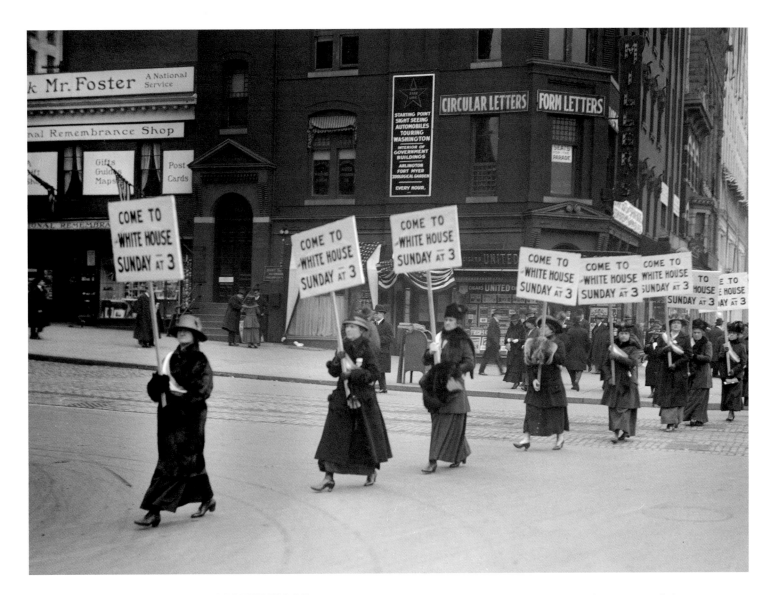

ABOVE | Suffragettes marching with signs in Washington D.C., circa 1917.

SISTERHOOD

Sadie Elizabeth Holloway, Marston's wife and much of the inspiration behind Wonder Woman, was a real-life Amazon: in the early 1900s, an "Amazon" referred to a female rebel, which could have meant any college-bound girl since, by the end of the eighteenth century, most girls had not yet been taught to write; higher education was considered laughable. Nonetheless, women began attending college in significant numbers by the end of the nineteenth century, with the "Seven Sisters"— Mount Holyoke College, Barnard, Bryn Mawr, Radcliffe, Smith, Vassar, and Wellesley—leading the pack. It was at Mount Holyoke that Holloway embraced her love of the writings of the sixth-century Greek poet

Sappho. Indeed, at the time, Sappho's writings were in the midst of a Victorian revival, with an 1885 publication of her memoir by the translator Henry Thornton Wharton. Sappho had lived on the island of Lesbos, and the use of the word "lesbian"—literally a resident of Lesbos—to designate the same-sex attraction between women came into being around this time, though it wasn't used widely in popular vernacular. Sappho's name, however, became a kind of code word, a stand-in for the thing itself: female love. For a super heroine who hailed from an island populated entirely by women, Wonder Woman's preferred exclamation—"Suffering Sappho!"—was a phrase exclusive to a new kind of woman: unafraid, bold, brave . . . a warrior ruled by love.

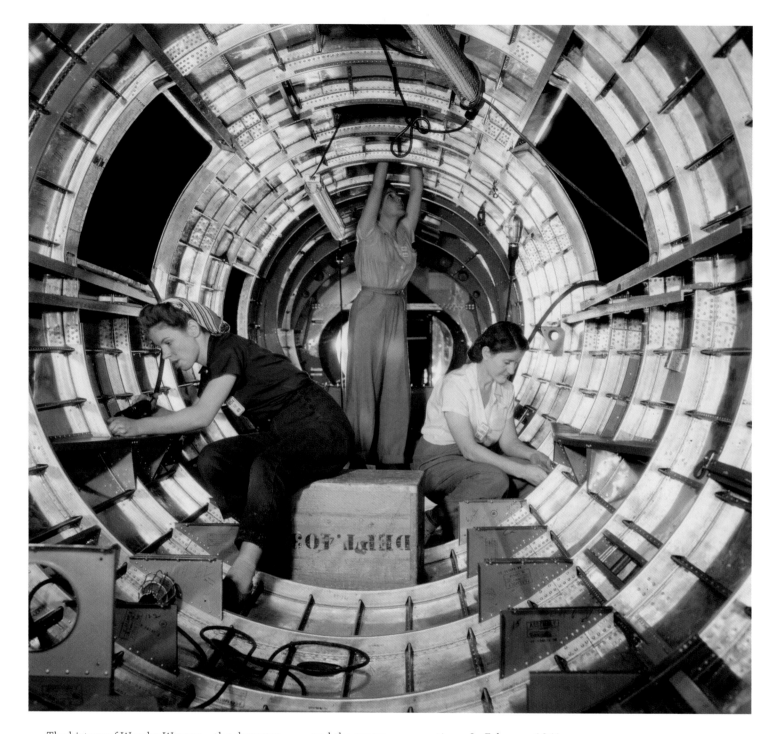

The history of Wonder Woman—the character, the comic book, and her ancillary forays into pop culture—is mired in the history of feminism, too, with as many fans claiming that she's a positive feminist role model as there are others who say she's not. What's indisputable, however, is the fact that her creator was invested in the dialogue of feminism, and, years later, the conversation and the controversy continue. In February 1941, Marston wrote to his editor, Sheldon Mayer, "A great movement [is] now under way—the growth in the power of women." He urged Mayer to "let that theme alone." Most other editorial or art-related changes Marston could work with, but the theme of female empowerment was not to be touched; it was the heart of *Wonder Woman*.

ABOVE | Women workers install fixtures and assemblies to a tail fuselage section of a B-17 bomber at the Douglas Aircraft Company plant, Long Beach, California.

OPPOSITE | Cover art by Ant Lucia, *Wonder Woman Vol. 4 #32* (August 2014).

SENSATIONAL FACTS AND ALL-STAR NEWS

> **"FRANKLY, WONDER WOMAN IS PSYCHOLOGICAL PROPAGANDA FOR THE NEW TYPE OF WOMAN WHO, I BELIEVE, SHOULD RULE THE WORLD."**
>
> —DR. WILLIAM MOULTON MARSTON

• In the Marston comics, Wonder Woman founds an all-girls school called Wonder Woman College. She also makes frequent visits to Holliday College, which is most likely a reference to Elizabeth Holloway and Mount Holyoke. The *H* emblem on students' clothing bears a resemblance to that of Marston's alma mater, Harvard.

Feminist cartoonist Lou Rogers influenced H. G. Peter's drawings of Wonder Woman.

• Ramona Fradon became the first woman to officially draw Wonder Woman for DC Comics with her work on the *Super Friends* and *Freedom Fighters* comic books in the 1970s.

• Trina Robbins was the first woman to draw the character in a multi-part solo *Wonder Woman* story with the 1986 miniseries *The Legend of Wonder Woman*.

• "Suffering Sappho" was only one of the catchphrases Wonder Woman used over the decades. She's also been known to utter more mythological-based exclamations like "Merciful Minerva," "Thunderbolts of Jove," "Shade of Pluto," "Athena's Shield," and "Great Hera," among others.

• The character was initially known as "Suprema, the Wonder Woman" in a first-draft installment written by Marston in 1941. Editor Sheldon Mayer cut "Suprema," shortening the name to her now-famous moniker.

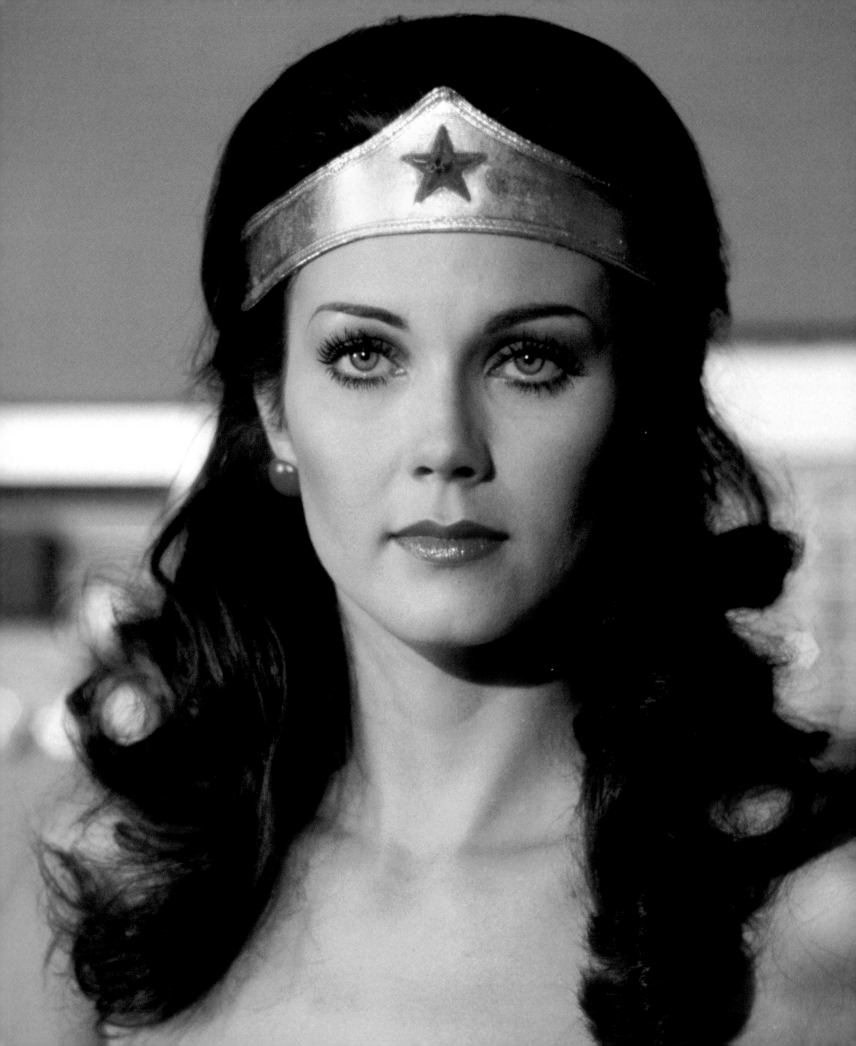

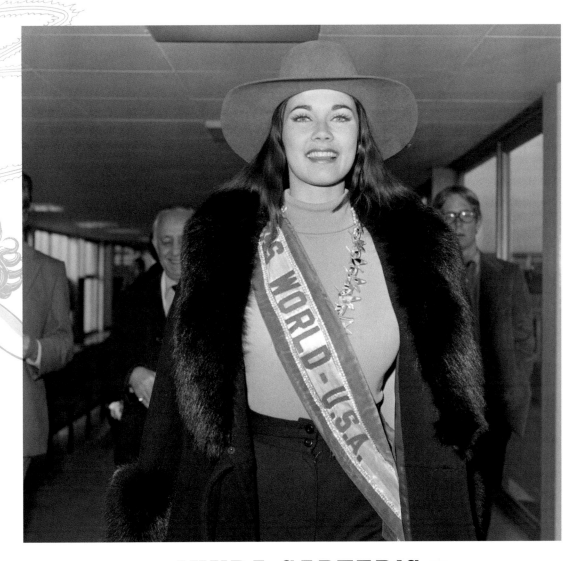

LYNDA CARTER'S WONDER WOMAN

LYNDA CARTER'S
WONDER WOMAN

For many die-hard fans, Lynda Carter *is* Wonder Woman. The 1970s television show *Wonder Woman,* known from seasons two to three as *The New Adventures of Wonder Woman,* is good, clean fun, and Carter, with her piercing blue eyes, dry wit, and daring heroism, looked every bit the part of America's favorite super heroine. Having been crowned 1972's Miss World USA, representing her home state of Arizona, Carter nonetheless was struggling to find work as an actress and musician when she secured the role of Wonder Woman. "To tell you the truth," Carter says, "I couldn't pay my next month's rent when I got the part. I was thrilled to have a pilot of my own."

From the show's title card—a colorful burst of 1970s-inspired graphics—to its original, disco-esque theme song, season one of *Wonder Woman* was a campy, tongue-in-cheek production aimed to entertain. A nod to H. G. Peter's illustrations, Carter's star-spangled costume was doubly intended to draw eyeballs, but the actress made the outfit look both sexy *and* strong. For Carter, Wonder Woman has always been about the character, not the costume. She says, "She was a nonpredatory female. This was not about luring men. This was about sisterhood, about intellect and attitude, and fair play and inclusion and not might makes right."

ABOVE | Miss USA, Lynda Carter from Phoenix, Arizona, strolls through the airport in London while on her way to the Miss World contest, November 22, 1972.

OPPOSITE | Carter as Wonder Woman.

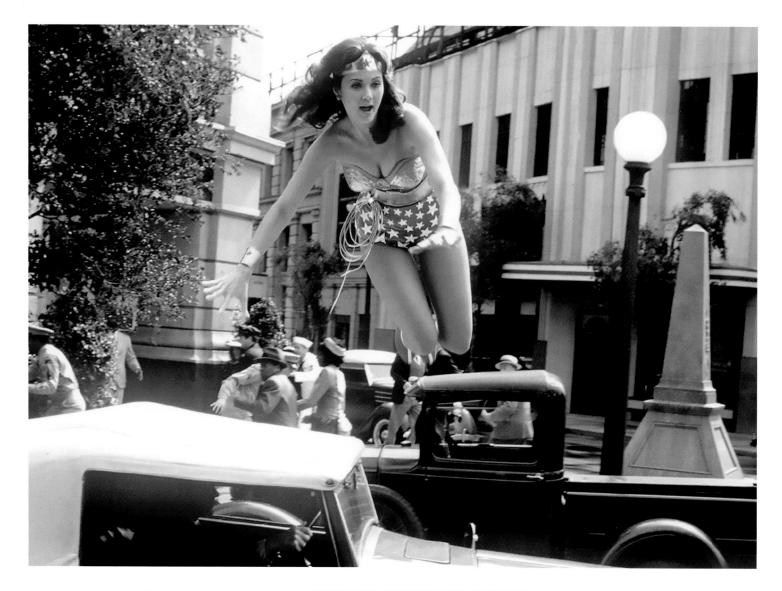

In the show's second season, many of its comic book components were scrapped, which gave Carter leverage to play the character "straight." In a 2004 TV movie commentary that accompanied the 1975 pilot, Carter says, "I think I was much better in the part when it was modernized." At the very least, Carter was able to assert a wholesome image of a modern woman, whether she was portraying Wonder Woman or her alter ego, Diana Prince. Wonder Woman emerged from the 1970s as an enduring icon of modern female power. She has come to symbolize women's struggles as well as their daring moments of heroism. At her most base, she represents the heroic potential within all of us to rise and fight for truth, love, and justice—whether in satin tights or pantsuit.

WONDER WOMAN IN ACTION

Carter didn't just play a super heroine on television. Her swagger was real. A natural athlete, Carter performed many of her own stunts. Check out the helicopter scene in the show's second-season episode "Anschluss '77," in which Carter literally dangles from a helicopter as it makes its way up and out of a ridged valley. With their lead literally hanging on for her life, it's no wonder Carter made CBS execs nervous . . . or that she simultaneously won the admiration of the show's stunt people. While the stuntwoman handled the majority of the hard-core stuff—helicopter work excluded—Carter says she ended up doing most of the fights herself. "The stunt guys taught me how to throw a punch," she says,

ABOVE AND OPPOSITE | Carter as Wonder Woman in the Warner Bros television series (1975-1979). While Carter used body doubles, she also performed some stunts on her own and personally invented Wonder Woman's signature spin.

ATTACHED | Signed publicity photo of Lynda Carter as Wonder Woman.

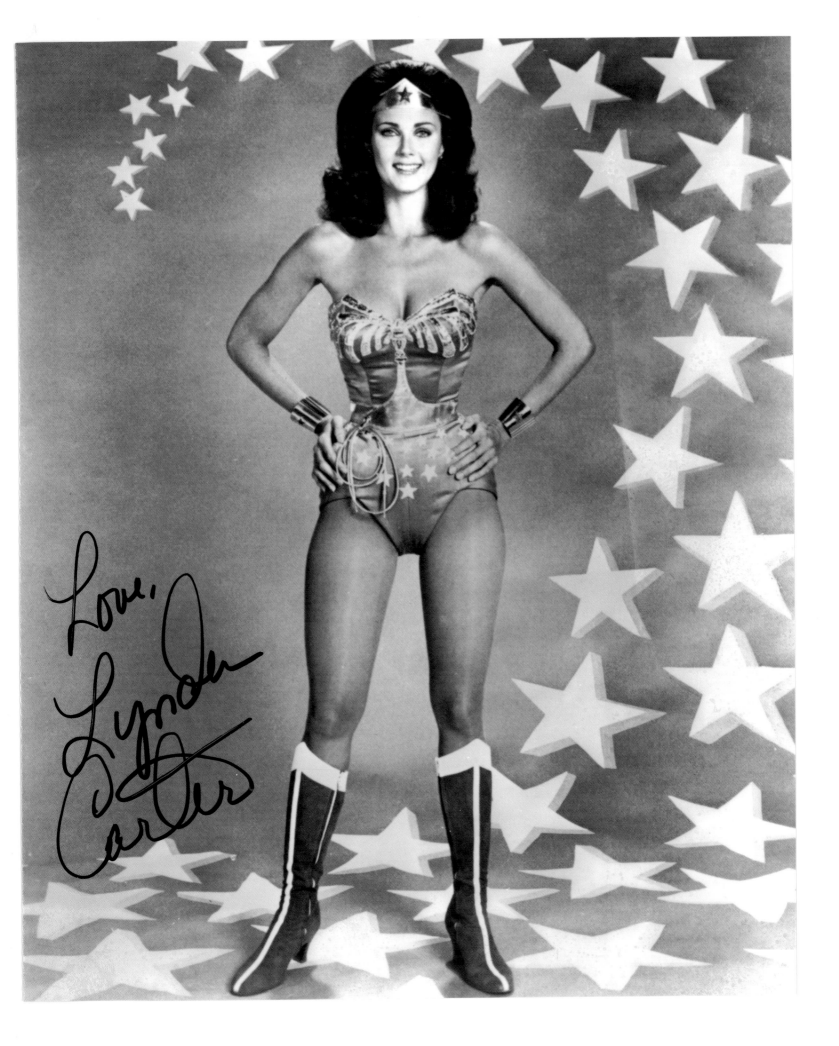

Love,
Lynda
Carter

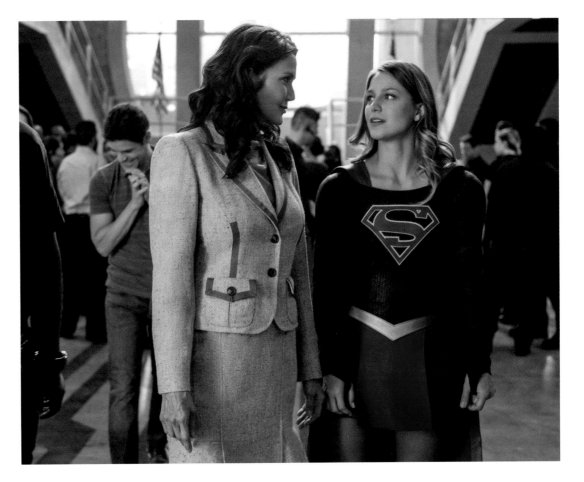

a pirouette or a spin.' They put in the explosion later on." It took more than a few episodes of spins for the show to get the effect right. The first spin in the pilot left Diana awkwardly holding her clothing. By later seasons, however, Carter had effortlessly spun out of every imaginable 1970s fashion ensemble—from bathing suit to Studio 54-inspired gown to rodeo wear—and from every imaginable location—loading dock, elevator, tarmac, even while rolling down a hill—with nary a lock of hair out of place.

Lynda Carter's Wonder Woman has become so iconic that DC Comics brought her character full circle by adapting the show into comic book format with the digital-first series *Wonder Woman '77*, which launched in 2015. Using the actress's likeness for the character, the series followed in the footsteps of the already popular *Batman '66*. In fact, the two shows combined when the iconic Wonder Woman met the classic Batman and Robin in a crossover that never happened on television. She later created more

television-to-comic-book history when DC Comics partnered with Dynamite Entertainment for a crossover with another iconic 1970s heroine, the Bionic Woman. Throughout this new kind of series revival, the comic books stayed true to Wonder Woman's signature spin, incorporating the effect into the comic panels as the character transformed from everyday woman to heroine for a new generation of fans.

In 2016, Carter herself reentered the DC Comics Universe in the CW's *Supergirl* television show, portraying President Olivia Marsdin, whose last name sounds more than a little bit like Wonder Woman's creator, Dr. William Moulton Marston. Carter has said that her performance as president was inspired by none other than Secretary of State Hillary Clinton, never mind that Wonder Woman ran for president well before the famous Democrat. In fact, Wonder Woman ran for president twice—first, in a comic book by Marston in 1943 and again in the pages of *Ms.* magazine in 1972.

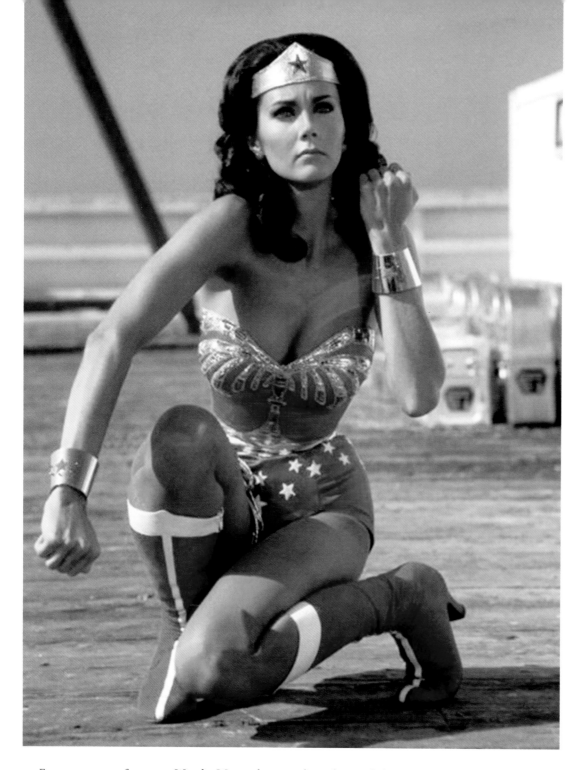

For over seventy-five years, Wonder Woman has been a beacon of female heroism and role model for both girls and boys. Her heroism borders on the magical: Who can forget Paradise Island and the first time we see Princess Diana deflect a bullet shot at close range in the pilot episode? Or when Wonder Woman lassos a helicopter and grounds it with her own brawn in "Pot of Gold"? Her impact has been legendary and, for many, Lynda Carter will forever be associated with the Amazon. For Carter, though, Wonder Woman is more than a fictional character. She says, "Wonder Woman's fighting for truth and justice and the secret self that exists in all women and girls. There's a moral fiber and a goodness about her that all women have."

LEFT | Lynda Carter showing off her bullet-deflecting skills. The metal from which her bracelets are made is called Feminum. In the Marston comics, it was called Amazonium.

OPPOSITE | Cathy Lee Crosby as Wonder Woman in the pilot episode filmed in 1974.

SENSATIONAL FACTS AND ALL-STAR NEWS

> "OUR FILM REALLY DRAWS FROM THE ORIGINAL WONDER WOMAN COMIC BOOK BY WILLIAM MOULTON MARSTON. THE GOAL WAS TO TAP INTO WHAT ALWAYS SPOKE TO ME ABOUT HER—TO HONOR WHO SHE WAS, HER LEGACY, AND TO MAKE HER AS UNIVERSAL AS SHE WAS TO ALL US LITTLE GIRLS WHO RAN AROUND PRETENDING TO BE LYNDA CARTER WHEN WE WERE KIDS."
>
> —PATTY JENKINS

- Carter wasn't the first actress to portray Princess Diana on the small screen. Tennis-pro-turned-actress Cathy Lee Crosby starred in the 1974 *Wonder Woman* pilot.

- Angela Bowie, aka "Jipp Jones" (and David Bowie's first wife), auditioned for the role that Crosby won.

- Two other notable pilots were filmed for *Wonder Woman* television series. The first was a five-minute pilot presentation for a comedy shot in 1967 by the producer of the *Batman* TV series. More recently, critically acclaimed TV producer David E. Kelley produced a full pilot for NBC in 2011 starring Adrianne Palicki.

- In the Lynda Carter series, Academy Award-winning actress Cloris Leachman originated the role of Queen Hippolyta to humorous and endearing effect. Other actresses who appeared as Hippolyta during the series run were Beatrice Straight and Carolyn Jones, who audiences knew more for her portrayal of Morticia Addams the 1960s series *The Addams Family*.

- While the pilot and season one of *Wonder Woman* took place in the 1940s, season two updated the story by some thirty years to the present-day 1970s—and the show was renamed *The New Adventures of Wonder Woman*. The show also moved from ABC to CBS between seasons one and two.

- A young Debra Winger played Princess Diana's younger sister, Drusilla (aka Wonder Girl), in three episodes of season one.

- In the series pilot, Princess Diana dons a skirt as part of her official Wonder Woman costume. The skirt is in homage to the original costume worn by Marston's comic book character. Princess Diana removes it when Queen Hippolyta suggests it might be cumbersome.

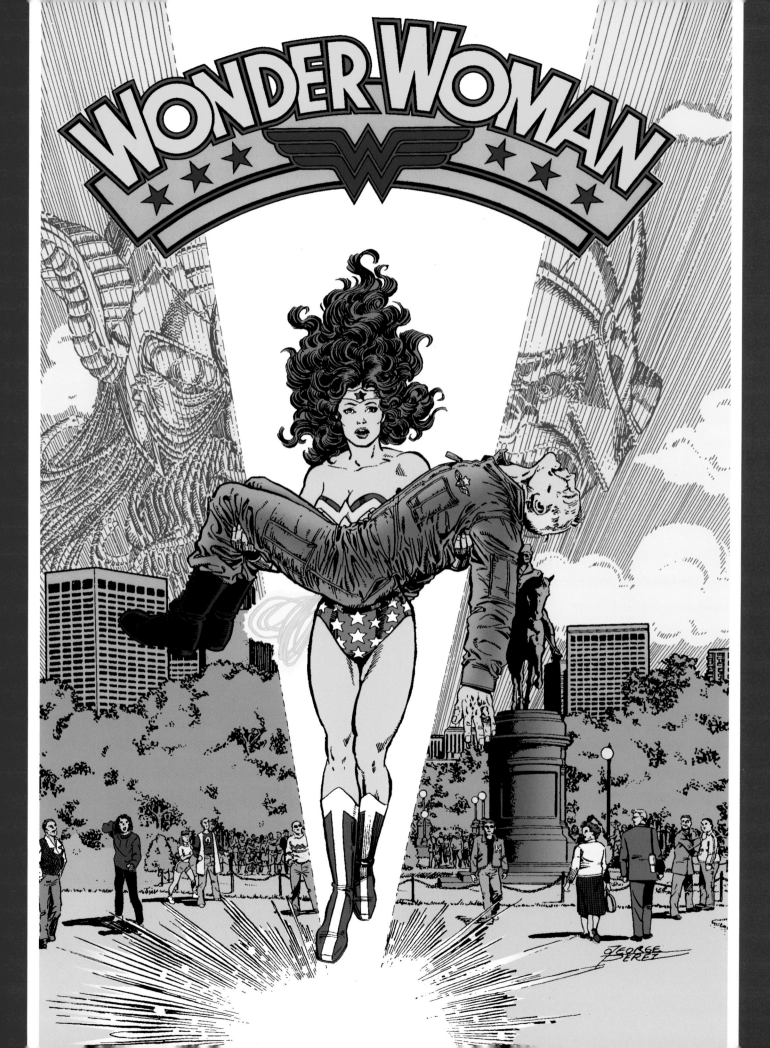

Wonder Woman

MAN'S WORLD: STEVE TREVOR

In Dr. William Moulton Marston's original story line, Wonder Woman's love interest is Captain Steve Trevor, a World War II pilot who crash-lands on the all-female Paradise Island. Princess Diana falls for the blond-haired, blue-eyed hunk almost immediately. The mutual attraction doesn't set in, at least in Marston's version, for a while, and Trevor spends the majority of his time on an island populated by scantily clad beauties as a convalescent being nursed back to health. While Trevor wavers in and out of consciousness, the island springs to life as the Amazonian women compete against one another in a series of Olympic-like contests of strength and agility—javelin throwing, running, high jump, et cetera—to determine who will escort the poor, helpless, and handsome military man back to "man's world."

The contest culminates, of course, in the death-defying "bullets and bracelets" act, whereby the two finalists take turns shooting each other at close range. The women can protect themselves only by using their bullet-deflecting bracelets and trigger-fast reflexes. In a move that surprises no one—except her mother, Queen Hippolyte—Princess Diana, disguised as a competitor, wins and is summarily granted the golden lasso, tiara, and a red-white-and-blue wardrobe to become Wonder Woman, whereupon she vows to fight for justice on behalf of mankind everywhere . . . and give Trevor a ride home in her invisible plane. Wonder Woman and Steve Trevor's relationship is a favorite for armchair analysts: What straight man wouldn't want an entire island of athletic women fighting amongst each other for the honor of his

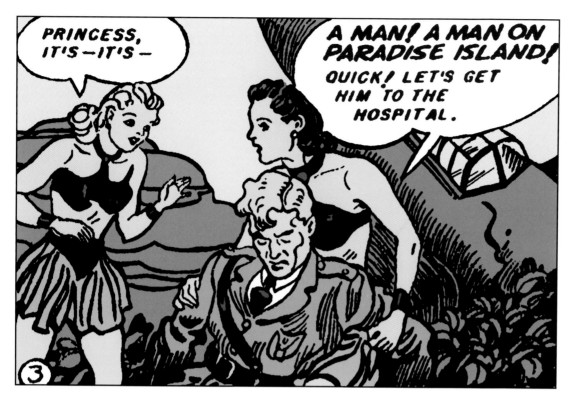

company while *simultaneously* another group of beautiful women nurse his wounds? Trevor's subdued masculinity coupled with Wonder Woman's apparent lack of "needing" a man makes their story rife for (mis)interpretation, depending on the viewing lens. Like most relationships, it's complicated.

While theirs is certainly a romantic and flirtatious relationship, it's also a steadfast, protective friendship with its own twists and tangles, occasional marriage proposals, deaths and rebirths, improbable rescues, and intimate betrayal, all set against a background of government espionage and flying bullets. Throw in page after comic book page of Wonder Woman being tied up and tied down while battling her way out of any number of compromising situations—some of which are caused by Trevor himself—and there's enough sexual tension to make *Wonder Woman* a good old-fashion bodice ripper. No wonder the comic was a success among female and male readers alike.

Marston's Wonder Woman was most likely an amalgam of traits and characteristics from the women in his life, but it's unclear as to whether Steve Trevor was inspired by Marston himself. What's certain is

that the characters' gender-flipping dynamic was, at the time, a refreshing, even radical departure from the standard super hero fare that dominated the comic book scene and, perhaps more importantly for Marston, made for a publisher's dream: a must-have, profitable read.

I'M THE MAN

Trevor, like Wonder Woman, has been subject to so many different interpretations over the years that his character morphs with almost each new writer. Central to the discussion, however, is who he *isn't*: Steve Trevor isn't Superman. He isn't even a Batman-type character, a businessman with enough money and know-how to manufacture superhuman powers. Nope. Trevor's a regular guy, someone who's a little braver than most (being a soldier). He's normal and down-to-earth: the perfect date to bring home for the holidays. He gains entry into Wonder Woman's heart much the way a wounded animal would. Despite being raised on an island of women and by a mother who's warned her of man's aggression and immorality, Wonder Woman doesn't see Trevor as a vicious creature nor as a threat. She interprets his subdued, injured

LEFT | Interior panel artwork by H.G. Peter, *All Star Comics #8* (December 1941).

ABOVE | Interior panel art by Phil Jimenez, *Wonder Woman Secret Files & Origins #1* (May 2002).

> I CAN ONLY DO MY
> BEST.
> —STEVE TREVOR,
> *WONDER WOMAN*, "THE NEW
> ORIGINAL" WONDER WOMAN

TOP AND BOTTOM | Stills from the 2009 *Wonder Woman* animated film highlight the quickly-forming bond between Diana and Steve Trevor.

state as gentleness, and her sense of his kindhearted goodness is as much a reflection of her personality as it is of his own.

Forever a gentleman in jeopardy, Trevor's character (at least in Marston's original premise) reverses the classic damsel-in-distress trope whenever things get too dull, prompting Wonder Woman to come to his rescue time and time again. Even when he tries to save the world (or himself) on his own, he usually requires some form of assistance from Wonder Woman. He's not hapless, though. Quite the contrary: he's always up for a good fight even when he knows he's outnumbered, outmanned, and outwitted.

Over the years, Steve Trevor, like Wonder Woman herself, has had some questionable moments: he assumed a more aggressive and stereotypical role; he stalked Wonder Woman like a jealous lover; in a stunning role reversal, *he* began rescuing *her*. By the time he showed up in 2009's animated film *Wonder Woman*, starring Keri Russell as the voice of Wonder Woman and Nathan Fillion as Trevor, his character had gotten a masculinity makeover to better reflect the complexity of the modern era's battle of the sexes. What used to be hinted at in their relationship was in full, romantic display by 2009—and yet their dialogue reflected the fact that Trevor was no longer living in

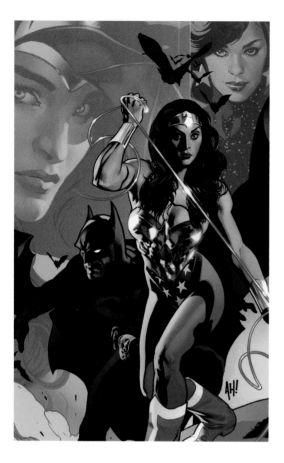

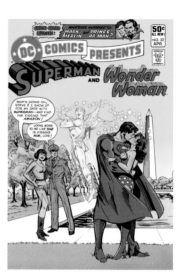

Wonder Woman's shadow nor she in his:

> **Steve Trevor:** *News flash: The Amazons ain't so perfect, either. You act brave, but cutting yourselves off from the outside world was cowardly. Not to mention stupid. Like less communication between men and women is what the world needed.*
>
> **Wonder Woman:** *How dare you?*
>
> **Steve Trevor:** *No! I'm not done. You met your first man, what, like fifteen minutes ago. And you think you have us all figured out. Well, I'm sorry, but not everything a man does is to further some misogynistic agenda. We don't hold doors open or pull out chairs for women because we're trying to keep you down. And I didn't save you because I thought you were some damsel in distress. I saved you because . . . because I care about you, Diana. And I'm not gonna abandon a friend in need, man or woman.*
>
> **Wonder Woman:** *You should have saved the world, and not me . . .*
>
> **Steve Trevor:** *Maybe I figured the world's not worth saving if you're not in it.*

THE LIFE ROMANTIC

Steve Trevor isn't the only man who's got Wonder Woman's number. Blessed with immortality, beauty-queen looks, and a swagger all her own, Wonder Woman's got the time and the goods to be choosy with her love. For fans who think Trevor's too vanilla and undeserving of Wonder Woman's superhuman prowess, her other love interests have included Superman—when Lois Lane isn't in the picture, of course—Aquaman, Trevor Barnes, Batman, and Tom Tresser (aka Nemesis). Wonder Woman's too cool to have a "type"—Aquaman and Steve Trevor may both be blond-haired, blue-eyed hunks, but that's where their similarities end. Trevor Barnes and Steve Trevor may have their names in common, but Barnes, unlike Trevor, lacks staying power.

Introduced by writer/artist Phil Jimenez, Barnes arrived on the scene in 2001's *Wonder Woman #170* as Wonder Woman's first major boyfriend in years. Their romance, however, was short-lived: By *Wonder Woman #194*, Jimenez was replaced by writer Walt

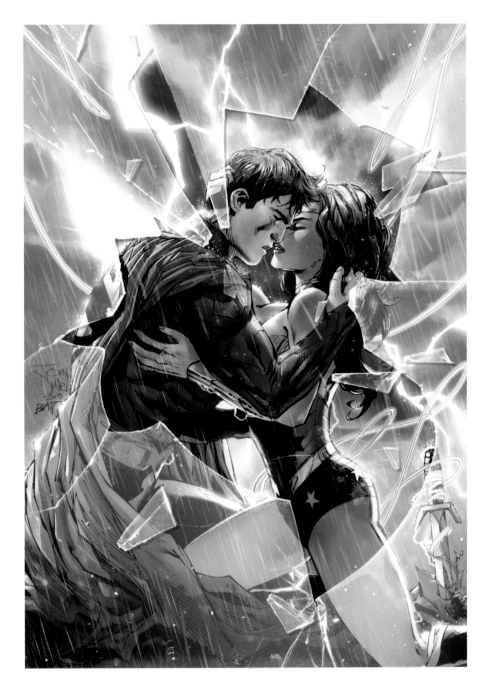

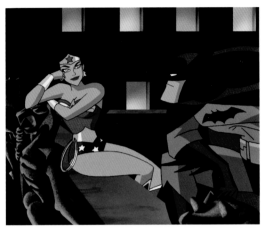

Simonson and Barnes was killed off. For a gal whose work calendar revolves around dodging danger, her men have to be superpowered and bulletproof . . . or, in Steve Trevor's case, charming enough to warrant constant rescue.

In issue #74 of *The Obsidian Age*, *JLA* series writer Joe Kelly romantically links Wonder Woman with Batman. Their kiss, however, doesn't preclude Batman from later standing Wonder Woman up on a date. The animated series *Justice League* and *Justice League*

Unlimited, broadcast between 2001 and 2006, advances the couple's relationship even further.

As far as (super)power couples go, Superman and Wonder Woman are *it*. They've hooked up time and time again, most notably in 1998's *Superman: Distant Fires* and later in Frank Miller's *Batman: The Dark Knight Strikes Again*. Amazingly, in both story lines, Wonder Woman and Superman become parents—in *Superman*, to a boy and, in *Batman*, to a girl they name Lara in honor of Superman's Kryptonian mother. In *Kingdom Come*, the critically acclaimed graphic novel by Mark Waid and Alex Ross, Wonder Woman engages in another relationship with Superman after the Joker kills Lois Lane. The pair start a family once more, with Batman playing uncle to their children. In one of their longest relationships, the couple is paired again in the *New 52* with their own *Superman/ Wonder Woman* monthly series that ran for two and a half years.

With so many men to root for, it's surprising that there isn't a clear favorite. Writer Gail Simone explains, saying, "There's a truism about Wonder Woman that many of her most devoted fans have a gut-level dislike of *any* man she takes an interest in. No one is 'good enough' for Diana—ever." When Simone wrote Nemesis as Wonder Woman's love interest in 2009's *The Rise of the Olympian*, she knew the relationship needed to play into fans' understanding of Wonder Woman's core character. She says, "Diana doesn't want to marry a god. She doesn't look at a normal, decent human male from some lofty throne. She looks at

ABOVE | Cover art by Tony S. Daniel, *Superman / Wonder Woman #4* (March 2014).

RIGHT | Still from *Justice League Unlimited*, "This Little Piggy" (2004).

their merits, and anyone familiar with Nemesis knows that guy has a soul." For Simone, their relationship is of mythic proportions. "I've said it before," she says, "but in some ways, it's a very dynamic, almost fateful relationship, because everything about Nemesis is about deception in the service of good while Diana is a living avatar for greater truths."

As an avatar for greater truths, Wonder Woman consistently works in service of her sense of compassion and from a place of sincere justice. It's no wonder then that Steve Trevor consistently emerges as her longtime beau. Diana doesn't see Trevor the way audiences do, the way Batman does, the way society at large does: She sees a person who's easy on the eyes, yes, but is also selfless and kind, supportive and brave.

It's a testament to Wonder Woman's goodness that she sees the goodness in Steve Trevor, too; she makes him a better man, and he makes her more human.

In Greg Rucka's 2016 *Wonder Woman #2*, Wonder Woman's love life got a serious reboot when Rucka announced the possibility of Wonder Woman's lesbian background. For a heroine who originally hails from an island of women, perhaps it's not a man's world after all. As Rucka explains, "When you start to think about giving the concept of Themyscira its due, the answer is, 'How can they [the Amazons] not all be in same-sex relationships?' Right? . . . It's supposed to be a paradise . . . You're supposed to be able . . . to have a fulfilling, romantic, sexual relationship. And the only options are women." If audiences accept this logical

LEFT | Cover art by Terry & Rachel Dodson, Wonder Woman Vol. 3 #7 (June 2007).

ABOVE | Cover art by Adam Hughes, *Wonder Woman Vol. 2 #178*

OPPOSITE | Lyle Waggoner and Lynda Carter, promo shot for *Wonder Woman*.

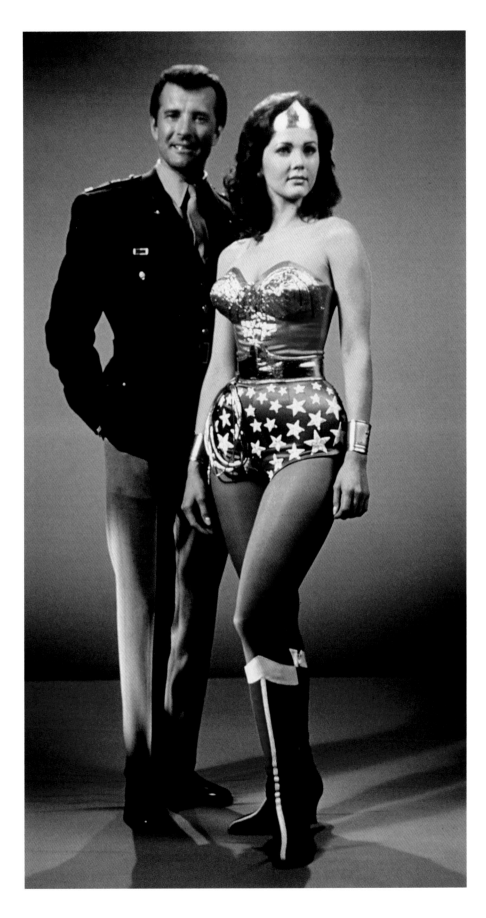

premise, Wonder Woman's heroism intensifies—she doesn't leave the island because she's doe-eyed and lovelorn for Trevor. "She leaves," as Rucka says, "because she wants to see the world, and somebody must go and do this thing. And she has resolved it must be her to make this sacrifice."

LYLE WAGGONER AS STEVE TREVOR

It isn't easy to keep your masculinity intact when you're overshadowed by a superstrong Amazonian woman who bounds over buildings, grounds helicopters with her lasso, and fights sharks bare-knuckle. To his credit, Colonel Steve Trevor never loses face. With his good-guy good looks, actor Lyle Waggoner played opposite Lynda Carter in *The New Adventures of Wonder Woman* television series. Though the Kansas-born actor appeared on *The Carol Burnett Show* for seven years and was a *Playgirl* centerfold, he's probably best known for his tongue-in-cheek portrayal of Wonder Woman's sweetheart.

When writer Stanley Ralph Ross adapted Trevor's character for the small screen, he described him as being a man "jut of jaw and strong of mien, a Lyle Waggoner type." Better yet, Ross suggested, instead of Trevor being a "Lyle Waggoner type," the producers should simply secure the actor. To Ross's amazement, Waggoner signed on. With Carter and Waggoner both, the show had miraculously cast real-life carbon copies of Marston's characters. While Carter was the star of the show, Waggoner didn't mind being second fiddle. "I may have become the highest-paid actor per word on television," he confessed in a 1979 *TV Guide* interview. Of the role itself, Waggoner said, "It's fun. There's no big message, no symbolism. Sure, it's a cartoon, but everything on television is a cartoon because it's escapism. Wonder Woman just happened to have been in the comics."

The secret to Waggoner's lasting fame in the role that turned him into a household name may have been explained best by Ross when he said, "He could play the part of Steve Trevor with a twinkle in his eye."

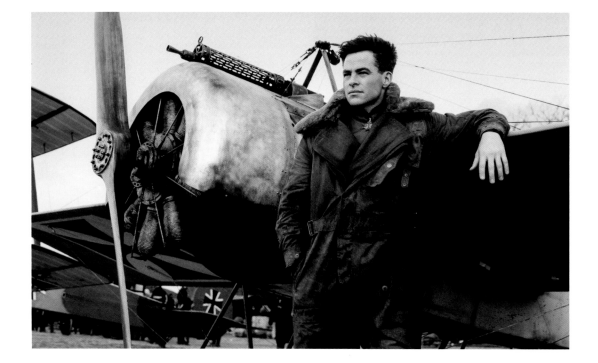

CHRIS PINE AS STEVE TREVOR

In the 2017 *Wonder Woman* film, several aspects of Marston's origin story were changed—Zeus is her father and she fights for the good of mankind against the backdrop of World War I, not II, among other details. A core component, however, that remains firmly intact is the relationship between Trevor and Wonder Woman, albeit with some pointed dialogue to keep modern audiences keenly aware of the gender dynamics at play. Actor Chris Pine—previously best known for his role as Captain Kirk in the *Star Trek* reboots—plays Steve Trevor. In the film, the romance between Wonder Woman and Trevor is in its nascent stage, and the film tracks Wonder Woman's blossoming maturity accordingly. As she sheds her naïve persona as Princess Diana to become the more practiced and battle-seasoned Wonder Woman, Trevor races to keep up. Undaunted by her strength, the pair becomes a formidable team.

"It was fun to fall in love with Gal Gadot," Pine says, speaking of his costar. "There's a nice love story at the center of an action film, and I don't think you see that often in these kinds of films." The romance that plays out over the course of the film affects both characters in significant ways, culminating in Trevor's ultimate act of heroism as Wonder Woman engages in her final battle with the film's villain, Ares. It is that blending of action and heart that makes *Wonder Woman* standout as a signature super hero movie, and a perfect representation of the character onscreen.

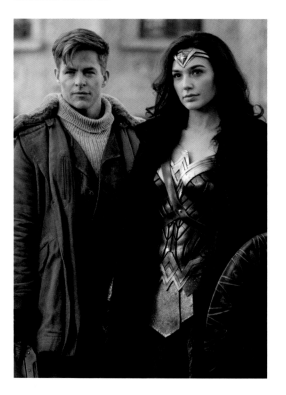

THIS PAGE AND OPPOSITE | Chris Pine and Gal Gadot as Steve Trevor and Diana of Themyscira in *Wonder Woman* (2017).

SENSATIONAL FACTS AND ALL-STAR NEWS

"[STEVE TREVOR] IS ROUGH AND ROGUISH. HE'S GOT A SENSE OF HUMOR ABOUT HIMSELF."

—CHRIS PINE

- Steve Trevor's full name is Steven Rockwell Trevor.

- Trevor marries Wonder Woman's longtime best friend, Etta Candy, following 1985's *Crisis on Infinite Earths*.

- Trevor's nickname for Wonder Woman is "Angel."

- Wonder Woman kills Trevor in *Justice League: The Flashpoint Paradox*. She also kills him in *Wonder Woman: Amazonia*, published by DC Comics's Elseworlds imprint.

- Trevor is depicted as being African American in *Wonder Woman: Earth One*.

- In 2015's comic *Convergence*, Trevor becomes a zombie.

- Actor Lyle Waggoner (who starred as Trevor in the 1970s Lynda Carter vehicle) was a finalist to play Batman in the 1960s TV series but lost the part to Adam West.

- In the most recent DC reboot, Trevor becomes involved with an organization called A.R.G.U.S.—the Advanced Research Group Uniting Superhumans.

ETTA CANDY
A GIRL'S BEST FRIEND

The real-life Mary Sears, friend to Olive Byrne, was the inspiration for the character of Etta Candy, Wonder Woman's most loyal friend and sometime sidekick. At Tufts University, Sears was a member of the Alpha Omicron Pi sorority; Etta Candy is president of Beeta Lambda at the fictional Holliday College. Etta's first appearance was in the Marston-penned *Sensation Comics #2* (1942), and from the beginning, her can-do attitude, gumption, and sense of humor made her a fan favorite.

When audiences first glimpsed Etta, she was malnourished and ill, languishing away inside a hospital Wonder Woman visited. The next time readers got a look at her, though, she was healthy and strong, the result, she said, of eating lots of sweets. Etta's figure literally sets her apart from other female comic book characters, including Wonder Woman. Etta is plus-size and proud of every curve. Even her comic book exclamations—"Bursting brandy drops!" and "Great chocolates!"—speak to her love of the sweet life. While some comic book writers have struggled with Etta's weight, making the character self-conscious about her physical appearance, her natural good humor usually finds its way onto the page, curves intact.

Unlike Wonder Woman, Etta's just a regular gal, raised in the real world. She's quick-witted, brave, and

> YOU KNOW, ETTA, YOU OUGHT TO CUT DOWN ON THE CANDY. IT WILL RUIN YOUR CONSTITUTION.
>
> —WONDER WOMAN
>
> NUTS, DEARY! MY CONSTITUTION HAS LOTS OF ROOM FOR AMENDMENTS.
>
> —ETTA CANDY, "THE GREATEST FEAT OF DARING IN HUMAN HISTORY," *WONDER WOMAN #1*

WOO WOO! THIS IS EASY AS CUTTIN' CHOCOLATE FUDGE!

LEFT | Interior panel artwork by H.G. Peter, *Wonder Woman #28* (March–April 1943).

ABOVE | Interior artwork by Phil Jimenez, *Wonder Woman Secret Files & Origins #1* (May 2002).

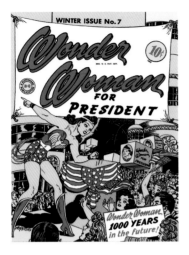

ABOVE | Cover art by H.G. Peter, *Wonder Woman #7* (Winter 1943).

RIGHT | Interior panel artwork by H.G. Peter, *Wonder Woman #7* (Winter 1943).

sassy—the perfect counterpoint to Wonder Woman's air of seriousness and practiced poise. Wonder Woman never downplays her friend's heroics. It's assumed that Etta can take care of herself—she usually does—and she's always quick to help her star-spangled friend. When Wonder Woman asks Etta to round up "one hundred beautiful athletic girls" to fight Doctor Poison in an early issue, she assembles a plucky gang of friends, the so-called Holliday Girls, to wage battle. Wonder Woman affectionately refers to this mortal army of women as "my girls," the Holliday Girls being the mortal equivalent of the Amazon sisters she left behind on Paradise Island.

In the lead story of 1943's summer issue of *Comic Cavalcade*, Etta and the Holliday Girls don WAAC (Women's Army Auxiliary Corps) uniforms to become special army intelligence agents. By December of 1943, Marston pushed the envelope even farther with

"America's Wonder Woman of Tomorrow," *Wonder Woman #7*. For this sci-fi-esque issue, Marston looked toward the future. Queen Hippolyte, blessed with the ability of precognition, reveals a daring prophesy: A woman will become president of the United States. This presidency, alas, will spark a battle of the sexes and, in the year 3000, Professor Manly will rise to power to form the so-called Man's World Party, an opposition political party whose message is in its name. Steve Trevor runs as the party's presidential candidate; Diana is his opponent. Trevor wins but, in the process, discovers that Professor Manly rigged the election. Trevor is kidnapped; Wonder Woman rescues him, and Diana Prince becomes president. While Diana Prince is busy saving the world of man from himself, Queen Hippolyte also reveals Etta Candy's future: She'll be awarded an honorary degree for discovering the secret to eternal life and become a

professor of public health at Wonder Woman College. Female US presidents are one thing, but life eternal is another.

With the exception of being written off in the 1960s—along with the Holliday Girls—Etta's stood by Wonder Woman's side through thick and thin, and in the 1980s, she was rewarded with a reboot by writer George Pérez in which she marries Wonder Woman's longtime on-again, off-again beau, Steve Trevor. In Pérez's version, Etta is a former Air Force captain and intelligence officer. Gail Simone kept Etta as an intelligence officer for her interpretation of *Wonder Woman*, and, in the remarkable "Rise of the Olympian," puts Etta squarely in the crosshairs of danger. Captured and severely tortured by the inhumane Genocide, Etta nonetheless stays strong and defiant . . . right up to the moment when she passes out. When Wonder Woman finds her friend's broken and battered body hanging with a note that reads, "She screamed a lot. She was FUN," readers know that Simone's tightrope walk is far more dangerous than anything Marston ever attempted. Tiptoeing revenge and violence, Simone shows Wonder Woman's true strength: Instead of succumbing to blind rage and killing Genocide for his cruelty toward her friend, Wonder Woman chooses in battle to let a helpless Genocide live. She knows that her efforts to contain Genocide must be in accordance with the threat the

monster poses to *all* of humanity and not just to herself and her friend. In this worldview, Etta and Wonder Woman are forever linked: their friendship is based on the real love, admiration, and sisterly respect they have for one another, and the common belief that battles aren't personal, they're global. Wonder Woman may have all the fun weapons, Amazonian superstrength, and an hourglass figure to die for, but Etta has a few tricks up her sleeves, too: She can deflect a bullet with a box of chocolate, disarm a villain with a few wisecracks, and call on an army of women to defend her any day of the week. Not bad for a girl who says she owes all her success to candy.

LEFT | Left Interior panel art by Phil Jimenez, *Wonder Woman #170* (July 2001).

ABOVE | Cover art by Renae De Liz, *The Legend of Wonder Woman #4* (May 2016).

OPPOSITE | (left to right) Beatrice Colen as Etta Candy in the 1970s *Wonder Woman* television show; interior panel art by Jim Lee, *The New 52 FCBD Special Edition* (June 2012); Lucy Davis as Etta Candy in the 2017 *Wonder Woman* film.

SENSATIONAL FACTS AND ALL-STAR NEWS

"WOO! WOO!"

—ETTA CANDY

- Etta's catchphrase of "Woo! Woo!" was inspired by the comedic styling of actor Hugh Herbert and Curly Howard of *The Three Stooges*.

- In Marston's version of *Wonder Woman,* Etta's father's name is Sugar Candy. Her brother is named Mint, and her boyfriend, Oscar Sweetgulper, attends Starvard College. In pre-*Crisis* issues, her father goes by the name Hard Candy, her mother is Sugar Candy, and her parents live on a ranch in Texas.

- In 1943's *Wonder Woman #3,* Etta rescues Wonder Woman and all of the children from a concentration camp.

- In *Sensation Comics #16,* Etta discovers that her fiancé, Hylo Goulash, is a Nazi in disguise and unceremoniously punches him out during the wedding ceremony.

- Actress Beatrice Colen portrayed Etta in the first season of the 1970s *Wonder Woman* television show.

- Etta's is a restaurant in the video game *Justice League Heroes* and features a classic image of the character on its signage.

- In the *New 52*—DC Comics's massive, cross-platform reboot—Etta is recast as Steve Trevor's secretary in *Justice League*. She's also portrayed as being African American.

- Lucy Davis portrays Etta in 2017's film *Wonder Woman*.

- Players can choose to play one of three different versions of Etta in the video game *Scribblenauts Unmasked: A DC Comics Adventure*.

A CONVERSATION WITH
DAN DIDIO

Dan DiDio serves in the role of publisher of DC Comics along with Jim Lee. DiDio first joined the company in 2002 as vice president of editorial after a career writing for animated television series before transitioning to the comic book industry. He has worked on a number of titles for DC, providing the scripts for series like *Superboy* and special issues and miniseries including *DC Universe Presents*. As publisher he has overseen major initiatives like the *New 52* and *Rebirth* and generally is the steward of story development for the company.

★

Wonder Woman: Ambassador of Truth | What issue or run of *Wonder Woman* first made an impact on you as a storyteller?

Dan DiDio | There was a story line when she first received her powers back after that period of time where she was powerless in the sixties. She basically went through the twelve labors of Hercules, just to see whether or not she was still ready to take on the hero's mantle. The stories themselves aren't that well done, but they have a rather charming—at least for me—place in Wonder Woman's history because of the way that she interacted with the other members of the Justice League, and the fact that at the end of the twelve labors, she was welcomed back to the team with open arms. She really resumed her mantle as the premier female superhero.

WW:AoT | As a publisher of DC, you're a steward of all of these characters. What aspect of Diana's character do you vigorously defend in editorial meetings? What is vital for you to see in any story line about her?

DD | For me, I like to talk about the balance between her humanity and godhood, and how she really straddles so many different personalities. She really is unique in her own right. When I think of her, she's extraordinarily rational in thought, extraordiniry passionate in her opinion, and she's not afraid to make a stand, which, I think, is something that is very essential to who she is. She is not a character that is passive in any way, shape, or form. She is someone who truly acts as an inspiration on those levels.

WW:AoT | What do you personally, as a reader, think defines Diana?

DD | For me, it's her ability to move among gods but move among men equally, and still be able to understand. There's a level of compassion and understanding, but also a level of strength and power that balances it all out.

WW:AoT | Do you see a difference in her as a character when she's doing her own run, versus when she's a player in a Justice League title?

DD | I've always considered her the most natural leader of the Justice League, and it's something that we've never fully explored in any of our incarnations, because in Justice League we play her more of as the tiebreaker. Whenever the team is split, they always turn to Wonder Woman to really follow her lead, or to tip the scales in one direction or another. I've always felt that she's been the natural leader. She has the most level approach to every situation, that's fully thought out in ways that judge godhood against mankind simultaneously. She has the emotional sense of presence that the team can rally around. I've always felt she would be the natural leader for the team, but the role she's played has been, for the most part, the social conscience of the team, the person they turn to when they need to confirm whether or not the choices they're making are morally right or wrong.

WW:AoT | Is there a narrative you feel that has really showcased that aspect of her character the most?

DD | In my time at DC, my defining period of time is when we were doing the lead into our *Infinite Crisis* story line, and Greg Rucka was writing *Wonder Woman*. He really got to the heart of the character and probably best embraced the sense of who the warrior was in a way that we hadn't seen up to that time. It was interesting because I never perceived her to be a warrior until I

WW:AoT | What are you looking for in a *Wonder Woman* story when someone is pitching? What's the process like for determining what stories get the green light?

DD | I've passed on Wonder Woman stories just because sometimes they go too far in the past. It's interesting how many people will pitch you a story where they strip the character of her power. That's a nonstarter, because if you can't work with who she is, then how can you really understand how to write the character?

The most interesting one for me was the one that gave me pause—and actually I had him go through some hoops in order to get it approved. It was Greg Rucka's story where Wonder Woman kills Max Lord [*Wonder Woman Vol. 2 #219*]. The idea that she consciously kills a character was a huge departure from anything that we ever did in that comic book storytelling before. We had created a story and situation where it seemed like she had no choice. We always say our characters always have a choice, but in this particular case we wanted to show that it's part of her warrior nature. This is part of an acceptable solution to her and her race. Therefore, it became—and because the story worked so well—it became part of her character and who she was. We didn't make her do something that was out of character. Instead, we actually strengthened her character by doing something that would be so untouchable. When you're able to find aspects of a character that's been around for close to eighty years, and find a way to interpret the new but still be true to who she is, I think that's when we create a win for us here in publishing.

WW:AoT | How do you see her right now, as a representation of modern society or looking forward into the future?

DD | The things that I find most intriguing about the interpretation of Wonder Woman today is how comfortable she is in herself and in who she is. How safe and secure she is in her own sense of being and presence, and the level of acceptance that she gives to other people for who they are. That's a really great balance, that level of confidence and security that she has in her own choices and her self that people should be able to emulate and feel good about themselves regardless of what's perceived around them. And then, on top of that, to accept other people for who they are without any judgment is a very important character trait for Wonder Woman that I think people could learn from.

saw Greg's interpretation and how clearly he explained it to me, and to all of us. We had to show that side of her because that's also one of her guiding principles. Honestly, that goes back to your other question about the difference between her in her own book and in the Justice League. In her own book she was able to make those same leveled decisions, but you're also going to have ramifications of the decisions probably not working as well as they might have in a team book. She's achieved her motivations, but she could also make her mistakes in a book and then learn from those mistakes as well, which I think makes her a more relatable character and somebody who you want to be rooting for in her stories.

WW:AoT | Especially with a godlike character, where it's easy for you to lose the reliability.

DD | Exactly. That's one of the things Greg and I used to talk about at great length. He always considered the character perfect in many ways. When you have a character that perfect, what you have to do is deconstruct who she is in a way to understand how she becomes that. How does she make the decisions to make her such a rounded character, and the challenges that occur by doing that?

ABOVE | Cover art by George Pérez, *Wonder Woman Vol. 1 #600* (August 2010).

A CONVERSATION WITH
JIM LEE

DC Comics publisher Jim Lee started working in the comic book industry around the time George Pérez began his critically acclaimed run on *Wonder Woman* in 1987. Lee counts that period as one of the watershed moments for Wonder Woman, which colored his impression of her as a character and influenced his own approach to her as a comic book artist. Lee started out as an artist for Marvel Comics before cocreating Image Comics with several other industry professionals in 1992, and he developed the Wildstorm imprint under that umbrella of creator-owned comic books. After several successful years launching original titles, Lee sold Wildstorm to DC Comics in 1998 so he could spend more time focusing on his artwork and his family. Over the years, he's drawn for a number of DC and Wildstorm titles. Though he has never been an interior artist for the *Wonder Woman* comics, he has drawn covers and played a significant role in establishing her various "looks" over the years.

★

Wonder Woman: Ambassador of Truth | Was there an issue of the *Wonder Woman* comic book, or run on a comic book, that most influenced your interpretation of the character?

Jim Lee | When George Pérez took over the book and wrote the series himself and really put the same energy and love into the character that Superman and Batman were getting . . . What I loved about it was that he really played upon her ancient Greek mythological roots and redefined what the gods would look like in their realm and how different it was from our world. It made Wonder Woman more believable within the real world, if that's possible. It was a multifaceted and very nuanced story that they created. He really got the character and wrote a lot of love and care into redefining her world, and it shows.

WW:AoT | Your work made mainstream media news in 2010 when you redesigned Wonder Woman's costume and shocked the world by giving her pants. What was that experience like?

JL | Getting that opportunity was pretty cool. I don't know if I would have pushed myself to put pants on Wonder Woman. That was the biggest change, but it was something that really came out of the story that JMS [J. Michael Straczynski] was creating for the character. He wanted her to basically walk amongst humanity and have a story where she was exploring her connection to humanity in a very common man, or common woman approach. He

wanted the character not to draw attention to herself if she walked down the street. That was the requirement: "Can we create a costume where if she walked down the street, she's not going to draw attention to herself because she's in a red, blue, and gold armored outfit?" It was interesting when we unveiled the look, that it was controversial. A lot of people reacted very strongly to the inclusion of pants, and that wasn't the first time she's been in pants. She was in a white jumpsuit back in the seventies. That was the first time that pants were used with the other more traditional elements of her costume.

There were definitely people that welcomed the change and thought it was a step forward, a progressive element added to her costume. But there were probably more people that felt that it was nontraditionalist, and it basically took away from the appeal of the original character. "*Blasphemy!*" It was really interesting to see that. Then when we took the pants off and went back to a more traditional look for the character—I had more people reacting positively to that change than we did when we put the pants on her. She's had a number of different looks over the eras, as Superman and Batman have had. We leave it up to the artist, or the person on the book, to really put themselves into the work and invest themselves in it. It's something that the fans react positively to. That it's not just, "Here's a character. Here's the style guide. It's never changed since the character was created seventy-five-plus years ago." We really invite people to add elements of their own.

After seventy-five-plus years of any of these iconic characters, they only survive and are adventurous to

LASSO OF TRUTH

was shown in *Batman v Superman*—and try to create something that unified both the cinematic look and the traditional publishing look. That's what ended up on that cover. That was really a one-time combination of elements that we incorporated; the *New 52*, her classic original look, and elements that I saw they were incorporating in the Gal Gadot costume. I was trying to incorporate a lot of different elements of her last seventy-five years into one look.

WW:AoT | How do you see Wonder Woman's role in the Trinity of DC Comics characters? In what ways is drawing her different from Batman or Superman, aside from the obvious gender-related elements?

JL | I think there is a slight difference in that Superman is an alien from another planet, Batman is a human, and Wonder Woman is descended from the gods. She is literally designed to create awe and inspire those who gaze upon her. I think you're trying to create, at least in the face, a look where she looks a bit otherworldly, a bit almost impossibly beautiful. It is difficult to do that, but that's sort of the mission when you draw her. She's not just any woman that you're drawing. She is the Wonder Woman. You might raise her chin up a little bit. There are things I do with the eyes, where they look like they're gazing off into the distance, kind of into the future a bit. These are very subtle things you are trying to incorporate, but you're trying to also make her look very badass.

WW:AoT | What defines Diana among the pantheon of characters in the DC roster?

JL | I think it's her sense of sacrifice. She is a character that is unique in that she comes from the gods. She literally leaves paradise—Paradise Island—for the world of "men." She chooses to lead a life of immortality and a life without disease, war, all the other horrors of conflict, and she comes to the world of "men," to really take on an ancient mission that the other Amazons really let go. I think there's a nobility in that and a tremendous sense of compassion and strength in her desire to bring justice and equality to the world. I think that the nobility of her mission, and the fact that she chose to take that path as an adult, really defines her in very different ways than a lot of other iconic characters who are often thrust into the spotlight. She chose this path.

our readership if we keep updating them and contemporizing them and making them feel new but classic at heart. Wonder Woman in particular strikes a national nerve. I remember we were telling a story, one that she changed her hairstyle at one point. It made national televised news. When we put pants on, same thing happened there. With the most iconic characters, even small, minute changes really do strike a nerve with not just our core readership but fans all around the world. They're heavily invested in these characters.

WW:AoT | In celebration of her seventy-five years in the industry, you got to draw her anniversary cover. What were the most important elements of her character you were trying to portray with the piece?

JL | I was trying to pick a number of somewhat similar looks—like her traditional look and the costume that

ABOVE | Cover art by Jim Lee, *Wonder Woman 75th Anniversary Special #1* (December 2016).

PART TWO
WARRIOR

POWER & WEAPONRY

The moment Princess Diana gathers her weaponry, dons her uniform, and leaves Paradise Island to become Wonder Woman, it's *on*. While her exploits and adventures in the world of man have varied from the sensational, like battling Nazis, to the questionable, like giving up her powers altogether, it's an accepted, universal fact that Wonder Woman leaves Paradise Island to *fight* for the good of humanity.

Over the decades, Wonder Woman has seen her fair share of scuffles. Training for a mysterious battle that always seemed inevitable was an integral part of her youth. Yes, Paradise Island was a land of peace, but the world the Amazons had shut themselves off from was an ever-looming threat. When Princess Diana emerged into that world, she did it during one of the greatest conflicts to ever impact the globe: World War II. She was more than prepared for the fight, and yet she was still sidelined as secretary for the Justice Society, even though her strength had been considered almost on par with Superman's at various points in her history. Wonder Woman's journey as a warrior has taken her through many different incarnations, from secretary to ambassador and, for a time, even the God of War. Through it all, she has called on those same principles of love, truth, and honor that are key components in her arsenal.

As a woman warrior, Wonder Woman is outfitted with some of the best weapons ever created, both

PREVIOUS SPREAD | Interior panel artwork by Don Heck, *Wonder Woman Vol. 1 #204* (February 1973).

OPPOSITE | Interior panel artwork by Jim Lee, *Justice League of America Vol. 5 #3* (January 2012).

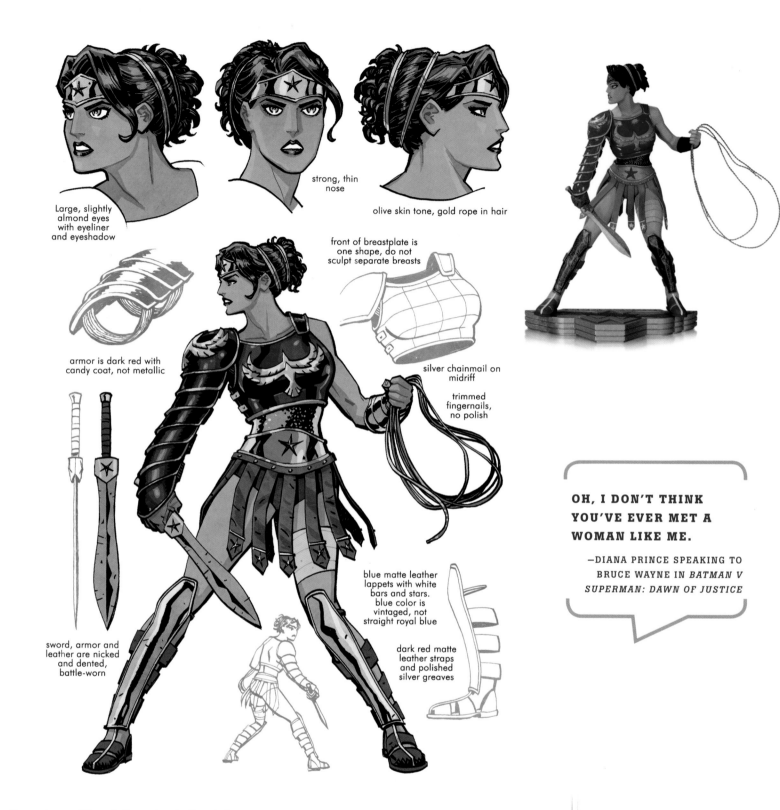

Large, slightly almond eyes with eyeliner and eyeshadow

strong, thin nose

olive skin tone, gold rope in hair

armor is dark red with candy coat, not metallic

front of breastplate is one shape, do not sculpt separate breasts

silver chainmail on midriff

trimmed fingernails, no polish

sword, armor and leather are nicked and dented, battle-worn

blue matte leather lappets with white bars and stars. blue color is vintaged, not straight royal blue

dark red matte leather straps and polished silver greaves

OH, I DON'T THINK YOU'VE EVER MET A WOMAN LIKE ME.

—DIANA PRINCE SPEAKING TO BRUCE WAYNE IN *BATMAN V SUPERMAN: DAWN OF JUSTICE*

figurative and literal. From her bullet-deflecting bracelets to her tiara-slash-boomerang to her lasso of truth, among others, Wonder Woman's arsenal is packed and fully loaded. A great warrior, however, isn't totally dependent on her hardware. Wonder Woman knows that a battle is as much mental as it is physical, and from the moment she engages with any enemy, she doesn't let up. Wonder Woman, as evidenced by her more than seventy-five-year run as one of DC Comics's Big Three, plays the long game.

LEFT | Cliff Chiang's design for the DC Collectibles *Wonder Woman: The Art of War* statue.

ABOVE | Interior panel art by H.G. Peters, *Wonder Woman Vol. 1 #2* (December 1942).

SECRET IDENTITIES: A PRINCESS FOR A PRINCE

Wonder Woman, like so many other super hero comic books, dabbles in secrecy and disguise, and flirts with the idea that an average, everyday plain Jane can possess extraordinary hidden talents, strengths, and skills. Without Superman, Clark Kent is but a mild-mannered journalist. Take away Batman's suit and his high-tech gadgetry and Bruce Wayne is just another Gotham City playboy billionaire-slash-layabout. Diana Prince, Wonder Woman's alter ego, is a bit more . . . complicated.

Over the years, Diana has racked up quite the impressive résumé, holding down several high-level jobs at a number of organizations. In Marston's comics, Diana was originally a nurse, having bought her ID and subsequent credentials from a woman named Diana Prince, who bore an uncanny resemblance to Wonder Woman. (Later in the series, the real Diana Prince married her long-term beau and changed her last name to "White," effectively giving Wonder Woman full claim to her name.) After a stint in nursing, Diana switched to the military, first gaining employment as a secretary and, later,

moving on to field operations, where she got enough experience and expertise to interrogate suspects on her own, eventually becoming an intelligence officer and, over the years, rising up the ranks from lieutenant to major.

Forget Wonder Woman: Diana Prince is a fully developed character in her own right, literally holding down jobs that historically had been the purview of men. Though she lacks Wonder Woman's self-confidence, she compensates with her own brand of steely reserve and calm. During the 1940s, of course, with men taking up wartime duty, American women *were* shouldering jobs that otherwise had belonged to their husbands. Each job and subsequent promotion Diana secured gave her a wider range of opportunity to conveniently position herself in just the right place at just the right time to secure information integral to Wonder Woman's success. Diana's intel was often pivotal to Wonder Woman being able to save the day. Diana Prince is Wonder Woman's best ally, proving that "two" women working together are indeed better than one.

POOR DIANA DOESN'T RATE WHEN STEVE'S THINKING ABOUT **WONDER WOMAN!** FOLLOW HER AMAZING ADVENTURES EVERY MONTH IN **SENSATION COMICS!**

Steve Trevor only had eyes for Wonder Woman and couldn't see beyond Diana's bespectacled disguise. In *Sensation Comics #1*, Trevor delivers a blunt appraisal, saying, "Listen, Diana! You're a nice kid, and I like you. But if you think you can hold a candle to Wonder Woman you're crazy!" Obviously as attractive as Wonder Woman, Diana lacked the super heroine's spirit and sense of agency. For a wallflower, Diana could be prickly, and, at least in the 1970s television show, met Trevor's snide, occasionally belittling comments with her own brand of sarcasm and roll-your-eyes wit. Shooing off other men's unwanted advances, Diana was largely luckless in love with Trevor. In DC Universe's parallel world of Earth-2, Wonder Woman gives up both her secret identity and her immortality in order to marry Trevor, with whom she shares a daughter named Hippolyta "Lyta" Trevor (aka the super heroine Fury). Even in a parallel world, Trevor doesn't wed Diana, preferring, instead, to marry a mortal version of Wonder Woman.

LEFT | Lynda Carter as Wonder Woman's alter-ego, Diana Prince.

ABOVE | Interior panel/ad by H.G. Peters, *Sensation Comics #5* (May 1942).

Like Wonder Woman, Diana Prince has undergone many character reboots over the years that have seen her as a nurse, a civilian employee of the military, a businesswoman, a translator, a clothing boutique owner, a romance editor, an astronaut trainee, an agent for the UN Crisis Bureau, and an ambassador, among other occupations. Her fluctuating job titles have mirrored much of the real-life social and professional expectations many American women faced in their own lives. After World War II, for example, American women were expected to leave the wartime factories and job posts and resume their familial duties at home. Wonder Woman was no exception, and her story lines in the decade that followed focused on three major themes: family, love, and relationships.

By the early 1960s, the adult Wonder Woman was no longer the key player in her own comic books as other characters, like Wonder Girl, Wonder Tot, and Wonder Queen began to crowd the page. In 1968, *Wonder Woman* entered the "Diana Prince Era," a period during which Wonder Woman, having abandoned both her costume and her superpowers, effectively loses her identity. The comic books began to focus solely on the everyday exploits of Diana Prince as she donned Mod clothing, ran a boutique, and, under the tutelage of martial arts master I-Ching, sought out espionage, similar to the Emma Peel character on the international television hit, *The Avengers*. Wonder Woman was essentially out of the picture but, sadly, Diana Prince had changed as well. Wonder Woman and Diana Prince are symbiotic—each confirms the other's identity.

By 1986, Diana's scattershot resume caught up with her, and the character was abandoned completely. Wonder Woman was referred to as "Diana of Themyscira" when not in costume, and, with no secret identity, was able to live openly as an Amazon Princess in everyday life. *Wonder Woman Vol. 3 #6*, introduced the world to Agent Diana Prince of the Department of Metahuman. Diana's new alias, created in part by Batman, allowed her to work undercover while she rooted out superhuman baddies. But in DC's 2011 *New 52* lineup, Wonder Woman got a *major* promotion: she's not just a super hero, she's also the God of War and the Queen of the Amazons. An alter ego seems a bit useless with a job title like that, and Diana got the pink slip again. It's not easy playing second fiddle to an Amazon, yet audiences have long adored Diana, primarily because she humanizes Wonder Woman and gives us mortals a lens through which we can imagine the greatness, the untapped potential, we may also possess.

LEFT | Cover art by Terry & Rachel Dodson, *Wonder Woman Vol. 3 #6* (May 2007).

ABOVE | Cover art by Cliff Chiang, *Wonder Woman Vol. 4 #23* (October 2013).

OPPOSITE | Gal Gadot's Diana Prince made her entrance into the DC Extended Universe before *Wonder Woman* in the 2016 film *Batman v Superman: Dawn of Justice.*

SENSATIONAL FACTS AND ALL-STAR NEWS

"SHE'S A MYSTERIOUS WOMAN INTERESTED IN THE SAME THINGS BRUCE WAYNE IS. THE FUN OF IT IS IF YOU DON'T IMMEDIATELY REVEAL HER IN SUPER HERO GUISE. YOU GET TO REVEL IN THE MOMENT WHEN SHE FINALLY DOES REVEAL HERSELF."

—SCREENWRITER CHRIS TERRIO ON DIANA PRINCE IN *BATMAN v SUPERMAN: DAWN OF JUSTICE*

- Wonder Woman's birth name/alias comes from Diana, the Roman goddess of the hunt, the moon, and nature. The mythological woman is equal to the more familiar Greek goddess Artemis.

- Artemis is the name for several characters in comic books, but most notably it is the moniker of an Amazonian ally who, for a time, adopted the mantle of Wonder Woman.

- In post-*Crisis* continuity, it was established that Steve Trevor's mother, Diana Rockwell Trevor, was an Air Force pilot who visited Themyscira during World War II and Diana was named after her.

- In the *Wonder Woman* television series starring Lynda Carter, Diana Prince was a WAVES (Women Accepted for Volunteer Emergency Service) secretary and, in the second and third seasons, she was an agent of the Inter-Agency Defense Command (IADC).

- In writer Gail Simone's version of Wonder Woman, Princess Diana of Themyscira has several aliases, including Diana Prince; the Destroyer; the Avatar of Pain; the Dragon; Daughter of the Hunter's Moon; Helm-Princess; Athena's Grace; and Themyscira's Mistress of the Hunt.

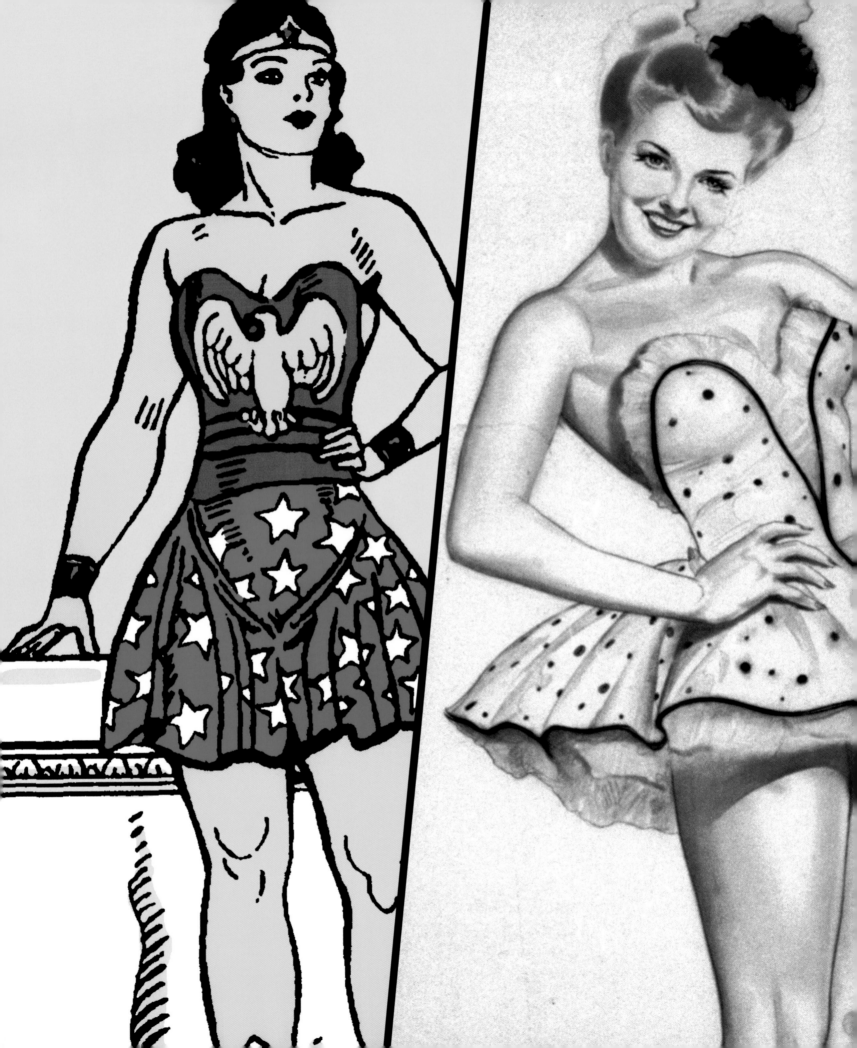

DRESS LIKE A WOMAN
THE COSTUME & SUFFRAGIST STYLE

OPPOSITE (LEFT) | Interior panel artwork by H.G. Peter, *All Star-Comics #8* (December 1941).

OPPOSITE (RIGHT) | Pin-up art by Alberto Vargas of actress Vivian Blaine circa 1940's.

ABOVE | Interior panel artwork by Gene Colan, *Wonder Woman #288* (January 1982).

Creator Dr. William Moulton Marston believed that Wonder Woman was meant to be psychological propaganda for the new type of woman who, he believed, should rule the world. However, it was not known what that woman should look like. Even less known was how she should dress. To help him figure it out, Marston hired H. G. Peter. With a background in drawing suffrage cartoons for *Judge* magazine, Peter was uniquely positioned to bring Marston's ideology to illustrative light.

Peter's early work bore the influence of the so-called Gibson girl—American illustrator Charles Gibson's stylistic interpretation of the 1890s' feminine ideal—combined with the assertiveness of the classic Vargas girl. Where the Gibson girl's come-hither sexuality was full of disdain, Peruvian artist Alberto Vargas's pinup girls inhabited the other side of the spectrum. Inviting and naturally athletic, a "Vargas girl" appeared every

month in *Esquire* magazine and conveyed the can-do confidence of the modern 1940s woman—albeit dressed in clothing so skimpy, Marston's Wonder Woman looked positively wholesome in comparison. Not that *Wonder Woman* publisher Charles Gaines had a problem with nudity. As far as he was concerned, less clothing meant more copies sold. Jill Lepore, author of *The Secret History of Wonder Woman*, writes, "Peter got his instructions: Draw a woman who's as powerful as Superman, as sexy as Miss Fury, as scantily clad as Sheena the jungle queen, and as patriotic as Captain America." Peter's sketches went through a series of changes, but his first attempt—tiara; bracelets; short skirt, blue with white stars; sandals (later changed to boots); and a red bustier etched with an American eagle—was closest to the mark. In the end, Wonder Woman was less Gibson, more Vargas or, as Lepore calls the look, "the suffragist as pinup."

THE SUIT MAKES THE WOMAN

By the 1960s, after various story lines that denied her super heroine powers, Wonder Woman was back in charge, and this time she traded in her skirt for a bodysuit and tight, athletic short-shorts. Sometimes less truly is more: her trimmed-down costume maximized her strengths—and weaponized her feminine "charm"—to full effect, and has had audiences talking for decades.

By the late 1960s, however, a Silver Age reboot was under way: issue #178, which came out in October 1968, encouraged readers to "Forget the Old." "The New Wonder Woman Is Here" boasted the cover. This "new" Wonder Woman swapped out her super heroine powers for tae kwon do kicks and her iconic costume for a wardrobe consisting of Emma Peel-like Mod style—think leather leggings, geometric print tops, and an abundance of white. Wonder Woman, it seemed, was in the midst of a fashion and identity crisis. Her savior arrived in the form of Miss World USA pageant winner Lynda Carter, who received a standing ovation from cast and crew the first time she rocked Wonder Woman's classic red-white-and-blue costume on the set of the hit 1970s television show.

Carter's version of Wonder Woman restored the character to her original state, and her iconic costume has endured minimal changes since. One notable exception occurred in the 1980s when DC Comics replaced the eagle on her bustier with the now-iconic Double-W. The eagle on her bodice was replaced by the more stylized "WW" for practicality: the publisher could much more easily trademark the "WW" emblem than they could the original eagle. But that wasn't the only significant business decision made with the iconic character in that time. To celebrate Wonder Woman's forty years in continual publication, DC Comics also created the real-life Wonder Woman Foundation, an organization that provided financial grants to women forty years and older. The foundation was the brainchild of Jenette Kahn, president and publisher of DC Comics in 1981. Its goal was to assist women who were entering the workforce after raising children.

In the comics of that decade, Wonder Woman experienced something of a lifestyle change as well. During George Pérez's five-year stint as writer on the series, the artists working with him drew her muscles MMA-taut; she was fit, fierce, and strong. This period revitalized interest in the DC flagship character, but with Pérez's departure as head writer, Wonder Woman's story lines and aesthetic evolved again. Her shorts got shorter so they resembled high-cut lingerie, and

ABOVE | Cover art by Mike Sekowsky, *Wonder Woman #187* (June 1969).

OPPOSITE | Interior panel art by H.G. Peter, *Sensation Comics #2* (February 1942).

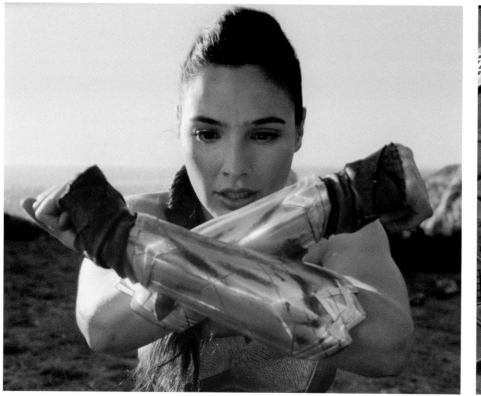

her athletic legs were suddenly runway ready and stretched on for miles. This was very much the look for women across the comics industry in the 1990s. Wonder Woman eventually returned to her costume roots—minus the skirt—but the evolution never truly ends.

In 2010, Wonder Woman got another fashion makeover in an attempt to desexualize three decades' worth of art originally rooted in the pinup. Wonder Woman was now covered up with black pants and a jacket. This change didn't last long. Only one year later, DC writer Brian Azzarello and illustrator Cliff Chiang reverted to the strapless bodysuit fans know and love, albeit with Chiang's stylistic imprint: the line drawings are fantastically crisp and clear, modern. This streamlined approach looks good on Wonder Woman; even her tiara and bracelets have been buffed to a sleek, metallic shine and complement the bling—a choker necklace—around her neck.

In issue #41, David Finch debuted the most clothed Wonder Woman in the history of *Wonder Woman*: pants; long-sleeve top that bordered on being a turtleneck; thigh-high boots; and sharp, golden blades

that protruded from her bracelets. The most material of all her costumes, Finch's version has endeared itself to a sect of fans. But, as author Tim Hanley points out, "It seems to be whenever they change Wonder Woman, most fans just sit back and wait for her to go back to [the] original costume." Perhaps . . . but with Gal Gadot's big-screen debut, Wonder Woman's look may be forever altered.

Wonder Woman's big-screen aesthetic—a visual mash-up of gladiator-slash-Amazonian-warrior-slash-princess-slash-femme-fatale lets Gadot's action scenes do the talking. Hers is a costume designed for an all-out, save-the-world brawl. As *Batman v Superman* costume designer Michael Wilkinson and director Zack Snyder crafted her first cinematic look, they thought carefully about the character's origin. "One of the first things that Zack and I talked about [Wonder Woman] is really wanting her costume to feel like she's been wearing it for 3,000 years," explains Michael Wilkinson. So, they carefully aged her costume to include "centuries of wear from battle." And, of course, no Wonder Woman costume would be complete without the iconic tiara, lasso and bracelets.

LEFT AND ABOVE | Gal Gadot as Diana, wielding her gauntlets and sword in *Wonder Woman* (2017).

IN THE QUEEN'S CHAMBER... OH, DIANA--YOU LOOK BEAUTIFUL!

THIS *MAGIC LASSO* IS MADE OF TINY *GOLD* LINKS WHICH ARE *UNBREAKABLE!* AT APHRO-DITE'S COMMAND, THEY WERE TAKEN FROM THE *MAGIC GIRDLE*--WHICH MAKES ME *INVINCIBLE!* THE *MAGIC LASSO* CARRIES APHRODITE'S POWER TO MAKE MEN AND WOMEN SUBMIT TO *YOUR* WILL! WHOEVER YOU BIND WITH THE LASSO-- *MUST* OBEY *YOU!* IF ANYONE TAKES IT *AWAY* FROM YOU-- AND BINDS *YOU* WITH IT-- THEN YOU MUST OBEY *HIM! NEVER* LET IT BE TAKEN FROM YOU!

VERITAS: LASSOS AND LIES

Every super heroine has her hang-ups. For as cunning as Wonder Woman is, she can't stand a liar. And since you can't always beat the truth out of rogues, Wonder Woman keeps the perfect weapon coiled in her arsenal: the golden lasso of truth. According to creator Dr. William Moulton Marston's origin story, Princess Diana was gifted the lasso by her mother, Queen Hippolyte. Forged in flame, the rope is virtually indestructible. (According to writer George Pérez, even Hercules cannot break its bond.) Its length? Infinite. Its power? Awesome. Once encircled by the gleaming rope, its captive is compelled to tell the truth. Is there anything more terrifying than a confession of wrongdoing? The truth, it turns out, can break even the strongest of men.

As a psychologist, Dr. Marston was a professional truth seeker: He trafficked in uncovering and exploring individuals' lies and truths, his own included. While a student at Harvard, he developed the systolic blood pressure test, a precursor to John Augustus Larson's polygraph. Thinking there was money to be made in the detection of deception, he had several publicity photos taken of himself administering the test to willing female subjects, along with a 1921 press release titled "Machine Detects Liars, Traps Crooks." Marston's device—comprised of a series of wires and

straps, a blood pressure cuff, and an administrator's earphones—was woefully cumbersome by Wonder Woman's standards. When Marston created Wonder Woman's lasso of truth, he distilled the mechanics of the polygraph into a single, beautifully wrought golden cord—truth at its simplest, purest, and most noble design. Interestingly, though, when the comic made its debut, the lasso was, as author Noah Berlatsky

TOP | Interior panel pencils by Ross Andru, *Wonder Woman Vol. 1 #159* (January 1966).

RIGHT | Cover art by Irv Novick, *Wonder Woman Vol. 1 #53* (June 1952).

points out, less a truth-telling device and more a mechanism of control. "If you were caught in it," he says, "you had to do anything Wonder Woman said. It got changed to a lasso of truth, maybe around the time of the seventies television show."

In more recent decades, readers learned that the lasso was made from the Golden Girdle of Gaea and worn by Aphrodite. It was fashioned by the Greek god Hephaestus the blacksmith. Wonder Woman uses the weapon as offense and defense both. She snaps it like a whip, knots it into a noose, and ropes her enemies like cattle. Few enemies have successfully broken its spell, but when they do, there have been serious repercussions. In issue #62 of *Justice League of America* (March 2002), Rama Khan of Jarhanpur offered a confession Wonder Woman didn't buy; once truth itself was in doubt, the lasso was broken, powerless, and reality began to unravel. Denial can be just as dangerous as an outright lie; the strength of the lasso of truth, it would seem, is

ABOVE | Interior panel artwork by Curt Swan, *Wonder Woman Vol. 1 #219* (August 1975).

LEFT | Animation still from *Super Friends: The Legendary Super Powers Show* (1982–85).

clothing store in Dennis O'Neil's 1960s version of the comic books, the lasso of truth was about as effective as a hip-slung belt. In the 1980s *Super Friends* animated series, the lasso followed Wonder Woman's telepathic commands, comically moving around on its own accord to accomplish tasks both big and small. When writer Gail Simone was at the helm of the *Wonder Woman* series, the lasso made something of a comeback. Simone unleashed the lasso's potential and power in the 2009 "Rise of the Olympian" arc when Wonder Woman retrieved her golden lasso in issue #27. The lasso had been stolen in the previous issue by Genocide—a godlike nemesis whose claim to fame was having been created by the worst impulses of mankind itself. Where Wonder Woman embodies hope and strength, Genocide represents mankind's lack thereof. Poised against such an enemy, the lasso of truth is, as Simone says, "a nuclear bomb waiting to go off." She says, "It's a deadly weapon that not only binds you and follows its mistress' commands; the damned thing can see into your soul."

For Simone, the lasso of truth is an underutilized if incredibly powerful artifact from the DCU canon. Making an enemy submit to it, however, is risky. Simone says, "When Diana uses it on a person, there is a bond there, however brief, between Diana and the subject. But what we're only now starting to see is that Diana can take that much, much farther . . . that the lasso is a dimension of its own, and in that place, Diana knows the soul of her captive and more dangerously still, the captive sees into Diana." At the moment when Wonder Woman is at her most powerful, she is simultaneously vulnerable, captor and captive both. "Would you want your own universal truths exposed to anyone, including those you love?" Simone asks. "It's a dangerous, dangerous thing. It puts you in a place where you can feel pity and sympathy for a Nazi, and yet, you might feel coldness and distance when you see directly into the soul of your best friend and ally." With so much responsibility woven into the very fibers of the lasso itself, Wonder Woman knows it's wise to keep your friends close but your enemies closer.

ABOVE | Cover art by Michael Turner, *Identity Crisis #4* (November 2004).

dependent on Wonder Woman's ability to confront uncomfortable truths.

Over the years, Wonder Woman's weapons have, at times, been blunted and dulled or reinterpreted as lesser, stranger entities. The lasso of truth is no exception. When Wonder Woman abandoned her superhuman powers to run a boutique, Mod-inspired

A CONVERSATION WITH
MICHAEL WILKINSON

When costume designer Michael Wilkinson (*Man of Steel*, *Watchmen*, *300*, *Sucker Punch*, **American Hustle**) began to design Wonder Woman's signature costume for the 2015 *Batman v Superman* film, he knew that he was taking on decades of history. Strong, heroic, iconic, and practical—these were just a few design notes that he needed to create the beloved Amazon's iconic armor.

★

Wonder Woman: Ambassador of Truth | What was it like to bring Wonder Woman's iconic costume to life on the big screen for the first time?

Michael Wilkinson | It was such a thrill and an honor to be able to contribute to the way that the next Wonder Woman was seen on the big screen. It's a character that I've been fascinated by for so long, and working with Gal was such an amazing pleasure. She's full of such fantastic ideas and brings such a gravity and a grace to the role.

WW:AoT | What influenced your designs for this adaptation of the costume?

MW | Wonder Woman has been wearing this costume for her entire history, which is 3,000 years. So, you can see the history of the character within the costume itself. It was something that was developed in ancient Greek times, so you can see the influence of Greek culture in the gladiator style metal armor, the split skirt, the leg armor that she wears.

We really wanted the character to have a perfect balance between a power and a sense of intimidation, but also balance that with a grace and a majesty that I think Gal encapsulates.

WW:AoT | Wonder Woman's suit was more than just a beautiful piece of armor. It had to be practical as well. How did you account for the stunt work?

MW | My first reaction when Zack told me that he wanted the suit to look like metal was, "That's a great idea." And then I went away and thought, "How am I going to pull that off?" Metal is rigid, and the choreography and stunt requirements in the script were so immense and epic. So, we actually developed a material that looked like metal with a beautiful ancient feel to it, but was flexible and able to take a paint finish. I designed

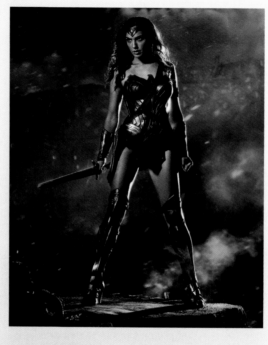

the breastplate to be sectioned with expansion joints, so she's able to breathe and bend and do all of her amazing stunt moves as well as look like she's encased in this incredibly strong metal armor.

WW:AoT | You dressed Diana Prince elegantly, and Gal comes from a high fashion background. What was the collaboration like?

MW | At all times when we're thinking about Gal's wardrobe, whether it was her superhero clothes or her civilian clothes, we really wanted her to be a character that was taken seriously with legitimacy and authenticity to it. We really wanted to create clothes that were very striking, unique, individual looking, but also were grounded in the reality of the film and not over the top. So, what we strove for was a European sort of elegance and sophistication. She's obviously been around for centuries, so she knows how to dress.

A CONVERSATION WITH
LINDY HEMMING

The 2017 film *Wonder Woman* wasn't Lindy Hemming's first experience outfitting a hero, or even a DC Comics character. The Academy Award-winning costume designer worked on all three of the Christopher Nolan-directed *Batman* films. For *Wonder Woman* Hemming brought an extensive resume of action and fantasy to create the looks for a movie that spanned centuries. Classical mythology mixed with historical warfare and modern-day scenes to present a variety of looks for the designer to achieve. Hemming may have inherited the character's signature costume from the film *Batman v Superman: Dawn of Justice*, but the designer still had plenty of opportunity to make *Wonder Woman* her own.

⭐

ABOVE | Gal Gadot and Connie Nielson in their costumes inspired by the natural colors of Themyscira.

OPPOSITE | Wonder Woman's film costume debuted in *Batman v Superman*.

Wonder Woman: Ambassador of Truth | Wonder Woman has gone through so many phases in seventy-five years as a character, where her look may have been more focused on the male gaze than on appropriate utilitarian clothing for what she does. How did you design for the world of women in this film?

LH | The first thing was to not think of sexualizing. In the research that I did, I looked a lot at modern sportswear and I tried to think, "Well, if young people are going to watch this, they have to believe these people can fight in these clothes. They can't look like something which we've just made up in order for them to look beautiful." So there had to be an element of rough, tough armor about it. But of course men's armor is like wearing a box. It doesn't stick against your body. So we were battling with that and how they'd be able to move if we made their armor body-hugging. Patty [Jenkins] definitely wanted them to look as if they could move and as if they could do things. That was one of the prime feelings. And then we approached each character.

Robin Wright is the most, as they say, "incredibly badass." She's the boss of all the girls so she had to be wearing a costume—or, in my opinion, she wore a costume—which she'd had for a long time. So hers perhaps is a bit more leathery and a bit less evolved than the others. She was somebody who wouldn't change. But she didn't need to change. She can fight anyone wearing what she's got. But the Queen's costume, we said, was made of precious metals and we reckoned that this society have great abilities at making things in metal. They have really refined artistic senses. The Queen wears gold and silver and bronze, or gold and silver and copper, so I felt that the lower levels, as you

went down, it would have to be copper and below; sort of metal combined with leather so that they wouldn't have the utterly precious metals. That's why there are more browns. The other thing is we came up with some natural colors, like purples and burgundies, for Robin Wright and Doutzen Kroes. We reckoned that those were colors that would be to do with a royal household, but also colors that they would be able to dye with the kind of dyes that they'd be able to find on the island . . . We went from all the colors of the nature on the island except green, so we were taking sand, clay, yellows and trying to make sure that their clothes matched the scenery, and with the feeling of the island.

WW:AoT | Was it a challenge to work with a character with such an extensive history? Did it inhibit your design choices?

LH | The thing is, you're not supposed to start thinking, "How can I make this mine?" Your job is to look at it all and read the story and try to think, "How can I make this interesting? How can I make this more believable? How can I give this costume a story and therefore give the actor more information?" It's exactly the same process as Batman. Batman exists already and Wonder Woman exists already. If someone asks you to design a chair, well, you look at the chair, don't you? And you go from there. But I can't suddenly come up with somebody else instead of Batman. I've got to go with that, and I've got to go with Wonder Woman and any information that I get from comics or from history or from the director, from the actor, and from Michael Wilkinson. All of that is adding into the design process. That's how I go about it.

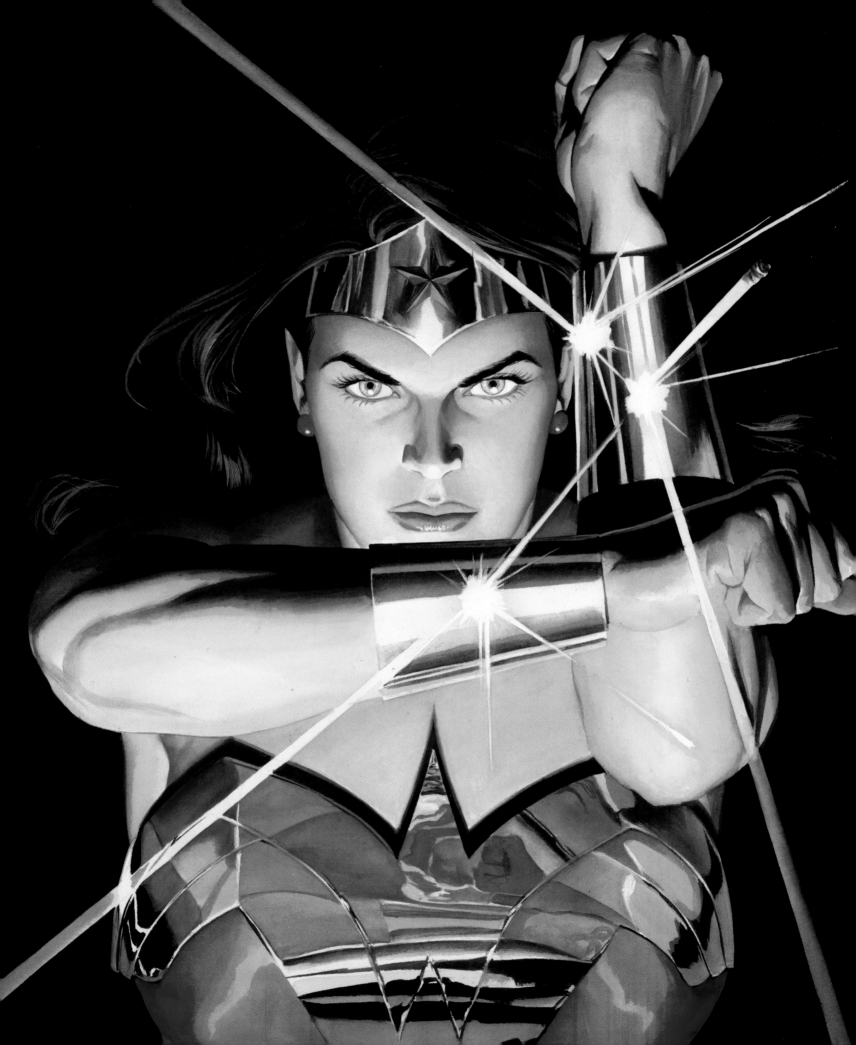

OPPOSITE | *Wonder Woman: Mythology* art by Alex Ross.

ABOVE | Cover art by Gil Kane, *Wonder Woman Vol. 1 #303* (May 1983).

ATTACHED | Wonder Woman temporary tattoos recreating her famous gauntlets.

BULLETPROOF

Assuming that a super heroine is only as good as her toys, weaponry is hugely important in defining Wonder Woman. Most of her gear originates from ancient mythological roots and is given to her by her mother or some other goddess or god. Her earrings are an exception. One set of gold-and-silver earrings can be activated to provide air in outer space. Another set, gifted to her by the queen of the planet Venus, is

gnetized. With this accessory, she has the netic hearing, keeping her in permanent th Venus. When she temporarily lost her e had another pair of earrings that were grenades.

ember 1928, a young woman by the name rne began wearing a matching set of wide-celets. It has been speculated that Wonder rself was deeply inspired by the women n's life, principally Byrne and Elizabeth who were themselves close companions. acelets were most assuredly the real-life behind Wonder Woman's most famous t-defying accessories. Byrne's imprint on oman extended far beyond her fashion-ver.

aunt was the early feminist rebel and ol activist Margaret Sanger. The author *nd the New Race*, Sanger advocated for a f woman with a manifesto that mirrored philosophical underpinnings of Marston's oman. When Joyce Hummel was hired to n write Wonder Woman, Byrne presented the young woman with Sanger's book. Everything Hummel needed to know about Marston's "new woman" was in its pages.

Wonder Woman's Bracelets of Victory are also known as the Bracelets of Submission to symbolize the time of enslavement to Hercules. All Amazon women wear these unbreakable, bulletproof, silver cuffs that were forged from the shield of Zeus. If the bracelets are lost, the result is insanity. When welded together, the bracelets weaken the former owner, much the way Kryptonite affects Superman. But when the bracelets are working the way they are supposed to, the silver cuffs will repel any weapon—bullets, knives, or death rays—that are fired at the wearer. At times, their power has increased exponentially so that when crossed in front of the face, the bracelets create a magic shield that protects the whole body. On rare occasions, the bracelets can generate a sword.

Also worn on the arm is the Gauntlet of Atlas, a gold cuff that spirals up the arm. The Gauntlet

WHERE IN THIS ENTIRE WORLD CAN YOU FIND A PLANE WHICH IS UTTERLY SILENT—TRANSPARENT—AND WHICH ANSWERS **ONLY** TO THE SOUND OF **ONE** PERSON'S VOICE? **WONDER WOMAN**—BEAUTIFUL AS APHRODITE, WISE AS ATHENA, SWIFTER THAN MERCURY, AND STRONGER THAN HERCULES—WILL ANSWER THE MANY LETTERS YOU HAVE SENT CONCERNING HER UNIQUE VEHICLE—IN THE STARTLING ADVENTURE OF------

"The ORIGIN of the AMAZON PLANE!"

N·845

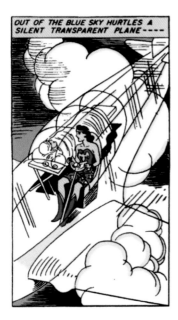

magnifies Wonder Woman's strength by ten times but comes with a caution. So much power is difficult to control and can drive the wearer into a berserker warrior frenzy.

WONDER WOMAN TAKES FLIGHT

Though the invisible plane originally came from Themyscira, where the Amazons seemingly have a fleet ready and waiting to zip back and forth to the world of man, this mode of transportation is neither ancient nor swathed in myth. In fact, considering the era Marston created it, the invisible plane—and with a woman flying it, no less—was a marvel of modern 1940s-style warfare. Being invisible, it signaled the possibility of espionage and allegorically spoke of a woman's ability to hide her power and, in Wonder Woman's case, go undetected in the world of man as Diana Prince. Its first appearance was in *Sensation Comics #1* (January 1942), and it originally went by the name *transparent plane*.

When Wonder Woman first arrived on the comic book scene, her superhuman powers, while robustly Amazonian, nonetheless had her feet firmly planted on the ground. Unlike her male counterpart with the swirly pompadour, Wonder Woman couldn't fly; hence the plane. In the Silver Age, Wonder Woman did develop the power to ride on air currents, and she could bodysurf the airwaves for short distances. This had its obvious drawbacks. If the air current died down, she went into free fall, and if there was no wind to speak of, she was forced to rely on her old reliable: the invisible plane. When not in use, the invisible plane was supposedly stored in a secure yet undisclosed location in a barn somewhere outside of Washington, DC. To summon it, Wonder Woman relied on her tiara, which sent telepathic signals to the aircraft. Similar to a cowgirl whistling for her horse and having the animal appear, saddled and ready to ride, the invisible plane always appeared at the exact moment Wonder Woman needed it most, gassed up and ready for takeoff. She didn't even have to file a flight plan.

Over the years, Wonder Woman's bulkiest weaponized prop went from being a fairly clunky plane

with a drop ladder to a sleek and supersonic jet capable of soaring into outer space and capable of blasting mist, fog, and heavy clouds with rainbows. The plane has been the subject of several backstories that range from the simplistic—Wonder Woman built the aircraft herself—to the mythological—Pegasus, the winged horse, is transformed into the invisible plane after Wonder Woman tames the wild beast—to the complex—the plane is actually alien technology that can morph into any number of invisible objects, including a flying fortress called the Wonderdome. In *Wonder*

OPPOSITE | Interior panel art by H.G. Peter, *Wonder Woman Vol. 1 #211*, a reprint of *Vol. 1 #80*. (May 1974).

ABOVE | Interior panel artwork by H.G. Peter, *Sensation Comics #1* (January 1942).

RIGHT (TOP) | Cover art by Jose Garcia Lopez, *Wonder Woman Vol. 1 #306* (August 1983).

RIGHT (BOTTOM) | Animation still, Wonder Woman in the invisible plane, *Super Friends: The Legendary Super Powers Show* (1982–85).

Woman Vol. 1 #261, the invisible plane picked up the ability to speak, becoming a kind of aerodynamic KITT to Wonder Woman's Michael Knight.

Though the invisible plane has been an integral part of her arsenal, the truth is Wonder Woman has used it less and less as time went on. Wonder Woman is a low-maintenance, get-up-and-go kind of girl. The invisible plane is high maintenance, and, more often than not, required Wonder Woman to shuttle around friends like Etta Candy, the Holliday Girls, and sweetheart Steve Trevor, making her more like a roving soccer mom than a woman warrior. Today, the invisible plane is still part of the DC Comics universe, having been acquired by A.R.G.U.S. Wonder Woman, however, no longer flies it.

FROM HEAD TO TOE

Princess Diana and her mother are the only Amazons who wear a regal headdress. While the tiara indicates Wonder Woman's royal status, it's more than just a pretty princess accessory. When thrown as a boomerang, it's also a lethal weapon. Wonder Woman used it to decapitate the dreaded Deimos in "The Ares Assault," *Wonder Woman #5*, and cut Superman's throat when he was under the influence of Maxwell Lord in "Sacrifice, Part IV of IV," *Wonder Woman Vol. 2*

#219. Historically, the tiara itself is usually described as being made of gold though it's sometimes rendered in silver, and bears a single star, usually red, at its center. Whenever Wonder Woman forgoes her tiara, it's usually during moments of crisis and powerlessness, though the tiara itself doesn't confer power on her. It is emblematic, however, of her Amazonian heritage, its metal being one of Earth's strongest and Wonder Woman being the world's most powerful woman. For Princess Diana, the crown doesn't make the woman, but it certainly helps.

Her battle armor varies depending on the circumstances but usually reflects her roots as an ancient Grecian warrior with a breastplate and often a classic warrior skirt. Another version of her armor is a war suit, similar to one worn by Queen Hippolyta. Made entirely of copper and covering more of the body, this suit has the unique capability of being able to sprout wings to terrify the foe.

Footwear isn't generally considered a weapon, and Wonder Woman's red-and-white-striped boots didn't have special powers. The Gal Gadot Wonder Woman sports gladiator-style sandals that cover the knee and have a wedge heel—also not magic. However, Wonder Woman has been known to sport the Sandals of Hermes, the fleet-footed messenger

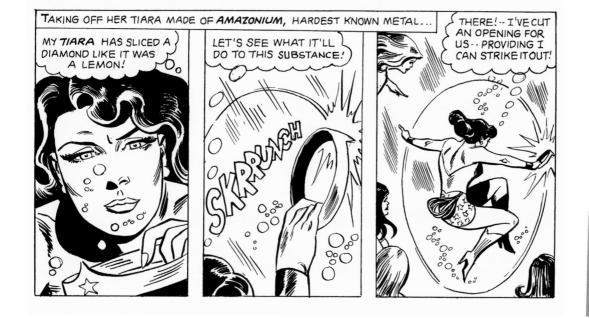

LEFT | Interior pencils by Ross Andru, *Wonder Woman Vol. 1 #171* (August 1967).

ABOVE | Gal Gadot as Diana in one of the first promotional images released for the film *Wonder Woman* (2017).

OPPOSITE | Interior panel artwork by Don Kramer, *Wonder Woman Vol. 3 #602* (September 2010).

to the gods. These winged sandals endow the wearer with superspeed and the ability to fly.

Much of her weaponry is standard hardware: swords, daggers, bow and arrows, axes and spears. She carries the Sword of Athena—also known as the God Killer in the 2017 *Wonder Woman* film. The name is taken from a sword introduced to the DC Universe in the *Deathstroke* comic book. In the film, it is believed that the weapon possesses a magical ability to work on invulnerable beings, and it is engraved with the following: "Life is killing life all the time and so the goddess kills herself in the sacrifice of her own animal." The same quote is also etched around the edge of her shield. This quote carries echoes of mystical

wisdom, but the derivation isn't ancient: It's from Joseph Campbell, author of *Goddesses: Mysteries of the Feminine Divine*.

Perhaps Wonder Woman's greatest weapons come from within. It should be no surprise that this is the point of her titular film. Many of her battles are won by her sense of humor and her cleverness as she pulls off a secret identity and takes on jobs ranging from archeology to fashion design. Her perception is razor-sharp, not requiring the lasso of truth to recognize deception and injustice. Amazon or not, she fights for women and children, the downtrodden and the helpless. She's a demigoddess and a princess with a righteous claim to divine wisdom.

BELOW | Interior panel artwork by Mike Deodato Jr., *Wonder Woman Vol. 2 #93* (January 1995).

OPPOSITE | Cover art by Aaron Lopresti, *Wonder Woman Vol. 3 #36* (November 2009).

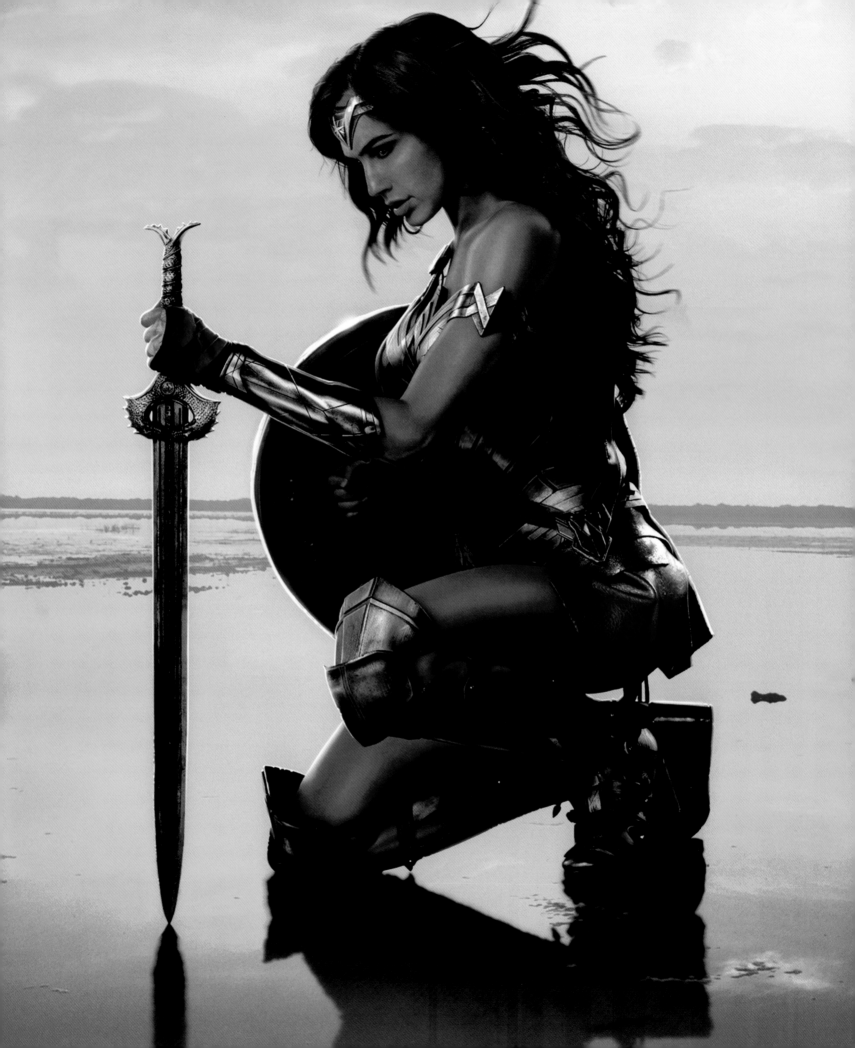

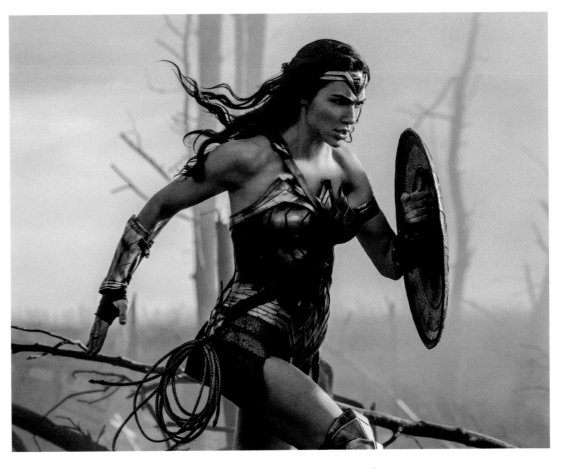

GAL GADOT'S WONDER WOMAN

OPPOSITE | Promotional image from *Wonder Woman* (2017).

RIGHT | Gal Gadot as Diana in the "No Man's Land" scene of *Wonder Woman* (2017). This scene represents the moment Diana becomes Wonder Woman.

The 2017 film *Wonder Woman* marks the first female-carried super hero movie in over a decade, the previous female-fronted film being 2005's *Elektra* with Jennifer Garner. With Gal Gadot taking on the titular role in the film directed by Patty Jenkins, Wonder Woman is finally front and center, and getting the cinematic attention she deserves and the critical and audience reception she has earned. The unique history of Wonder Woman as an enduring icon of female power plus fans' expectations meant the cast and crew felt the pressure to get everything right—from Wonder Woman's costume and Gadot's portrayal to the story line and its action-packed scenes.

Fans of *Fast & Furious* already knew Gadot as Gisele Yashar, one of the franchise's badass females known for her, fearlessness and excellent marksmanship. Gisele may be cut from a similar cloth as Wonder Woman, but it's Gadot herself who imbues her characters with strength and nerves as tough as steel. Having served two years of mandatory service as an enlisted soldier of the Israel Defense Forces, Gadot can handle a weapon just fine—a skill both *Fast & Furious* director Justin Lin and *Wonder Woman* director Patty Jenkins highlight to full effect. She isn't afraid of a little elbow grease, either. While in the army, Gadot didn't just survive its hard-core three-month boot camp, she excelled . . . so much so, in fact, that she became a combat trainer herself. The training paid off: "The things I've been through as a soldier," she says, "prepared me to deal with [my] career as well." Besides her athletic prowess and weaponry know-how, Gadot can also represent her people—she was crowned Miss Israel in 2004—and, as a former law student, also knows how to hit the books.

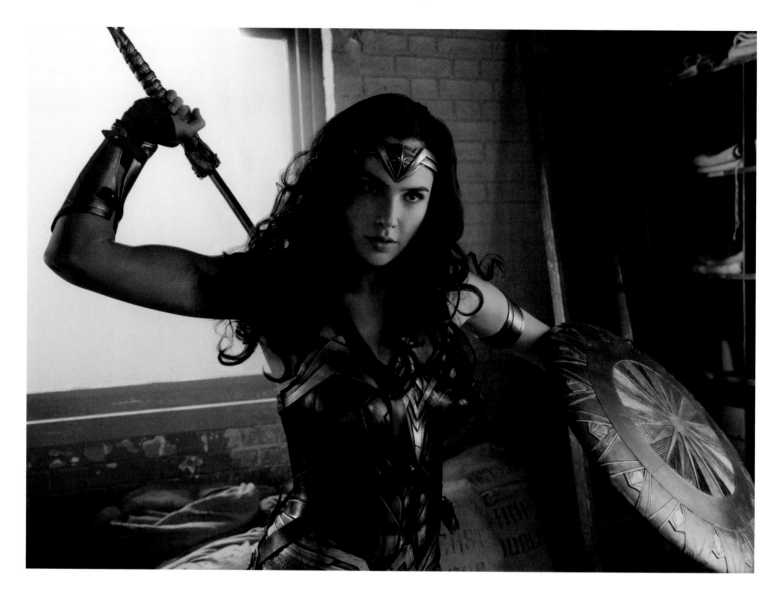

Wonder Woman is the perfect trifecta of beauty, brawn, and brains, and Gadot has the combo down pat. Turns out, the transition from combat trainer to formidable Amazon Princess was just a costume change.

WITH THE BOYS

As a founding member of the Justice League, Wonder Woman has proved, time and time again, that she can play with the boys. When casting Gal as Wonder Woman in *Batman v Superman*, director Zack Snyder felt the responsibility of choosing the perfect actress for the role. "We went through an extensive testing process with Gal. And the scenes that we shot with her, we felt like what she brought was fresh, courageous, and strong. Gal is confident and cool. Just all

the things you would want in a Wonder Woman." . No one was more shocked that she landed the part than Gadot herself. Due to the secrecy surrounding the film, she wasn't even aware she was auditioning for the role of a lifetime until a few days before her screen test with Batman's Ben Affleck. Two days after she got the part, she slipped into the Wonder Woman costume for the first time.

To prepare for *Batman v Superman: Dawn of Justice*, Gadot, along with Affleck and *Superman*'s Henry Cavill, underwent a rigorous nine-month training period that consisted of swordsmanship, kung fu kickboxing, capoeira, and Brazilian jiu-jitsu. That training was just a physical warm-up for the character prep that followed.

ABOVE | Wonder Woman engages in battle during WWI.

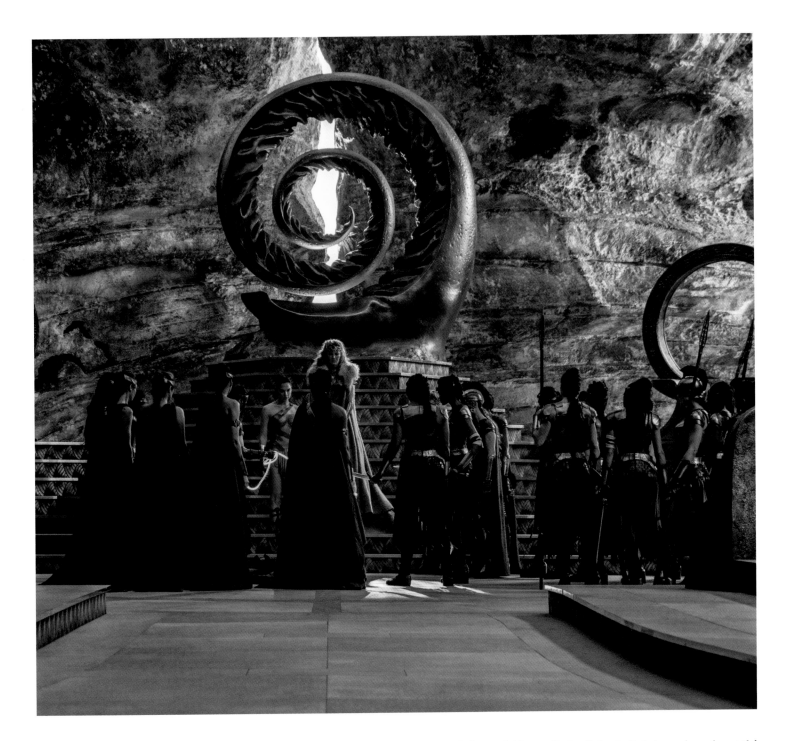

ABOVE | The Amazons interrogate Steve Trevor with help from the lasso of truth.

For *Wonder Woman,* director Patty Jenkins pulled the character back to her origins and where it all began—the all-female paradise of Themyscira. To set the tone for the filmmaking, the production team recreated the so-called Paradise Island for the cast, flying dozens of actresses and stunt doubles to Happy Village, a real-life Italian villa along the beaches of Capo Grosso. Gadot reports, "It was like a kibbutz, all of us living in little bungalows, beautiful and green with no cars. We had all these women in armor fighting on the beach, and meanwhile all the men—husbands and boyfriends—are walking around with strollers and taking care of the kids. It was exclusively badass, interesting women." For Gadot, it was important that Wonder Woman be both fierce and compassionate. "You can be powerful and also loving,"

she says. The message is clear: the best qualities of Wonder Woman—her strength, her moral compass, and her sense of love—come from a sisterhood of women warriors. Even for Wonder Woman, it takes a village and, in Gadot's case, preferably a happy, Italian, beach-front one.

In *Batman v Superman: Dawn of Justice*, Wonder Woman is a battle-tested warrior, already firmly entrenched in her sense of character and justice. Jenkins's *Wonder Woman*, however, represents Wonder Woman during the earlier stages of life; the film captures the chrysalis moment when Princess Diana leaves the island of Themyscira to *become* Wonder Woman and join the battle for mankind. Gadot explains, saying, "Wonder Woman is different from the woman you see in *Batman v Superman*. She's more naïve and pure, and she's this young idealist who doesn't understand the complexities of men in life. Whereas in *Batman v Superman*, she's super. She's very experienced."

Both Jenkins and Gadot wanted to create a modern-day Wonder Woman girls and boys could look up to. To do that, Jenkins drew creative inspiration from the 1978 *Superman* film, starring Christopher Reeve, and applied the same cinematic devices for Wonder Woman that already existed for Superman. Historically, there have been few active, central female heroines in cinema—women who are the principal actors of their lives and who don't sacrifice themselves for the "good" of the mission (or for a boyfriend, lover, or other, more dominant male hero)—and because of this, something fundamentally *exciting* happens when a positive, confident, and strong female protagonist gets the opportunity to stride across screen the way male heroes have for decades. "We've spent years treating male heroes in certain ways," Jenkins says. "I just applied those same tropes to her, and all these incredible radical moments suddenly appear to an audience." No one understood this better than creator Dr. William Marston himself, specifically in the 1943 magazine article cited earlier: "Women's strong qualities have become despised because of their weak ones. The obvious remedy is to create a feminine character

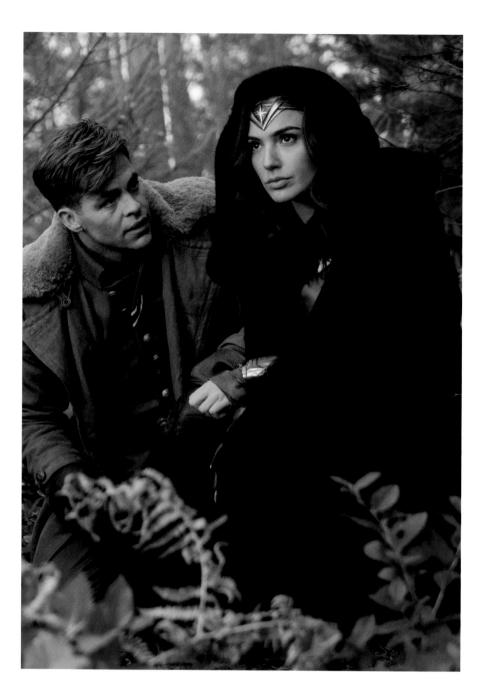

with all the strength of Superman plus all the allure of a good and beautiful woman."

For Gadot, the challenge was to both own those moments and imbue them with a sense of authentic femininity. "We knew it was tricky," she says. "We wanted to find the balance between portraying her as confident and strong and feminine and warm." Gadot found that balance and, along with Patty Jenkins, the writers, producers, and crew, presented a Wonder Woman that left audiences cheering for more.

ABOVE | Chris Pine as Steve Trevor with Gal Gadot as the characters prepare to stop Ares's plan.

OPPOSITE | Diana deflects an onslaught of bullets.

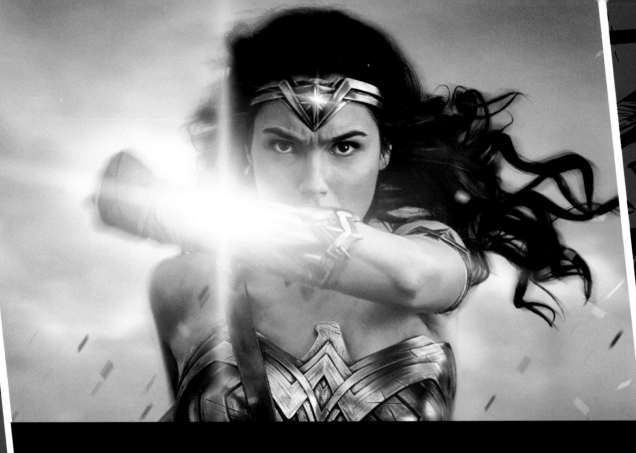

SENSATIONAL FACTS AND ALL-STAR NEWS

"NOW, GO, MY DAUGHTERS. HENCEFORTH, YOU SHALL FORM A SACRED SISTERHOOD. HENCEFORTH, YOU SHALL BE AMAZONS. AND NONE MAY RESIST YOUR POWER."

—HIPPOLYTA, *WONDER WOMAN, VOL. 2, #35*

- *Wonder Woman* is the second mainstream comic book film to have a female director. *Punisher: War Zone* (2008) was directed by Lexi Alexander.

- Wonder Woman as the daughter of Zeus is based on the origin story told in 2011's the *New 52* DC Comics period.

- In Marston's comics and the first season of the *Wonder Woman* TV series, the setting is World War II. In the 2017 film, Steve Trevor and Princess Diana meet in World War I.

- Gal Gadot lost the role of Bond girl Camille Montes in *Quantum of Solace* to Olga Kurylenko. Ironically, Kurylenko would later lose the role of Wonder Woman to Gadot.

- Prior to becoming a mother, Gadot was a dedicated motorcyclist and rode a black 2006 Ducati Monster S2R.

- *Wonder Woman* reportedly had a budget of over one hundred million dollars, making Jenkins the second woman to helm a film of that scale. The first woman to direct a one-hundred-million-dollar movie was Kathryn Bigelow for 2002's *K-19: The Widowmaker*.

- Jenkins's first feature film was 2003's *Monster*, starring Academy Award-winning actress Charlize Theron.

A CONVERSATION WITH
GAL GADOT

★

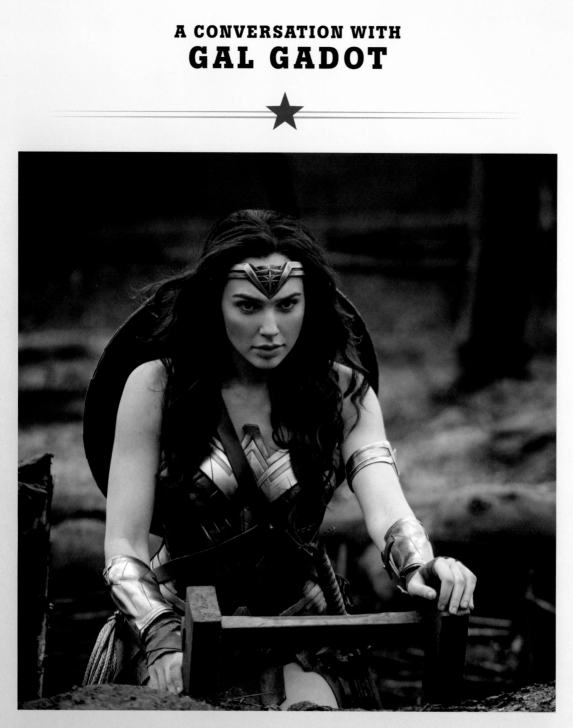

Wonder Woman: Ambassador of Truth | What is it about Wonder Woman's character that has allowed her to remain such a beloved character for over seventy-five years who is still relatable today?

Gal Gadot | I truly believe that it's all because of what she stands for—her values, what she symbolizes, and who she is. She's really a pure, beautiful character, so there's nothing not to love. I think this character is very

universal. Everyone can relate to Diana because everyone wants to have a better world. Everyone is seeking the good and beautiful and the pure things that we have in this world. And Diana really fights for it. She wants mankind to be happy. She wants mankind to have a good, beautiful life.

What I find so beautiful about Diana is that she's naïve, but not in a "stupid" way. She sees the world in a whole new way. She believes that our world is pure and

to fight. We actually had a very interesting discussion about her fighting in the solo movie. I came to the conclusion that Diana's powers should gradually evolve like Diana. I don't think from the first moment she knows how to fight like she's the most amazing warrior in the entire world.

We were talking about the beach battle and I told them I really think that is the first time she's been in a complicated battle. Before that, all she did was training. Now, it's a complicated battle. And I thought it would be a good idea for her to fight, but just with the two shields, just to defend herself and whoever's near her. Slowly and gradually she will expand and reveal all of her powers. But really, she would try to make peace by talking, by communication, by negotiating. The last option for her would be fighting.

WW:AoT | **People sometimes describe Wonder Woman as being perfect. She is the child of a god, after all. How do you allow her to connect with the audience?**

GG | Honestly, I think that each and every one of us wants to be a hero. When you see the way DC Comics heroes have so many real qualities, because they're not perfect, it makes us think that we can be heroes as well . . . I think that people love these movies because everybody wants this world to be a better place.

WW:AoT | **What do you hope the audience comes away with after seeing the movie?**

GG | Patty and I really started to explore Wonder Woman's story and the premise of the movie. We said we want people to leave the theatre talking about this story, and saying, "Wow, how amazing this movie was if each and every one of us is going to do something better and kill our inner Ares." This world might be fantastic. This world will be an amazing place to live in. I think that Wonder Woman, even though she's a female character everyone can relate to, she has such a big heart, she sees the world in such a simple way. It reminded me how I was growing up, you know? Seeing all the new things and thinking about how beautiful this world is and pure and only see the half-full glass without looking at the other half. There's something about Wonder Woman that is magical. You want to hug her. She really means well. That's the reason she's a very universal character. Everyone can relate to her because we have the same motives.

good and beautiful. But when she starts to understand the world, she realizes that it's really complicated. It's not just white. There's also black and gray, and other shades of complexity. What I love about Diana also is that she acts from emotion, but emotion is also what stops her from acting. Emotion is also her kryptonite, if you want to call it that. She loves people. She wants everyone to be happy and good and love each other . . . She truly wants all people to experience this beautiful world that she believes in. This is the journey of Diana becoming a true, smart, sophisticated woman who understands the complexities of life . . . All of her values and everything that she fights for is really relevant for today.

WW:AoT | **How does that goal of improving the world, and her approach to achieving it, set her apart from other heroes, particularly the male heroes she teamed with in _Batman v Superman: Dawn of Justice_?**

GG | She does it in a very sophisticated way. She wouldn't necessarily go and fight. Fighting would be the last option. She would try to negotiate her way. She would try to see if she could figure things out and resolve conflicts in a different way. But when there are no other options, then she will go and use her power

OPPOSITE | Diana prepares to enter "No Man's Land."

ABOVE | Diana enters a new world.

A CONVERSATION WITH
ZACK SNYDER

Director-Producer Zack Snyder effectively launched the DC Comics Extended Universe with his 2013 film *Man of Steel*. He continued to build that cinematic universe with *Batman v Superman: Dawn of Justice*, and then as a producer on *Suicide Squad*, laying the groundwork for 2017's *Justice League*. As a writer and producer on *Wonder Woman*, Zack worked alongside Patty Jenkins and the rest of the production to assemble the team that would bring the story concept to fruition with Gal Gadot's blockbuster performance of the iconic character.

★

Wonder Woman: Ambassador of Truth | What connected most with you about her story?

Zack Snyder | [William Moulton] Marsden said something along the lines of, "I write Wonder Woman as a new kind of propaganda to show the world what a woman could be. A new kind of woman for the future that's strong, assertive, smart, and who can do anything." Do comic books lay the foundation for those ideas? Is that possible? I think it is. In a comic book super hero you get an idealized perfection, much like Greek mythology. But it also shows our flaws and vulnerabilities at the same time. We insert these characters into our lives so we can use them to interpret modern problems. Wonder Woman offers a unique opportunity to really speak to what it is to be female and a woman, and to be strong, powerful, and independent.

I grew up with powerful women in my life, and I've always felt that powerful women are an important voice—not just in movies, but in the world. Having that equal representation of the male and female energy is important to me. It's an important thing we need to get out in the world as much as we can.

WW:AoT | What sets her apart from the other members of the Trinity and the Justice League as a whole?

ZS | There's a purity to Wonder Woman that I love. She doesn't have a broken past, she's not seeking revenge on the people who wronged her and she isn't coming from a dark place. She had an idyllic childhood and was taught to value life. She can be a hero purely from a place of wanting to do what's right in the world, which is really cool, and I think both Patty and Gal found the perfect way to convey that in the movie.

WW:AoT | How is that concept furthered in *Wonder Woman*? What is the essence of the film's story for you?

ZS | It's about finding a lost place, and from that lost place, finding a hero that can come into our world and save us from ourselves. She can save us by teaching us about ourselves. But it's also about the hero learning who she is through us. It's about making Wonder Woman into Wonder Woman.

A CONVERSATION WITH
PATTY JENKINS

SOMEONE JUST
ASKED ME ABOUT
HOW YOU DIRECT
THE ACTION. I WAS
LIKE, 'IT'S EXACTLY
THE SAME AS THE
DRAMA BECAUSE
IT IS THE DRAMA.'
EVERY SINGLE
MOMENT, SHE'S IN
A SITUATION WHERE
SHE HAS TO MAKE
A FAST DECISION
ABOUT HOW TO TAKE
THESE PEOPLE OUT.
SHE HAS A SWORD,
BUT SHE'S OFTEN
FLIPPING IT THE
OTHER WAY AND
KNOCKING THEIR
GUNS OUT OF THEIR
HANDS INSTEAD OF
STABBING THEM
THROUGH THE
THROAT. THAT IS
HAPPENING ALL
OVER THE PLACE. IT
BECAME SO FLUID TO
HER ARC.

—PATTY JENKINS

OPPOSITE | Zack Snyder and Gal Gadot filming *Justice League* (2017).

With the release of *Wonder Woman* in 2017, director Patty Jenkins shattered records, including the highest grossing film of all time from a female director. But the film's impact went deeper than the box office. During the movie's second weekend, Jenkins went viral on social media with her recap of reactions from the youngest audience members witnessing their first blockbuster super heroine on the screen. It was a fitting tribute for a woman who first fell in love with the character as a child playing *Wonder Woman* in the schoolyard.

Patty Jenkins was already an acclaimed director, working in film and television for over a decade before *Wonder Woman* made her a household name. Prior to the release, her signature work was the 2003 film *Monster*, which she wrote and directed. She was active on television as well, with her direction on the pilot episode of *The Killing* earning her an Emmy nomination. Jenkins was briefly attached to the first sequel to *Thor*, but left the production before the movie began filming. No matter. Another mythical hero was waiting for her. By the end of *Wonder Woman*'s opening weekend, Jenkins was already speaking of a sequel as audiences of all ages were clamoring for more. The director shared her thoughts with *Wonder Woman: Ambassador of Truth* shortly before the critical raves started flooding in and the film had its blockbuster opening.

★

Wonder Woman: Ambassador of Truth | When did Wonder Woman first come on your pop culture radar?

Patty Jenkins | The seventies TV show was my first definitive memory. I was in elementary school and the prime target for the show. Me and every girl in school were exactly the people whose minds it blew. We were totally obsessed with it.

WW:AoT | Me, too. Her and Isis and Shazam in the morning.

PJ | You are the only other one who remembers Isis. That's so hilarious. Because I remember so clearly on the playground: you fought to the death to get to be Wonder Woman, but if you didn't get to be Wonder Woman, you scrambled to be Isis.

WW:AoT | And now you get to direct Wonder Woman, which probably beats everyone else on the playground. As you started working on the film, what were your conversations with screenwriter Allan Heinberg about in what you both wanted to see from the character on-screen?

PJ | He was only a third of the way through the script when I signed on. It was a great marriage because I had been pitching something—not exactly the same, but similar—for a long time, too. He had all the plot points worked out, but I really like to have a big arc and themes about the characters. It was about pulling that line all the way through and making sure Diana's character arc followed her journey from a young, idealistic person with a dream, learning how that dream unfolds and then making a brave choice about it in the end.

WW:AoT | What did Gal Gadot bring to the character that illuminated the elements of Diana that you wanted the audience to see?

PJ | It's the fact that she's a tremendous actress and such a hard worker that she'll do anything to be great. She fits the bill physically and technically, but I think the thing that makes her special and different is how genuine the qualities of the character are to her. Gal is unbelievably kind, warm, loving, happy, and optimistic as a person. When she walks in a room and how she deals with everybody every day exudes the Wonder Woman spirit. It sounds cheesy, but I don't take these things lightly. I think that if you're going to represent a super hero in our world, it's so incredible if you can find

somebody who actually represents that spirit within their real life. It's not to put the pressure on her that she has to be Wonder Woman. She's not Wonder Woman but she's as good as Wonder Woman.

WW:AoT | You crafted part of the film around Themyscira, and the strong women who raised her. What was your approach to that mythical island?

PJ | The cool thing about Themyscira is that, yes, they're women, but they are a whole universe of their own. I wanted to make sure there was variety in the Amazon women. They're not all kind in the exact same way. They're not all warm in the exact same way. They are, in fact, very varied, but they all have the same origin, they were created to teach mankind love, and to symbolize mankind. But then mankind turned against them. They had to fight to free themselves and now they're hidden away on this island where mankind can't find them.

WW:AoT | When you make the transition away from Themyscira, there's the fish-out-of-water scenario that naturally comes with that. How did you allow Diana to be vulnerable in that situation, but never undermined her sense of self?

PJ | I followed the *Superman* formula. We would always let Superman have needs. We would always let Superman go into the world and not know how to do things, and that's part of the fun. It doesn't keep him from being Superman when the heroic moment comes. At first, he doesn't know what to do, but then he turns around and he saves the day and catches the helicopter. That's the point. I followed that exact same formula with her.

Steve Trevor is a fish-out-of-water when he's in Themyscira, and then they come to man's world and she's a fish-out-of-water. I wanted to have fun with both of those things, but they both learn from each other because they're both excellent at different things—and by the way, any main character needs to have vulnerabilities and growth in a journey.

WW:AoT | Steve Trevor has played many roles in the seventy-five years of Wonder Woman stories. What was important to showcase for him as he functioned as a guide, in a way, into this next stage of Diana's life?

PJ | Not unlike a great romance—you're looking for the best friend character that's also a love interest. Whether your lead is a man and you're casting a woman or the other way around—you're looking for somebody who's

ABOVE | Patty Jenkins with the cast on location as the characters move toward their ultimate confrontation with Ares.

COURAGE

POWER

ABOVE | Movie posters from the film's ad campaign.

RIGHT | A lighter moment in filming of the more conservative historical scenes of London in an earlier time.

a counterpart to the character to create a fun dynamic and journey alongside. In Steve's case, he's human. He's tough, cool, jaded and knows all about the world, and he's really funny. That was what ended up being so important: She's hilarious in the movie, but she's a total straight man. Diana is not playing the joke, so you need somebody who's registering everything about her from our point of view.

WW:AoT | **When you're framing Diana in her action sequences, when she's on the front lines or she's going against Ares, how did you want to portray her style of fighting? Was there something about the blocking that you wanted to set her apart from what the rest of her sisters?**

PJ | Hugely. Diana does not want to hurt anybody. It's not her intention. She wants to solve the situation and to stop the crisis or the violence. That is a very specific fighting style when you intentionally avoid punching people in the face. You're trying to just neutralize people, but yet you're neutralizing a lot of them at the same time so you're trying to keep up with everything. This approach influenced her fighting style and even her expression. She's never grimacing. She's never cocky. She's never mean or mad looking. Until the end when she's battling Ares, she's not angry. She's effortful looking. She's trying to stop the crisis, whatever the crisis is.

WW:AoT | **What do you hope the film does for the character and the legacy of Wonder Woman, along with charting a new path for seeing these kinds of women on film, and women directing these films?**

PJ | First and foremost—before I ever started thinking about being a woman—I was thinking about being the right director for the film and then loving Wonder Woman. Really, everything's genesis starts there. Wonder Woman is an amazing character, and I hope that I bring a character that I love to the world. I feel like I was a perfectly good director to do it because of my love of Wonder Woman. I happen to be a woman.

Then secondarily there is the realization that people have not always thought that making a successful female action movie was possible. Which I think is extremely late, if nothing else. There's a very diverse audience out there, and a huge group of stories worth telling. Wonder Woman, to me, is a no-brainer. She's one of the biggest super heroes of all time.

I'm not making a movie about being a woman and I'm not thinking about being a woman while I'm doing it. I am just trying to make the greatest version of Wonder Woman that I can for all the people who love the character as much as I do. Hopefully the success of the film will help us get to a place where a woman can star in an action film with a woman director and it is no big deal. That will be the amazing victory.

TEAM PLAYER

Growing up in the Amazon society on Paradise Island/Themyscira, Diana learned about teamwork and cooperation. While these fierce female warriors prepared and trained for battle, they were also part of a cooperative. They competed against one another but also worked together, which provided Diana with solid training for her position in the Justice League. Unlike many of the "lone wolf" super heroes who suffered extreme trauma in their youth, Wonder Woman's upbringing prepared her to work well with others. Though she didn't grow up in a traditional nuclear family with a mom, dad, and children, her childhood—surrounded only by women—nurtured her strength, ability, and self-esteem. She has the confidence to take charge and lead her troops into battle, whether her team are Amazons, WWI or WWII soldiers, or a gang of powerful super friends. Is she a team player? Yes, but she also knows her own mind. This much is clear from the moment she first joins forces with Batman and Superman in their cinematic battle against Doomsday and again when they reconvene in *Justice League*, along with some new superhero friends. Wonder Woman is smart enough to know when she needs help and when her powers would be best amplified by group effort. Replacing the Amazons is a next-to-impossible feat, but Wonder Woman comes close by readying a dedicated legion of mortal women—the Holliday Girls—to help her. When danger proves too rough-and-tumble, Wonder Woman can redouble her superhuman efforts by calling upon one of her high-powered assembly of super heroes: the Justice League, the Super Friends, or the Justice Society,

LEFT | Ben Affleck as Batman, Gal Gadot as Wonder Woman, Ray Fisher as Cyborg, Ezra Miller as The Flash, and Jason Momoa as Aquaman in one of the first images released from the film *Justice League* (2017).

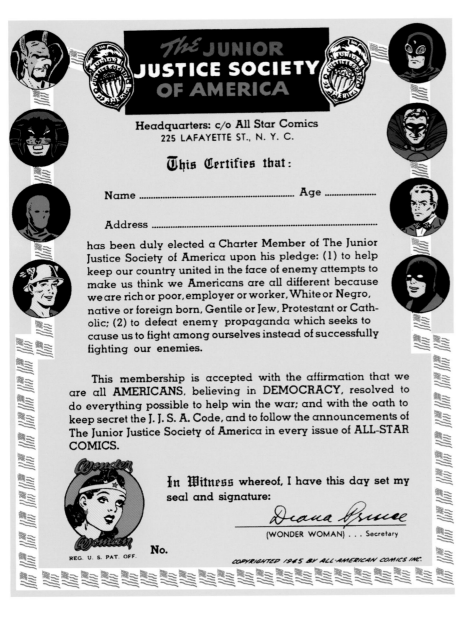

to name a few. Wonder Woman's been around long enough to know that you're only as strong as your team. Good thing she's got a full roster.

JUSTICE SOCIETY, SUPER FRIENDS, AND JUSTICE LEAGUE

While a power in her own right, Wonder Woman wasn't always seen that way, at least not when she joined the Justice Society in 1940. Led by Hawkman, the first meeting of the Justice Society was held in *All-Star Comics #3*, and its nine founding members were the Flash, Hawkman, the Spectre, Doctor Fate, the Atom, Green Lantern, and the Sandman.

Superman and Batman were honorary members, and only showed up when the situation was at its most devastating. Wonder Woman's inclusion in the Justice Society was based on readers' answers to a one-page questionnaire placed in *All-Stars Comics #11*: "Should WONDER WOMAN be allowed, even though a woman, to become a member of the Justice Society?" The answer was a resounding, no-contest "Yes": Of the first 1,801 questionnaires, 1,265 boys and 333 girls gave Wonder Woman the thumbs-up; 197 boys and six girls said "No." As soon as she was welcomed into the fold, however, she was benched, and assigned the paper-pushing job of secretary. While the "boys" went off to fight the Nazis, she was ordered to stay behind to answer the mail. In 1942's issue of "The Dragon Menace," the men leave on a mission to help war-torn Europe, and Wonder Woman begs off, saying, "I have to remain behind but I'll be with you in spirit!" Writer Gardner Fox clearly had no intention of putting Wonder Woman into play: the most exciting thing that happens to her is that the minutes from the past Justice Society meetings are stolen. Luckily, she would begin to flex her muscles a bit more in the Justice League.

In the late 1950s, a story line that mirrored the McCarthyism of the time saw the Justice Society disbanded in response to the demand that they remove their masks or be reviled as Communists. The Justice League, conceived again by Gardner Fox, rose to take its place. Wonder Woman was among the first seven members, including Batman, Superman, Aquaman, Green Lantern, Martian Manhunter, and the Flash. One of their first missions was to defeat the alien invaders from Appelliax, taking a first approach of individual battles and then joining together as a super-powered group. After a trio of try-out issues of *The Brave and The Bold*, the Justice League got its own comic book title: *Justice League of America* in 1960.

There was a time when Diana lost her Amazon powers and lived as a regular human, not able to participate with the Justice League team. When she was back to full strength, she wanted to return to her position on the team and felt compelled to

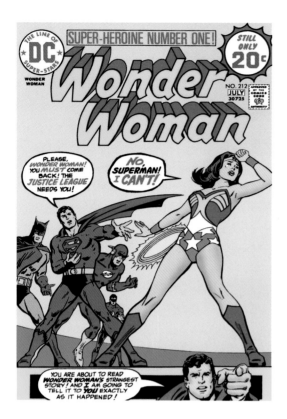

prove herself by performing twelve tasks. This story line ran from *Wonder Woman #212* in July 1974 to *Wonder Woman #222* in March 1976. Determined not to take her membership as part of the Justice League for granted, she says, "I will rejoin if I prove worthy! If—like Hercules—I succeed in twelve labors!" While the other members of the team don't feel the need to prove themselves in such a way, they have no problem giving Wonder Woman various tasks to test her mettle.

In the Justice League, Wonder Woman is certainly more active than she was in the Justice Society. It would take several more years, however, for the gang to fully recognize her strengths and accept her membership as an equal, no questions asked. Wonder Woman may be a fictional super hero, but she certainly isn't the first woman to be a trailblazing pioneer in a predominantly male organization. Over the years, Justice League team members have included other super heroes from the DC Universe, like Atom, Black Canary, Cyborg, Plastic Man, Hawkman, Hawkgirl, Green Arrow, Zatanna, and Captain Marvel, but through it all, Wonder Woman's been a mainstay.

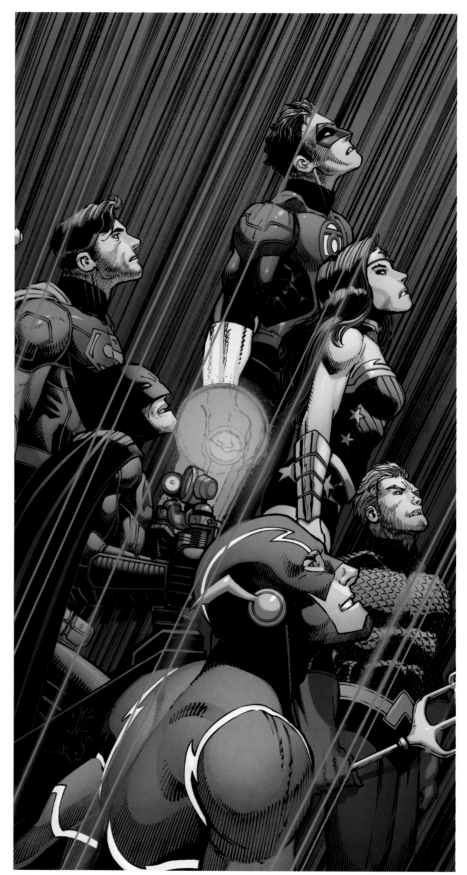

OPPOSITE (LEFT) | Cover art by Bob Oksner, *Wonder Woman Vol. 1 #212* (July 1974).

OPPOSITE (RIGHT) | Variant cover art by John Romita Jr., *Justice League of America Vol. 4 #10*, (January 2017).

ABOVE | Ezra Miller as The Flash, Ben Affleck as Batman, and Gal Gadot as Wonder Woman in *Justice League* (2017).

ATTACHED | Reproduction of a Hanna-Barbera *Super Friends* animation cel and background that combine to form a complete image.

From 1973 to 1986, the Justice League enjoyed great success as a spin-off. *Super Friends*, the cartoon series, introduced a new generation of fans to the exploits of Wonder Woman (and pals) every Saturday morning. Produced by Hanna-Barbera, the show was based on the DC Comics's *Justice League of America*, and was everything fans didn't know they wanted from this formidable collection of scrappy heroes and their tales of derring-do, including the new team member and caped crusader, Wonder Dog. When Wonder Dog—and his pals Wendy and Marvin— didn't pan out with audiences, the Wonder Twins, Zan and Jayna, were introduced with their blue pet space monkey, Gleek, who spoke an alien language only the twins could understand. Most memorably, Gleek helped out the twins whenever they needed to travel: Jayna became an eagle; Zan became water; and Gleek produced a bucket to hold Zan while Jayna carried them both. Wonder Woman, like the other super friends, took on a mentoring role in the lives of Wendy, Marvin, and the Wonder Twins, giving young viewers a different perspective on the comic book heroes they admired.

While *Super Friends* entertained countless cheering kids each Saturday morning, the *Justice League of America* was still chugging along, churning out comic book after comic book and shaking up the roster from time to time. Even prior to its most recent comic book relaunch in 2016, the team continued to entertain the public through television shows, video games, and more. The team finally earned its own live-action, big-budget film in 2017, with a cast of Hollywood superstars, including Ben Affleck as Batman, Gal Gadot as Wonder Woman, Amy Adams as Lois Lane, and the list goes on. Directed by Zack Snyder, the film goes a long way to cement the league's reputation as the universe's preeminent group of heroes. The best part? Wonder Woman's on the main stage. Those days of pushing paper and watching the boys have all the fun? Those days are dead and gone.

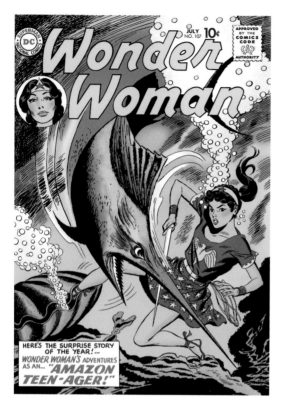

often exotic or mythical creatures, and Wonder Girl's priorities, more often than not, were romantic rather than combative with story lines that often centered on her ever-changing dalliances with Mer-Boy and Bird-Boy. Once Wonder Girl stepped out as her own fully realized character, she proved herself a pivotal member of the Wonder Woman mythos, and later evolved into a member and occasional leader of Teen Titans, an assembly of super heroes—Robin/Nightwing, Kid Flash, and Aqualad—akin to a junior Justice League. Starting with 1966's *Teen Titans #1*, this series was a successful spin-off in its own right, and illustrated the ever-expanding world of Wonder Woman.

If there's one person Wonder Woman can turn to in times of need, it's her li'l sis, Wonder Girl. The Wonder Woman/Wonder Girl partnership has played out in multiple variations—in comic books and on television—for decades. Wonder Girl made her first appearance as a stand-alone character in 1965's *The Brave and the Bold #60*, written by Bob Haney and artist Bruno Premiani. (Fun fact: this issue is also the first time Teen Titans use the name "Teen Titans," though it marks the group's second comic book appearance.) Prior to *The Brave and the Bold #60*, however, Wonder Girl was a stand-in for a younger version of Wonder Woman specifically created by DC Comics to court favor with its teenage readership.

In the early 1960s, Wonder Woman embarked on a series of so-called "impossible tales," in which she fought family-friendly battles as a younger version of herself named Wonder Girl. (Wonder Tot was an even younger doppelganger of the Amazon Princess.) The majority of these battles took place on Paradise Island and had fairy-tale-like qualities to them: Enemies were

LEFT | Cover art by Ross Andru, *Wonder Woman Vol. 1 #107* (July 1959).

RIGHT | Interior panel art by Bruno Premiani, *The Brave and the Bold #60* (April 1965).

DONNA TROY

Like her big sister, Wonder Girl has a myriad of origin stories, depending on the writer telling the story, and her plotlines have been woven in and out of Wonder Woman's various narrative arcs. In 1969, writers Marv Wolfman and artist Gil Kane created an origin story for Wonder Girl's alternate identity, Donna Troy, in the seminal publication *Teen Titans, Vol. 1 #22*. According to Wolfman and Kane's take on the character, Wonder Woman's raven-haired sibling

ABOVE | Interior panel artwork by Phil Jimenez, *Wonder Woman: Secret Origins #1* (May 2001).

RIGHT | Interior panel artwork by Nick Cardy, *Teen Titans Vol.1 #22* (August 1969).

was an orphan (her parents died in a fire; in another version, the orphanage itself catches flame) whom Wonder Woman saved. Along with help from her fellow Amazons, Wonder Woman raised her adopted sis on Paradise Island, proving it really does take a village. There, Wonder Girl was gifted superhuman powers and learned all she needed to know to make it through life as an honorary Amazon. Tied to both the *Wonder Woman* continuity and the *Teen Titans* continuity, Donna Troy has straddled two publishing worlds, and complications have naturally arisen.

During the Post-*Crisis* world of DC Comics, for example, Wonder Woman's character was relaunched, and the timeline of her existence altered. Because Donna Troy's existence was also tied to *Teen Titans*, the *Wonder Woman* version of her character couldn't be completely altered to fit the Post-*Crisis* plot and timeline. In 1989's *New Titans #55*, Donna changed her pseudonym from Wonder Girl to Troia and donned a new costume that, to match a new backstory that drew on Greek references, looked positively gladiatorial, came complete with a greave, a metal-like leg guard, and decorative embellishments around the waist and at the shoulders. In the early 1990s, Donna's career took an unexpected detour when she was recruited by The Darkstars, an interplanetary police force tasked with establishing order in the DC Universe. Donna's background was later rewritten by John Byrne, who incorporated a cosmic explanation to account for the different versions of Donna's character. This multiverse approach was further incorporated into the evolution of Donna's costume: Say goodbye to Wonder Girl's standard red bodysuit, decorated with old-school, comic-book-ready yellow stars. Beautifully rendered by artist Phil Jimenez, Donna Troy's new and sophisticated black catsuit glitters like the starlit universe.

DRUSILLA

Created by Mike Sekowsky, Drusilla made appearances in 1969's *Wonder Woman, Vol.1 #182–#184*. In the DC Comics story line, Drusilla was an Amazon messenger. In the 1970s *Wonder Woman* television show, however, Drusilla is yet another incarnation of

Wonder Girl. Fans of the show know Drusilla best as Debra Winger, the actress who played Diana's bright-eyed sister and sporty sidekick for three episodes. The setup was sitcom simple: Hippolyta, worried that saving the world might be too much for Diana, sends her second daughter, Drusilla, to convince Wonder Woman to return to Themyscira. The teenage Drusilla tries talking sense to her sister, gets kidnapped by

ABOVE | Cover art by Adam Hughes, *Wonder Woman Vol. 2 #186* (December 2002).

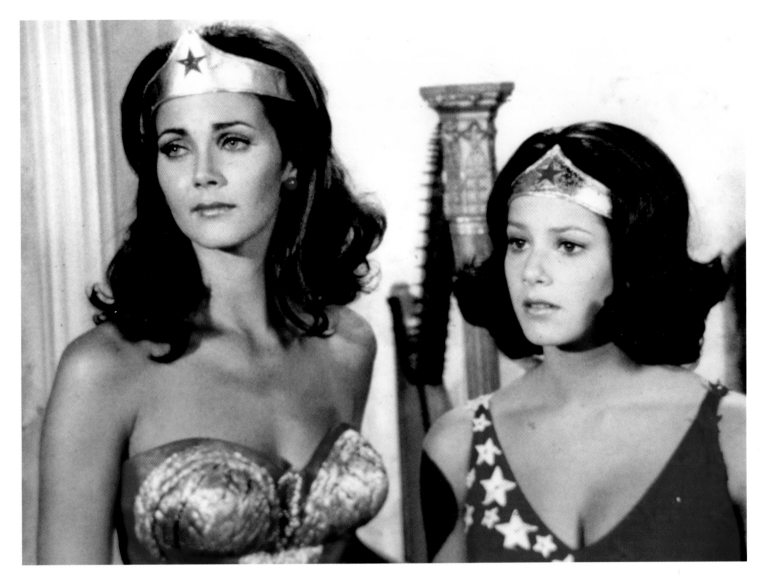

Nazis, and, after testing out her sister's signature spin, discovers that, beneath her bobby socks and pleated skirt, lies a super-powered beta version of Wonder Woman: Wonder Girl. Their look is nearly identical, albeit Wonder Girl's outfit (and starry outlook) is definitively more girlish. Three television episodes and Drusilla/Wonder Girl fades from the small-screen roster, although her legacy lives on today with die-hard fans assuming her guise at comic cons.

CASSANDRA "CASSIE" SANDSMARK

Donna Troy inspired another Wonder Girl in Cassandra "Cassie" Sandsmark. Created by John Byrne, Cassie first appeared in *Wonder Woman, Vol. 2, #105* in 1996.

Like the Wonder Girls who came before her, Cassie's story lines are dependent on the big-picture shifts within the DC Comics *Wonder Woman* narrative, specifically 2011's the *New 52* continuity.

Originally conceived as the daughter of archaeologist Dr. Helena Sandsmark and the Greek god Zeus, Cassie idolized Donna Troy, the second Wonder Girl; so much so, in fact, that she took to hiding her natural blond hair beneath a black wig to more closely resemble her mentor. Yearning to be Wonder Girl, Cassie first acquired her superhuman powers with the help of ancient, magical artifacts: the Gauntlet of Atlas, capable of magnifying strength ten times over, and the Sandals of Hermes that enhance speed and allow the wearer to fly. Not content with these

ABOVE | Debra Winger as Wonder Girl (right) and Lynda Carter (left) as her big sis in the *Wonder Woman* television series (1976). Winger later opted out of her own stand-along series as Wonder Girl.

accessories of power, Cassie later petitioned her father to bestow real superpowers upon her. He does, and Cassie steps out from Donna Troy's shadow to assume the mantle of Wonder Girl.

Donna gifted Cassie her first Wonder Girl costume —a red bodysuit—but in more recent years, Wonder Girl adopted the more typical wardrobe of an American teenage girl: skinny jeans and a form-fitting red top bearing the double "W" logo. And, like any active teenage girl, Cassie doesn't sit around at home waiting for a boy—or, more specifically, a *Superboy*—to call. She keeps herself busy as a card-carrying member of both Teen Titans and Young Justice. In issue #54 of *Teen Titans Go!* she's also head of her high school's Wonder Woman fan club.

In the *New 52*, DC Comics's 2011 relaunch, Wonder Girl is reintroduced to the *Wonder Woman* continuity in the pages of *Teen Titans,* where it's revealed that she's Wonder Woman's niece and Zeus's granddaughter. As the most recent incarnation of Wonder Girl, all eyes are on Cassie Sandsmark, and the character

has cropped up in everything from the DC animated movie *Justice League: Throne of Atlantis* to the video game *DC Universe Online*. She's even been rendered as a LEGO character, appearing in *LEGO Batman 3: Beyond Gotham*. Whether she's Donna Troy, Drusilla, Cassie Sandsmark, or even a younger version of Wonder Woman herself, Wonder Girl's very existence proves that the Amazon Princess is only as good as the girl she inspires.

LEFT | Cover art by Ed Benes, *Teen Titans Annual Vol. 3 #1* (April 2008).

ABOVE | Cover art by Sanford Green, *Wonder Girl Vol. 1 #6* (April 2008).

OPPOSITE | Wonder Woman with Hippolyta and Artemis, interior art by Nicola Scott, *Wonder Woman Vol. 3 #44* (July 2010).

PART THREE

AMBASSADOR

WISDOM & PEACEKEEPING

Wonder Woman isn't just a warrior princess, she's also an ambassador for peace—the death of an enemy is not a victory for her. Her nurturing humanity, her compassion, and her strong conscience are the mainstays of her character. Peacekeeping is always central to Wonder Woman's mission, and the ideological battles closest to her heart (and to those of her creators) include social and economic gains for all and the empowerment of girls and women around the world.

Wonder Woman has always served as a roving ambassador from Paradise Island to the world of man, even when it wasn't recognized as her official title. For the countless women and men who have felt the positive impact Wonder Woman has made on

their lives, Lynda Carter, Wonder Woman's real-life ambassador, explains the secret behind the inspiration, saying the character promotes "this idea that inside every woman is a secret self. It's much less about the color of your skin, much less about your height or weight or beauty but it's the attitude, the strength of character, the fight for rights, the beauty within, the wisdom within."

Wonder Woman's legacy took on a new dimension with the release of the *Wonder Woman* film in 2017. The movie's blockbuster success made a splash that could not be ignored. Big action movies could be focused on female characters and led by a female director. Fans around the world are celebrating the fact that they now have a big screen heroine to adore and emulate.

PREVIOUS SPREAD |
Interior panel artwork by
Phil Jimenez, *Wonder Woman
Vol. 2 #177* (February 2002).

OPPOSITE | Cover art by
Terry & Rachel Dodson,
Wonder Woman Vol. 3 #13
(December 2007).

From the playgrounds to the boardrooms, Wonder Woman has become even more of an inspiration. She continues to serve as an ambassador to generations of individuals, women and men, girls and boys, who understand that personal excellence, strength, and compassion are the traits of a true super hero.

BRAND AMBASSADOR

Wonder Woman has been an unofficial ambassador for her homeland since she first left that island of women to journey to the patriarchal society. She alone—most of the time—served as a representative of a people who did not always share the same set of beliefs as those in her adopted home of America. Her outfit may bear the stars and colors of the American flag, but she is almost as alien as Superman, living in a world that is very different from the one in which she was raised. That position was made formal in the Modern Age, when she fully embraced her role as emissary of Themyscira. Gone was her Diana Prince alias, replaced by the moniker of Wonder Woman,

or simply Diana to those who knew her best. As the most globally recognized member of her people, she embraced a new set of responsibilities and challenges.

Diana established an embassy in the United States, staffed largely by non-Themyscirans partial to Wonder Woman's causes. She became an outspoken advocate for her people, the oppressed in general, and women specifically. Themyscira opened its doors to visitors, though with a strict vetting policy. The decision to allow outsiders onto their shores was not entirely popular among Amazons. Modern Age Wonder Woman took the many progressive elements of Diana's character that had been present over the decades and

LEFT | Gal Gadot and Lynda Carter on the red carpet at the Hollywood premiere of *Wonder Woman* at the Pantages Theatre (May 25, 2017).

OPPOSITE | Interior panel artwork by Phil Jimenez, *Wonder Woman Vol. 2 #177* (February 2002).

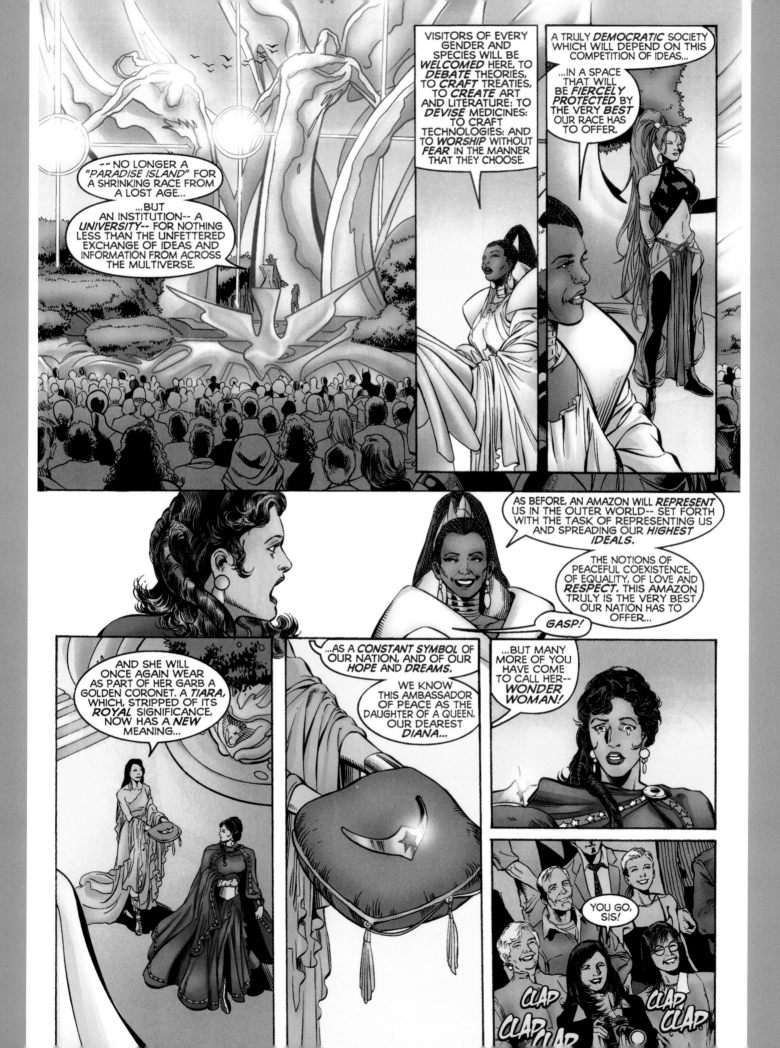

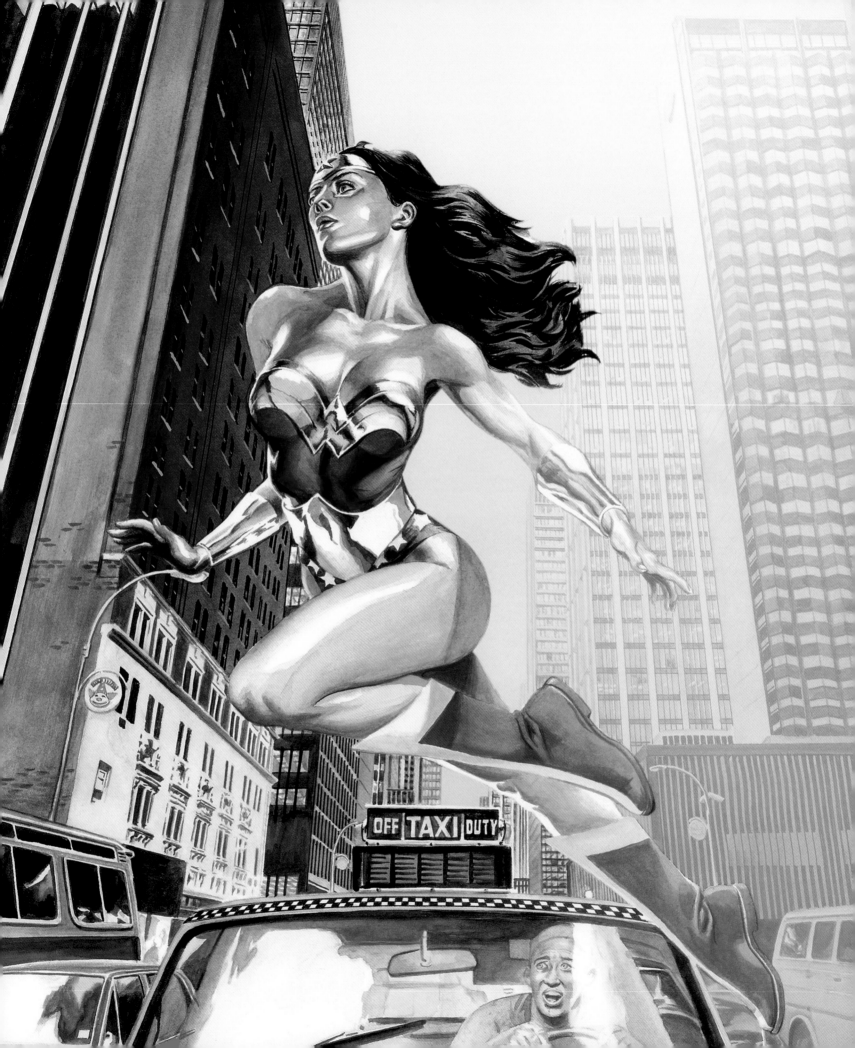

IF IT MEANS
INTERFERING IN
AN ENSCONCED,
OUTDATED SYSTEM,
TO HELP JUST ONE
WOMAN, MAN,
OR CHILD . . . I'M
WILLING TO ACCEPT
THE CONSEQUENCES.

—WONDER WOMAN, *WONDER
WOMAN VOL. 2 #170*

OPPOSITE | Cover art by J.
G. Jones for *Wonder Woman
Vol.2 #200* (March 2004).

ABOVE | Cover art by Alex
Ross, *Kingdom Come #2*
(August 1996).

embraced them fully. Peace was the cornerstone of this Amazon's belief system. She wasn't afraid to throw down when she had to, but her ultimate objective was uniting people around the globe. This was seen in grand gestures as well as simple statements, like her being vegetarian, only fitting for a woman who communicates with animals.

With this new role, the writers also fully embraced Wonder Woman's roots, bringing mythology to the forefront of her story. Mount Olympus became a prevalent location, and its gods were featured players. This allowed the modern creative teams to explore stories of politics and religion, viewing current events through a comic book lens. Like many noted leaders in the real world, Diana of Themyscira chose to spread her message by writing a book in the *Down to Earth* story arc that launched Greg Rucka's four-year run writing for the character. *Reflections: A Collection of Essays and Speeches* espoused Wonder Woman's beliefs as she had learned in the land of her birth. Unsurprisingly, the book became a huge bestseller within the fictional DC Universe, bringing her a new legion of fans and detractors, including Veronica Cale, who tried to use the ambassador's own words against her. The story line paralleled many stories of celebrities—especially female celebrities—who are built up only to be knocked down, and the censorship of people espousing what some might consider untraditional worldviews.

Wonder Woman's role as ambassador extends beyond the comic page as she, Superman, and Batman are considered the "Big Three" of DC Comics characters. There's a reason they were the headliners in Mark Waid and Alex Ross's groundbreaking 1996 *Kingdom Come* series, an entry into DC's Elseworlds imprint exploring story lines outside of the canon continuity. The events surrounding the first meetings of these three characters have been rewritten as many times as their origin stories, becoming the focus of Matt Wagner's *Batman/Superman/Wonder Woman: Trinity* trilogy in 2003 and the backbone of the film *Batman v Superman: Dawn of Justice*. Hard-core fans might be familiar with some of the more obscure heroes like Phantom Lady, Doll Man, and Matter-Eater Lad, but this particular trinity has mainstream recognition by people who have never picked up a comic book. Television and movies have helped expand their reach, but the global awareness of Wonder Woman transcends her heroic tales and extends her brand to everyday items like toys, clothes, and even cookie jars.

BE A CHRISTMAS MORNING HERO: MEMORABILIA

Wonder Woman memorabilia was scarcely produced before the 1960s, despite the fact that Wonder Woman had a dedicated audience and had been in print for as long as Batman and Superman, two characters who boasted a full range of collectors' items. If you wanted a piece of Wonder Woman merchandise in the 1940s, you had three options: a Valentine's Day card featuring an image of the super heroine holding the earth and text that read, "For you Valentine, I'd move

heaven and earth"; a small metal button; or postcards that doubled as promotional items for Sensation Comics. The sales of all three merchandising items went toward fighting polio.

In the 1960s, Batman made his television debut, and the production of super hero memorabilia exploded. Batman may have gotten most of the attention, but Superman and Wonder Woman got their share, too. One of the first pieces of Wonder

ABOVE AND LEFT |
In 2010 Moebius Models rereleased the Wonder Woman model kit previously sold by Aurora Plastics Corp in 1965. They even recreated the original packaging for the commemorative kit.

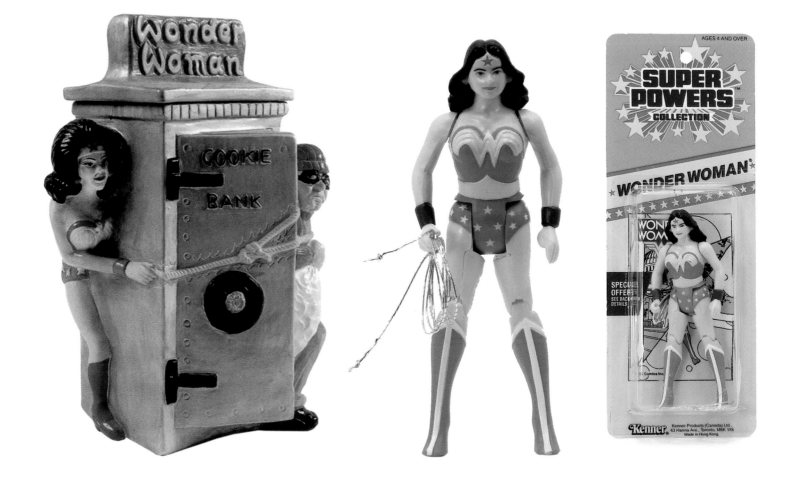

ABOVE | The Wonder Woman cookie jar produced by California Originals was sold in both its original form and an unpainted version.

ABOVE RIGHT | Kenner's Wonder Woman action figure from the *Super Powers Collection*.

Woman memorabilia to hit the stores was a kids' costume, released in 1961 by Dessart Bros. as part of their "Adventures Costume" line. Complete with a plastic mask and a flame-retardant outfit, it's fitting that the first notable item in the world of Wonder Woman memorabilia was a costume. From Wonder Woman's earliest stages as a commercial product, companies recognized the value in letting fans indulge their personal super hero fantasies. In 1965, fans could purchase a thirty-seven-piece plastic model kit of Wonder Woman improbably battling an octopus. While the toy sold for ninety-eight cents, a mint-condition kit can sell upward of eight hundred dollars today. Once Wonder Woman got her own television series, the toys and various merchandise rolled out in rapid succession. Some of the most popular items were 1977's Durham Industries' "Fun Putty"; 1978's

California Originals' fourteen-inch ceramic cookie jar, featuring Wonder Woman lassoing a thief in the doorway of the "cookie vault"; and Larami's light-up figural pen. Wonder Woman, due in large part to the success and popularity of Lynda Carter, had become a product in her own right—fans didn't have to be familiar with the original Marston comics to dress up like the heroine for Halloween.

The success of *Super Friends* ushered in a new wave of Wonder Woman–related merchandise, including the incredibly detailed four-inch Kenner action figure, which featured "Power Action Deflector Bracelets": When the figure's legs were squeezed together, Wonder Woman raised her arms and crossed her bracelets. A far cry from the dry spell of the 1940s, in the 1980s, fans had their pick of products—from action figurines and lunch boxes to View-Master reels and kites to

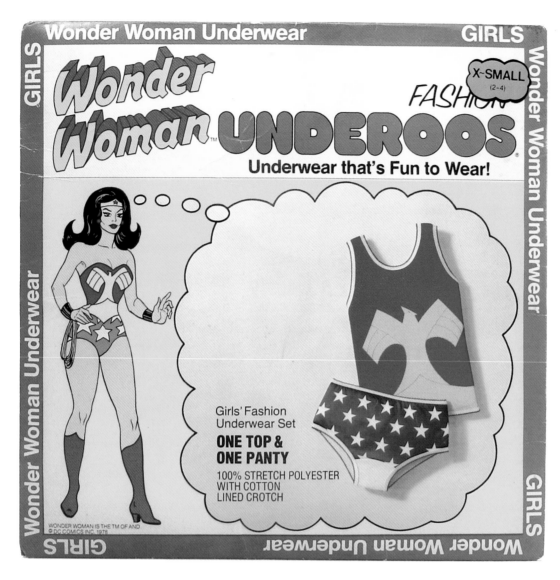

WONDER WOMAN IS THE TM OF AND
© DC COMICS INC. 1978

T-shirts and jewelry, even underwear. With the slogan "Underwear that's fun to wear," Underoos encouraged parents to be "a Christmas morning hero" and give the gift that's fun to give. A commercial at the time featured a young girl decked out in her Wonder Woman garb, confessing that her favorite heroes were her mommy and Wonder Woman—not necessarily in that order.

The 1990s saw a more high-end-collectable focus on memorabilia. Two standout limited-edition pieces are Joe DeVito's nine-inch, hand-painted porcelain sculpture of our favorite heroine bursting through swirling clouds, and Ron Lee's six-inch statue of Wonder Woman poised on an onyx base, golden lasso firmly by her side. By the new millennium, DC Direct built on the limited-edition craze and commissioned several pieces by fan-favorite artist Tim Bruckner, including a statue based on the cover of *Wonder Woman #72*, a minibust, a model of Wonder Woman fighting a three-headed serpent, and a series of six upscale sculptures released in 2010. The first of this series is simply stunning: Wonder Woman soaring from an orange-and-yellow-tinted plume of cloud, fiercely beautiful, defiant, and strong.

The 2017 *Wonder Woman* film delivers a bold, new look for our favorite super heroine. The film's accompanying product line is all-encompassing and gives fans, long-term and newbies alike, a range of merchandising options, with children's toys up to high-end collectibles. From her debut as America's

LEFT | Red and blue underwear, featuring Wonder Woman's eagle-inspired emblem on top (1980).

favorite and feistiest Valentine's Day sweetheart to the long sweep of promotional products in between, Wonder Woman has firmly secured her place as one of pop culture's most enduring personalities.

NOT YOUR MOTHER'S ACTION FIGURE

The term "action figure" entered the lexicon in 1964 when Hasbro released the first G.I. Joes, four plastic men representing each of the branches of American armed forces. These rugged soldiers bore a slight resemblance to Barbie's boyfriend, Ken, from the hugely successful line of Mattel dolls, but it had to be made clear that they were an entirely different kind of toy. The reason for this new terminology? Boys would *never* play with dolls. This deeply entrenched line of thought has segregated the toy aisles for decades. It has impacted everyone from corporate sales and marketing teams to Christmas shoppers looking to make their children's eyes light up with joy once they've torn the wrapping off their gifts. Representation of female action figures has had a spotty history, with two mainstays being Princess Leia and Wonder Woman. These strong female characters may not have always

TOP LEFT | Tim Bruckner's Wonder Woman statues created for DC Direct/DC Collectibles.

RIGHT | 1:18 scale resin model kit of Wonder Woman as she appeared in *Batman v Superman: Dawn of Justice*, produced by Moebius Models.

been the featured hero in a particular toy line, but they have been ever-present on store shelves once the toy industry caught on that kids would do anything to have their favorite characters in some form or other.

Wonder Woman played a key role in one of the earliest attempts at bringing girls into the super hero market with a line of figures from the Ideal Toy Company in a product launch clearly meant to serve the Barbie audience. They even made it clear in their marketing that girls could swap out Wonder Woman's uniform with any outfit from Barbie's closet or Ideal's own popular Misty doll. Not considered an action figure, this "Posin' Doll" was part of a line that included Batgirl, Supergirl, and Mera. Technically, the line was named Comic Heroines, but collectors today

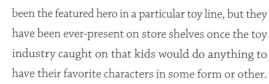

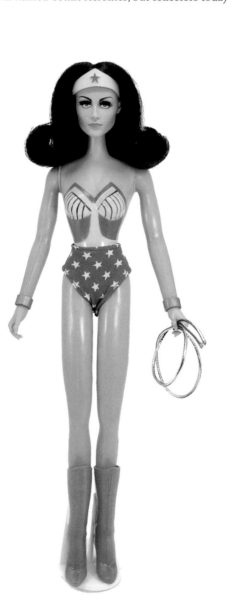

LEFT | As part of the *DC Stars Collection* by doll manufacturer Tonner, this Golden Age Wonder Woman doll was created for the adult collector and part of a limited edition run of 100 figures as an exclusive for San Diego Comic Con in 2014.

THIS PAGE AND OPPOSITE | Figures from the 1970's Mego toy line including several options of Wonder Woman/Diana Prince, Steve Trevor, Hippolyta, and Wonder Woman's half-sister Nubia, a rarely seen comic book character.

ATTACHED | Original paper doll created using Wonder Woman artwork from the official DC Comics style guide for the character.

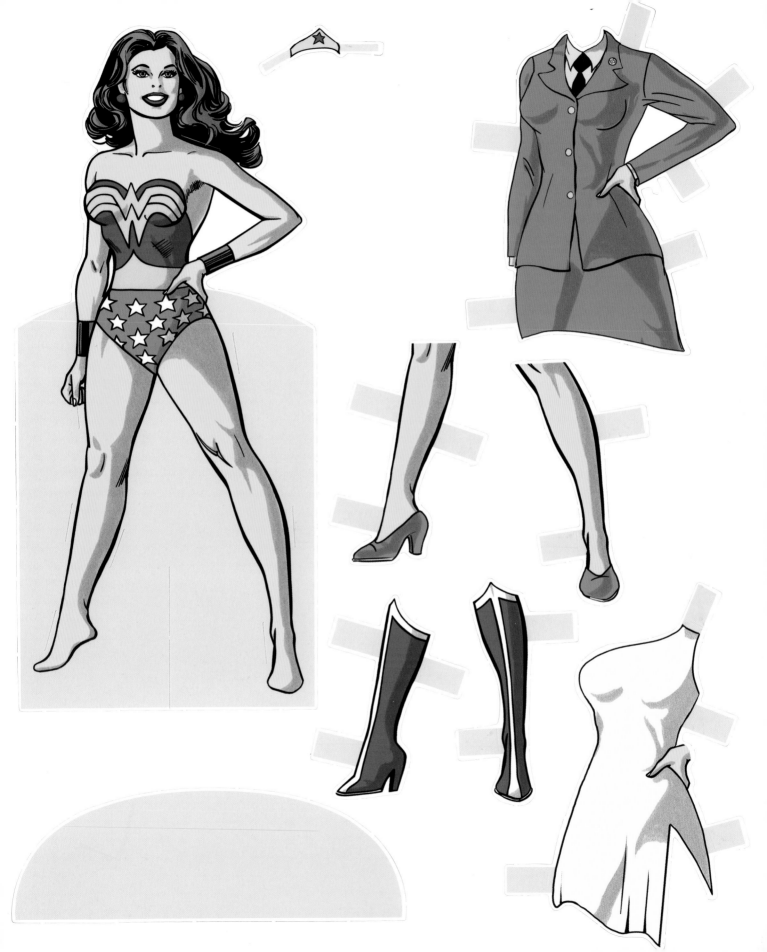

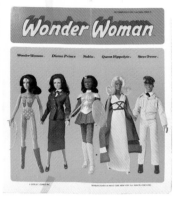

call them "Super Queens," a term that came from the marketing campaign. The line was not a success, which has made the dolls highly valued collectibles years later. This is especially true of the Mera doll, one of the few products ever to be created for the character. Although Aquaman's primary love interest has rarely been seen on toy store shelves since, Wonder Woman has continued to have a place in plastic, mixed in among Superman, Batman, Aquaman, Green Lantern, Flash, and the other DC heroes and occasionally heroines.

The Mego toy company made another notable entry in the Wonder Woman doll line in the 1970s with two styles of product. In 1974, the Mego *Official World's Greatest Super-Heroes* line featured a Bronze Age Wonder Woman as an eight-inch figure. The doll had an impressive fifteen points of articulation and a one-piece fabric outfit that was part costume and, oddly, part flesh. Two years later, they expanded

their line with twelve-inch figures that were initially promoted as bearing Lynda Carter's likeness and tied to the *Wonder Woman* television series. Several characters were featured in this line, including Steve Trevor, Hyppolyta, and Nubia, who was incorrectly promoted as Wonder Woman's super-foe. The line also featured a Paradise Island playset with exciting features like Wonder Woman's throne with a secret compartment where kids could hide her brush and comb. Today, the Mego Wonder Woman dolls are highly sought collectibles. It was one of the rare times in toy history that Wonder Woman and other female characters were the featured toys in a line, and not "also included."

That all changed in 2015 when a new effort by DC Comics, partnering with Mattel, launched a line specifically aimed at the underserved girls' action figure market. *DC Super Hero Girls* is more than a simple toy line, it's a full-on initiative. Now that more and more

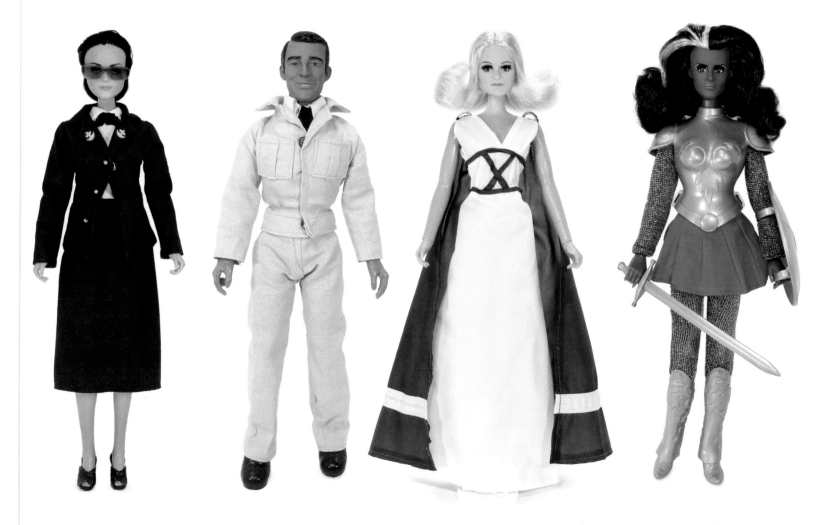

of the women who grew up playing with action figures are creating comic books and films, these industries are recognizing that this audience has always been there, *and* that Wonder Woman continues to be at its core. Thanks in large part to public outcry, the toy industry is addressing gender play stereotypes, with the Super Hero Girls making a significant step toward full integration in the toy aisles.

Centered around an animated webseries with Grey Griffin providing the voice of a teenage Wonder Woman and Mae Whitman voicing Batgirl, this new universe of *DC Super Hero Girls* is set at Super Hero High. Almost all the familiar heroes attend the school (though Superman and Batman are notably absent), but the focus in the series and the line is squarely on

the girls, and the products reflect that. Accompanied by twelve-inch action dolls and six-inch action figures, Mattel is keeping the *action* up front, not bothering to soften the language as was done in the past. Joining Wonder Woman and Batgirl are Supergirl, Bumblebee, Katana, Poison Ivy, and Harley Quinn, who all now have their own graphic novel adventures as well, even participating in the annual Free Comic Book Day initiative to encourage new audiences to find comic books. But this line expands beyond the comic page into a number of other book formats, as well as an entire licensing program with clothing, LEGO character playsets, and even a phone app, using technology the original Wonder Woman audience would never have dreamed of back in the day.

LEFT | Mattel's Wonder Woman action figure based on the DC Super Hero Girls version of the character.

ABOVE | Life-sized Wonder Woman statue made of LEGO on display at the annual Comic Con in San Diego, Californian (July 2016).

OPPOSITE | Wonder Woman and Steve Trevor statue with a design based on the characters in the 2017 *Wonder Woman* film, produced by DC Collectibles.

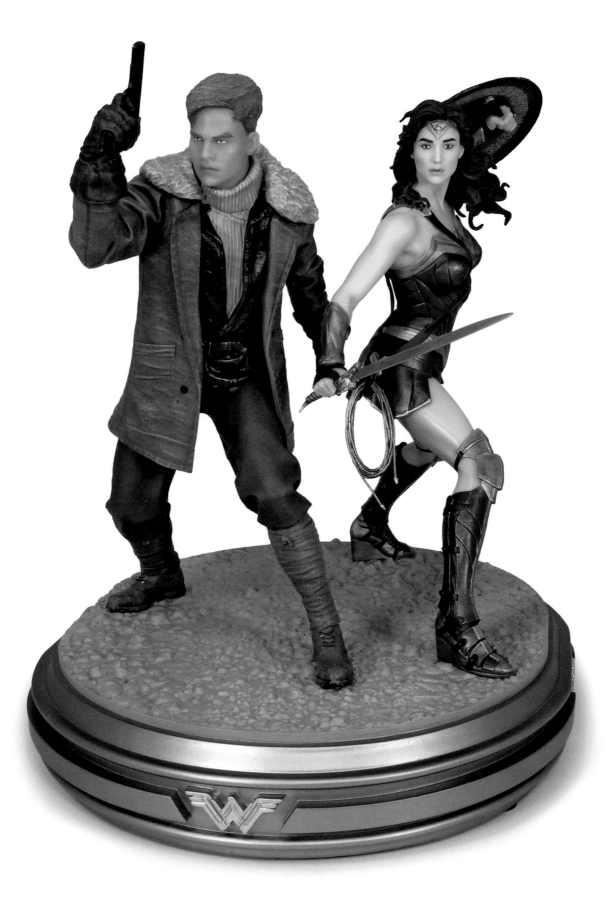

SUSAN EISENBERG'S WONDER WOMAN

OPPOSITE | Production artwork from *Justice League Unlimited*.

RIGHT | Susan Eisenberg during Wonderful World of Animation at San Diego Comic-Con 2004.

For many DC fans, Wonder Woman isn't Lynda Carter or Gal Gadot. It's Susan Eisenberg, voiceover actress extraordinaire. Playing the Amazon Princess for the past seventeen years in bestselling video games, direct-to-video animated movies, and several hit animated television series means that Eisenberg has a uniquely up-close and personal understanding of the super heroine. She started voicing Wonder Woman in the much-beloved 2001 animated series *Justice League*, which was quickly followed by *Justice League Unlimited* (2004–2006). While *Justice League Unlimited* expanded its roster of heroes and villains, the seven original founding members—Wonder Woman, Batman, Superman, Green Lantern, Hawkgirl, The Flash, and Martian Manhunter—remained at its core.

Though Eisenberg was familiar with the 1970s' *Wonder Woman* television show, she wasn't consumed, she says, with portraying her an as icon nor with taking her cues from Lynda Carter. "I was trying to play her as this woman that was presented to me," she says. She elaborates, saying:

> I was brought in by Bruce Timm who created the show [Justice League] and created my version of Wonder Woman, and Andrea Romano

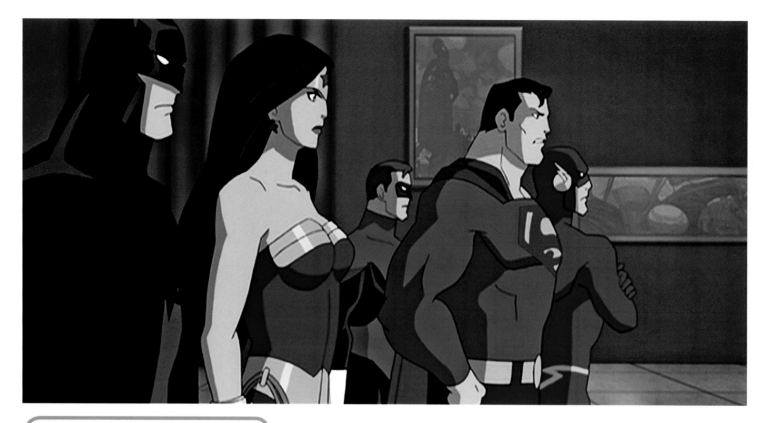

who was the voice director for the series. So I was trying to capture what they were presenting to me, which was, at the very beginning of the show, a woman—a girl/woman, who was leaving Themyscira, leaving this island to go help in a man's world. So playing that vulnerability, playing that passage in time in your life, that's what I was trying to play. The heroics weren't that gigantic in the beginning.

During the course of her career as Diana's voice, however, Eisenberg saw the character grow and change to the point where heroics did become much more of a driving force in the series. Eisenberg's vocal range had to shift with the character changes. "She grew up over the course of five years, in my mind"—five years being the length of *Justice League.* "Not like we had birthday parties for her, but I loved her aging. . . . She's matured." Eisenberg alters her portrayal of Wonder Woman for each project she undertakes. For *Justice League: Doom,* for example, Wonder Woman acts as a mentor for Supergirl, which required a different vocal component. Eisenberg explains: "She's wiser. She's more mature sounding. She's got that wisdom that you get with age." Technology grew up, too. Now, when Eisenberg voices Wonder Woman for the video game world, she's outfitted with a motion-capturing camera that records her facial expressions as she's voicing the character. Eisenberg's facial expressions are then digitized, so much so that she sees certain quirks of her own reflected in Wonder Woman's face, proving that Eisenberg is more than a vocal embodiment. Lynda Carter may have ruled the small screen, and Gal Gadot owns the big screen. Eisenberg's digital and animated territory, however, is vast and takes her as far as her voice can go.

ABOVE | Animation still from *Justice League: Doom.*

ANIMATION AND VIDEO GAMES

After the end of *Justice League Unlimited* (2006), Eisenberg cracked the golden lasso in the animated films *Superman/Batman: Apocalypse* and *Justice League: Doom*. She then jumped from film to the world of video games and voiced Princess Diana in *DC Universe Online* and *Injustice: Gods Among Us*. The beauty and benefit of the gaming world is that it's uncharted, fresh terrain for Wonder Woman. She's free, to a degree, from the traditional expectations that have followed her around for seventy-five years' worth of comic book history. Still, this doesn't mean there isn't crossover, especially between animated television and gaming. Eisenberg allows this herself. "The Wonder Woman closest to *Justice League*," she says, "is the one from *DCU Online*. . . . S. J. Mueller writes her so beautifully—strong and fierce, human." Eisenberg also acknowledges how some of the more recent comic book story lines have influenced her thinking about the character, saying:

> I wasn't voicing Diana through my own inter-pretation but rather through the lens of the tele-vision, video game, and film creators I worked for. But when I heard what Greg Rucka said about her sexuality in DC Rebirth, it made all the sense in the world to me. Having said that, so did her having a flirtation with Batman in Justice League. Love is love is love.

Since making her video game debut in 1995's *Justice League Task Force*, Wonder Woman has been a playable character across a wide range of DC video games—from *Justice League Heroes* and *Mortal Kombat vs. DC Universe* to *Injustice: Gods Among Us* and *LEGO Batman 3: Beyond Gotham*, not to mention *DC Universe Online*, *LEGO Batman 2*, *Scribblenauts Unmasked*, *Infinite Crisis*, *DC Legends* and *Injustice 2*.

Wonder Woman may have begun her journey in the pages of Marston's comic books, but she's evolved. Today, she's an online gaming presence, a movie star, and all-around icon of feminine empowerment. Her enduring popularity is dependent on her fans' voices as much as on Eisenberg's voice itself. "What's incredibly gratifying today is how far comic books and cartoons have moved into the mainstream," Eisenberg says. "As so from a niche industry that still struggles in some places, a louder voice has emerged, and it belongs to the fans, and the illus-trators, and the artists, and the techies, and the composers, and the cosplayers, and the geeks. And the louder it gets, the more it'll be heard."

ABOVE | Actress Susan Eisenberg attends the screening of *Justice League: Doom* at the Paley Center for Media in Beverly Hills, California (2012).

A CONVERSATION WITH
JILL THOMPSON

Jill Thompson became the artist for DC Comics's *Wonder Woman* series in 1990, working with writer George Pérez. She is perhaps best known, however, as author and illustrator of the graphic 2016 novel *Wonder Woman: The True Amazon*. In Thompson's version of Wonder Woman, Paradise Island is a fully realized, magical place, complete with mythological creatures, mysterious caverns, and outfitted with everything a girl (or an Amazonian fleet of them) needs to get by. Long fascinated with fairy tales, Thompson wove fable-like qualities of Greek mythology into her narrative, and focused on Princess Diana's life as a typical teenager: She's spoiled, bratty, and arrogant, and not used to anyone saying no to her.

In Thompson's world, Princess Diana has to work to become a true Amazon—and that hard work and effort informs her adult life. In her winner-take-all bid to prove that she's the best Amazon, Princess Diana gets reckless and cheats in a series of athletic events, and is effectively banned from Paradise Island for the damage she stokes. Her tiara and, in fact, her very costume, are given to her as punishment, and she spends her adult life righting wrongs—on a global scale. Steve Trevor doesn't make an appearance in Thompson's book, nor does Wonder Woman heed the call to fight injustice on behalf of mankind. She ends up, of course, doing just that, but only because she grows up, strengthens her weaknesses, and realizes she's not just a princess, she's also a woman warrior. Thompson puts Wonder Woman—and her flaws—on full display, and gives readers an authentic, fully realized fairy tale . . . and a princess who fights back.

★

Wonder Woman: Ambassador of Truth | **What was your collaboration like with George Pérez?**

Jill Thompson | I was simply a penciller. I never really spoke with George about stuff. He was working on two giant projects at the same time he was writing *Wonder Woman* . . . so I really didn't speak to him while I was working on it. I got scripts from him and then he ended up not working on it anymore, and I was then working with William Messner-Loebs for, I think, the end of my run on the book. So it was more of a case of, I was working on scripts written by one of my favorite artists and I was working on a character whose reinvention I really loved. Wonder Woman is a character who is hard not to love. She's super amazing and strong, and I liked his more mythological connection that he had brought to the character and a naiveté when she came to the world. She questioned a lot of things about the way we approached life, which I liked.

WW:AoT | **Was it happenstance that she came back into your orbit again with your graphic novel in 2016, or was it intent?**

JT | It was a little bit of both. As a female creator in the comic book industry and having worked on Wonder Woman, the sort of statement-question that was always being projected towards me was, "Oh my gosh, when you got to draw Wonder Woman, it must have been like a dream come true, because you're a girl." Unfortunately, my answer was, "I wasn't really a fan of Wonder Woman when I was starting reading comics."

It wasn't until later on that I established myself as a storyteller that I thought why wasn't I drawn to Wonder Woman as a character when I was younger? The thing that I always would come back to is, every time I would find a Wonder Woman comic, she always seemed perfect. If you start her with no flaws whatsoever, it's not interesting to me. Even when I was working with George, his was based so much in Greek mythology. The one thing that I thought is all Greek—and I love Greek mythology and I love fairy tales—there's always a flaw in the character. It can be a terrible, "Oh my gosh, I'm accidentally sleeping with my dad in my terrible Greek tragedy." Or something like Achilles's heel. Like, "We made this character perfect, except for that one spot we were holding on to when we dipped him into the magic,

perfect potion." And that's his Kryptonite. That's his problem. And I found that Wonder Woman didn't have that. She was all these great things that you wanted to be, but I felt no identification with her. So personally, when I wanted to write something, I was like, what would make her interesting for me?

WW:AoT | What was the hook that helped you connect with her character? Your story is a new take on her creation and younger years on Themyscira.

JT | I love ancient history. I was always a big fan of world history in school. I thought about that the Amazons live in this really amazing, awesome society. It's kind of a paradise with all these women there and there's no guys. But what happens if you throw a baby into the mix? I was inspired by the fact that you would have an island of doting aunties and grandmas. That made me think of all the fairy tales, and *The Prince and the Pauper*, where there's always a person that grows up in a royal situation, or a perfect world, so they have to go live amongst the regular people to learn something. I thought maybe she wasn't Wonder Woman to start out with. Maybe she had to learn how to be Wonder Woman. Maybe there are better examples of what Wonder Woman would be. So I said that she would not grow up to be the perfect princess, she would grow up to be like that guy who has to be taken down a couple pegs, and that's the way I approached my story.

WW: AoT | In your story, she's quite flawed growing up. She has to earn her moral compass. How did you approach that part of her character?

JT | Everyone on the Internet has their own version of Wonder Woman that they like, and there are a lot of purists that want her to be completely peaceful. Sometimes there are situations that call for sterner action. Nobody wants to go to war, but I think everyone would agree that World War II was a noble war. When you think about sacrifice and people that were willing to just drop everything and go try and defend an ideal, which is the thing that we should be defending right now. I feel like the character of Wonder Woman, in general, embodies that, and I wanted to give her a way to go off and fight for it. Not because she was trying to convince everybody it was right, but because she knows what it's like when you're wrong.

I feel like Wonder Woman, or at least my Wonder

Woman, is a lot more Batman than she is Superman. People always separate Batman and Superman as opposite sides of the same coin, but I feel like she embodies a bit of them both, if you have to try and quantify her by two male characters. As part of the trinity, I feel like she technically could be stronger than either of them. One thing that the DC characters, especially the three major characters of the company, have going for them is that you can do a lot of different takes on them based on their general recipes. The characters work really well and you can do variations on them. That's what makes them actually classically mythological. The premise of Batman, you can set in the Middle Ages, or whenever, and it works. I think that it can work for Superman. It's a matter of answering the question of what happens to them. What if Batman was here? What if Wonder Woman was there? You can hang questions that change how they become who they are, or where they do what they do and not impact the actual core of their character.

WW:AoT | No character is gender based in terms of writing. Obviously, Wonder Woman was created by a man. She's had some really wonderful arcs written by men, but a woman can sometimes find a way into a female character just because of experience. What do you think you brought to the character as a woman writing her story?

PREVIOUS PAGE | Cover art by Jill Thompson, *The True Amazon* Graphic Novel (July 2005).

ABOVE AND OPPOSITE | Interior panel artwork by Jill Thompson, *The True Amazon* Graphic Novel (July 2005).

JT | I always bring a lot of myself in everything that I do, whether it's intentionally or unintentionally. Mostly it's a lot of unintentionally because I find that I'm just trying to tell a good story. I know that because I tend to be incredibly emotionally connected to most everything, I want to create characters that really feel. I feel like my job as a storyteller is to create a moment that will really resonate with the readers. Whether it makes you cry, or it makes you happy, or you feel disbelief or a good connection with somebody, I think there may be a little bit of all of those things in my Wonder Woman story.

A lot of people tell me, "We were reading this and we were surprised that she makes mistakes. Wonder Woman doesn't make mistakes." And I say, "Well, my Wonder Woman did." And she still will in the future. She made some big mistakes because she was arrogant and selfish. I don't think that's because I'm a woman that I try to make those things happen, but sometimes, I think when you care a lot more about fictional characters than maybe someone else does when they read something. Like, I cry at every Pixar movie. Every single one of them. *WALL-E*, I cried at *WALL-E*, and everyone was like, "Chill, it's just robots." And I'm like, "But the Earth

is destroyed and people can't do anything and I really care about those robots; I don't want anything to happen with them!" So I try and build up from emotion. I love the comic book medium, just like any other medium. I mean I've cried watching films, and I've felt shock and amazement while reading a book, or had characters who are nothing like me affect me because of the situations they're in. I guess that's what of myself I'm trying to bring to it, is because not everything I do is how I would react to a certain thing, because that would be boring comics, or boring stories.

If Wonder Woman comes up against something she's never seen before, she would approach it from a sense of wonder of being a person who doesn't live here or hasn't experienced the culture the way we do. It wouldn't come from a place of, "How does a woman respond to that?" To me, it's kind of wrapped up in her whole character because she's more of an assertive person in my estimation. If she was upset, she wouldn't go sit on her couch and eat a pint of ice cream because she's crying. She would be eating a pint of ice cream because she'd say, "This is an amazing new invention that I like! I want some ice cream!"

A CONVERSATION WITH
GREG POTTER

Known for the Jemm, Son of Saturn series, comic book writer Greg Potter was tasked, in 1987, with the first relaunch of the *Wonder Woman* comic book. The seven-issue volume of "Gods and Mortals" didn't disappoint. (Potter worked on the foundational first two issues of this run; writer Len Wein completed the volume.) He and artist George Pérez breathed new life into the *Wonder Woman* series by grounding the character in Greek mythology—a trend that continued with later writers, too. Potter was especially interested in showing how Wonder Woman, an Amazonian warrior, navigated the modern world of man away from the creature comforts of home. By seeing the world—and its many issues— through Wonder Woman's eyes, audiences gain a new perspective on the frailty of mankind and the importance of moral honesty.

★

Wonder Woman: Ambassador of Truth | When did you first become aware of Wonder Woman?

Greg Potter | I began collecting comics as a kid in 1963. I bought my first comic book and I was instantly in love with comic books. I still have the first comic book that I bought. It's in terrible shape because I riffled through it and reread it so many times. It was an issue of The Flash, and it would be worth a lot of money now if I hadn't done that. But I instantly fell in love with comic books and started collecting them every week. I eventually got thousands and thousands of them, so I became a real fan. I'm still a fan today, and I'm delighted with what they're doing with the characters and the movies and everything. But DC comics was my favorite company. I loved The Flash, Superman, Batman, Wonder Woman, the Justice League, that whole group of characters. And so naturally I'd go down to the drugstore every Tuesday and get a batch of comics, and when Wonder Woman came out, she was one of the ones that I bought because she was in the DC line and she was a member of the Justice League, and also she was a key figure in the history of comics: the first female super hero. She was legendary.

WW:AoT | How did you go from writing horror comics for Warren Publishing to being involved in the relaunch of Wonder Woman in the eighties?

GP | On the strength of having a portfolio of Warren stories, I went to see Paul Levitz, who was the editor at that time—he became president of DC later—but he was the editor of their mystery books: *House of Mystery*, *House of Secrets*, *Secrets of Haunted House*, that kind of stuff. He looked at my stuff and he liked it, so I started sending him my ideas, and I started writing for DC. Eventually it led to me writing a super hero for a series called *Jemm, Son of Saturn*, which I created.

I was just coming off of finishing that series—it was designed as a twelve-issue story—and I was at a comic book convention, talking with Dick Giordano, who was at the time the editor in chief at DC. He had worked with me on the *Jemm* series and he liked it. So he said, "We're doing our Big Three: Superman, Batman, Wonder Woman for the eighties. We want to start them all over again. And we've already got people lined up for Superman and Batman, but not for Wonder Woman. Would you care to send in a proposal?" And I immediately said yes, just based on the fact that here is one of the top characters in comics. I immediately went back to that issue of Wonder Woman that I had bought years ago as a kid on her origin story and said I'd like to redo that.

WW:AoT | Was that pitch very involved with the genesis of what interested you with the origin story again, of going back to that Greek mythology?

GP | That's really what the key to it was for me. I thought, "That's the core of her being, really, is that she should be steeped in Greek mythology." The Amazons have purposely walled themselves off from the world of men because they've been lied to, cheated, and enslaved by men, and they're going to make it on their own. But

LASSO OF TRUTH

**ABOVE** | Cover art by Gene Colan, *Jemm, Son of Saturn #1* (September 1984).

George wants to do some of the plotting as well." So I said, "Fine." George was a superstar in the industry at the time. So that was thrilling to have him work on it.

He was even more knowledgeable in Greek mythology than I was. George taught me a lot about the Greek gods and who was whose brother and sister and who was sleeping with whom. I think he liked the fact that I had grounded this in mythology. I think he liked the fact that I also planned to ground her in more realism. Originally we put her in Boston. I wanted a real city. It wasn't Metropolis. It wasn't Gotham City. It was Boston. I'd done Boston because I'd lived there for seven years, and I loved the city. He liked that as well. In fact, he had me go and take pictures of Boston, and you could see the background in this artwork. It's accurate because he followed the pictures. So that was kind of the genesis of it. George and I were in sync with what we really wanted to do with the character, I think.

WW:AoT | Once you had provided the outline and you and George were put together, what was the collaboration process like?

GP | One of my first core concepts when I first wrote it—and it was in the first Wonder Woman book that I wrote—it starts off with a caveman, and he's had his hand cut off and he goes back to his cave and he murders his mate, and her spirit is what becomes Wonder Woman later. I really wanted to ground her in the brutality of man's civilization that way. And George liked that. That got him. I think George wanted to expand the mythology even more than I did.

George brought in a lot of characters that I hadn't thought of. He brought back—it was funny—when I said I wanted to get rid of some of the sillier aspects of Wonder Woman—he wanted to bring back the character Etta Candy. My initial thought was anybody whose name is Et A Candy shouldn't be in a realistic book. But he did a brilliant job. He had her in the military, and she was Steve Trevor's aide, and he did it so that she gave a lightness to the story that wasn't there before.

WW:AoT | How did you find the fan reaction to your work?

GP | I was on the book for a short while, and I had done my writing by the time the fan reactions started coming in. The fan reaction was tremendous. People loved it, and the sales on the book just blossomed. I

over the years I've felt *Wonder Woman*, the series, had gotten clogged up with a lot of elements that were silly and didn't make sense. That's what happens to super hero characters over the course of the years.

It didn't have an artist at the time, so I worked back and forth on the proposal part of the book for about a year doing rough scripts. Then Janice Wraith, who was the editor, called me up all excited and said, "George Pérez has just said he'll do the artwork! But

think it was because of that quest to ground her in mythology and get rid of some of the silliness. Also, both George and I didn't want her to have her secret identity anymore of Diana Prince. Shedding that because she's supposed to be a strong, independent woman—she's an Amazon—why should she hide? Why should she be anybody but herself?

We also had Steve Trevor come in as he had done in the original Wonder Woman, and crash on her island, but he was an older guy. He wasn't a love interest. That had really stuck in my craw years ago in the old Wonder Woman books, when here is this Amazon woman, very powerful, and she was doey-eyed for this blond-haired pilot. It was a weird relationship because there were scenes of him picking her up and calling her angel and acting like a typical male towards a weak woman, and yet here she could beat him to a pulp. So that was part of it, too. It wasn't just mythology part, it was that I wanted her to have an inner sense of, "I am who I am. I am proud of it. And I don't need anybody else." I don't say that to make her cold. The other thing about Wonder Woman is she teaches peace and love and that's her thing. But she doesn't really need any man. And that's what the Amazons are all about. They don't need them. They'd like to work with them, but they don't need them.

WW:AoT | As a writer and someone who helped craft a very important turning point for the character in the comics, can you look back now and identify her greatest strength and her greatest weakness?

GP | I think her greatest strength is her independence. That sense that she's a whole person. She doesn't need anybody to save her, and she doesn't pretend to be anybody else. She's just who she is. When you say her greatest strength, that's her greatest appeal to me as a character. I think her greatest weakness that she had to overcome is that she was suddenly dropped in a world that she'd never experienced before, and she was naïve about it. In our series, she wanted to be an ambassador of peace, and yet she didn't realize the realities of the world. So that's something she had to deal with. I think that's her greatest weakness.

I think the Wonder Woman that we crafted was a truly good, admirable person. And still interesting. There's a lot of characters now in comics that are very dark, and some of them are very good. I'm not saying that's a bad thing. But I'm proud of the fact that we brought her back and we didn't rely on making her darker or making her morally compromised. She was still that beacon of morality that she was intended to be.

ABOVE | Interior artwork by George Pérez, *Wonder Woman Vol. 2 #1* (February 1987).

A CONVERSATION WITH
BRIAN AZZARELLO

Comic book fans have long been acquainted with veteran DC Comics writer Brian Azzarello. Known for his work on *Batman*, *Superman*, and *Hellblazer* among other series, Azzarello became the head writer for *Wonder Woman* in 2011 as part of the *New 52* relaunch, reteaming with artist Cliff Chiang. Azzarello's three-year run on *Wonder Woman* redefined the Amazon Princess, and was a critical hit for DC Comics.

Azzarello returned Diana to her origins and updated the Greek mythology for the modern age. Unlike Marston's version, Azzarello's *Wonder Woman* isn't birthed from clay. Instead, she's the daughter of Zeus and Queen Hippolyta. The family dynamics inform much of Azzarello's interpretation of Wonder Woman's character, and help ground her in reality.

In Azzarello's world, Themyscira isn't fun and games. The island is a dangerous place, home to epically violent battles among man, beast, and god. You know things are bad in paradise when Ares is killed off and Diana herself is crowned the new God of War. Azzarello's run culminated in 2014 with *Wonder Woman #35*. Fans and future DC Comics writers alike often cite Azzarello's work as being a seminal turning point in the *Wonder Woman* series. In returning Wonder Woman to her roots, Azzarello made her relevant again, and introduced a new generation of readers to her many wonders.

★

Wonder Woman: Ambassador of Truth | How did you start writing for Wonder Woman?

Brian Azzarello | I came to the character in a roundabout way. DC had been trying to get me to take on one of the Justice League characters to be an extended run. It was something that I just really wasn't very interested in. It would be a long story. We were having dinner with Dan DiDio, who was editor in chief at the time. We were discussing this other character, and then I said, "What are you doing with the other ones?" He told me what they were planning for Wonder Woman and it was appalling to me. And I was like, "You can't do that to that character!"

I knew about her and her backstory and all that stuff; I said, "This is fundamentally wrong to do. You can't give her that kind of baggage." And he said, "Well what would you do?" By the end of dinner I was writing the character. The other character, I wasn't going to do anymore. So I came to Wonder Woman by just being a little bit protective.

WW:AoT | Was your story something that had been rattling around in your head so you could have brought it up at that table? Or is it something you came up with on the spot?

BA | It's the latter. It was like, I came in and they said what they were going to do, and it had some mythological elements, but I thought their mythological elements don't logically fit in with Greek mythology. Didn't really fit it in, and that's all.

WW:AoT | You were fairly autonomous on that title for a while. How were you able to do your arc separate from what was happening in the rest of the DC Universe at that time?

BA | That's because I pitched a three-year-long story. I had the outline approved, so when they were coming up with all these other things along the way, it's like, "No, we're not going to do that. You already approved this."

WW:AoT | Were you and Cliff Chiang immediately on the same page on where to go with Wonder Woman stylistically and tonally? How did you approach working together on this book?

BA | Cliff and I were talking about what we were going to do next because we had done *Doctor 13* together. . . . And I called him and said, "Cliff, you want to do *Wonder Woman* for a few years?" He said, "Well, what's your idea?" I told him the idea, and then he said, "Yeah, let's do it."

WW:AoT | What were the things that were most interesting for you in your run?

BA | What made it enjoyable was reaching those long-time readers again. I've been at this for a long time, but Wonder Woman's fan base is in for a *long* time. She's a particularly difficult character to work on, because she stands for something more. And unfortunately, if you play into that, if she's perfect, she's boring.

I didn't put anything to change that character. Fundamentally she's the same thing, I just changed the world around her, and gave her different things than she'd normally been reacting to. It was really important to establish a strong supporting cast, which is something I really don't think was there before. She had Etta and Steve Trevor, but those characters in those stories have been done to death. I just wanted to do something new, that hasn't been done. When I write Batman I'm like, "Can I come up with a Batman story that nobody has written before?" I just wanted something fresh, because these things live forever now. If you like toga gods, there's plenty of volumes of toga gods.

She became the center, which was not my intention going into it. The most centered person turned out to be her, and she was the one that was supposed to be kicked off-kilter. That aspect of her character became more apparent to me, that she really doesn't get flustered too much. She's very centered. She kind of *knows*. Despite what we did with the story—which was tweaking her origin a little, and tweaking the Amazons—but it was like, "You're not who you think you are." The whole point of that story for three years was that she *is* who she thinks she is. She's right about who she thinks she is.

WW: AoT | Diana is learning about herself through that run. Of what her boundaries are, what her standards are. Was that your goal from the start?

BA | The intention going in was to try and—"ignore" might be too strong of a word—but definitely not be beholden to her iconic status. That's part of the perfection, again, because she's an icon and she means something outside of being a character. That's fine. But to me, that has nothing to do with her stories; that people attach that Wonder Woman as an image, to certain "-isms." That's fine, but you can't tell stories with those characters. For me, it was like, "Let's not try to treat her like an icon. Let's try to make her a character—that's all—in her own story. Instead of somebody who you already know." She's a character.

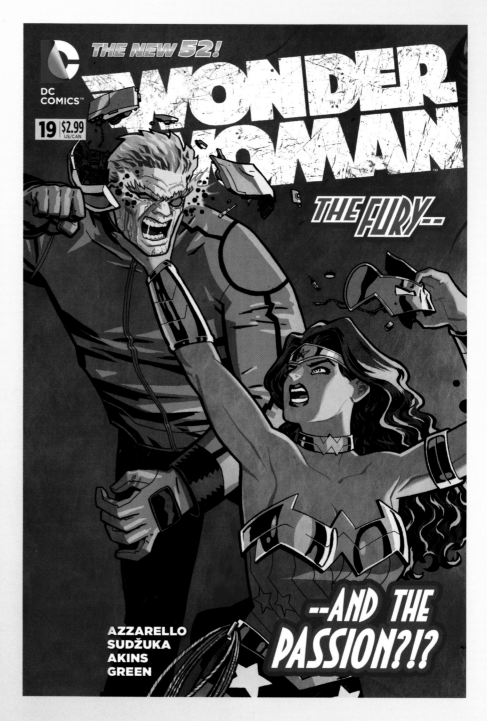

She's not a Care Bear who shows up and is like, "This is what I stand for!"

WW: AoT | You're in the comics field, so you're aware of the immediate reaction to anything that people may or may not like—

BA | Yeah, you know what? If there's no noise, that's the worst thing of all. I would rather hear screams than crickets. . . .The people that come up to me at a

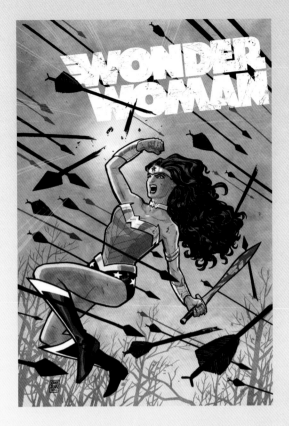

RIGHT | Cover art by Cliff Chiang, *Wonder Woman Vol. 4 #1* (November 2011).

way. Was there something surprising for you when you explored that?

BA | The immediate reaction is war is bad, she can't be the God of War. But there have been a lot of just wars. We get into war. So, how do we reconcile that? There's never not been war. We can all say war is bad, but we can't stop doing it.

WW:AoT | Exactly, and what does that do to somebody? What does that do to somebody who has to make those kinds of choices?

BA | That's the one thing I wish could've stuck. Because I think that, that ground is really fertile. When is it okay to cross the line? When is it just? When does it make sense?

WW:AoT | What to you is Wonder Woman's greatest strength as a character? And her weakness?

BA | For all these characters . . . they're great, and not just her. It's also Batman, Superman. Their greatest strength is their staying power. They're able to operate as vessels to be filled with stories, which is good. Their greatest weakness? Sometimes their stories are boring. It's not just her, that's like comic books.

WW: AoT | Your wife, Jill Thompson, also worked this title. Do you talk while you were doing your series, or do you keep kind of—

BA | Oh yeah, yeah, we talk.

WW: AoT | Were you in the same mind when you were doing your run? She obviously worked on it before in the nineties, and then came back to it again. But when you were working on your run, were there a lot of conversations between the two of you about the character?

BA | Oh, absolutely. I don't think that can't not happen. A lot of the most radical departures that were made, she was firmly behind. She loved them. The Amazons, and the pirates—she liked that. I would bounce ideas off of her, she'd bounce ideas off of me. That book she just did was fantastic. I think it's one of the best Wonder Woman stories ever. Finally, that character got that kind of story. I like what I did. Our story, it's *big*, it's so massive. It's not like you can hand somebody a volume of it. But what Jill just did, it's definitely something like that.

convention, clearly they only have good things to say. The other people, they stay anonymous online. They don't come up to me and say stuff. There have been people to go like, "Oh, this is my favorite run." But that's what they're going to say to me. If there was no such thing as the Internet, I would tell you one hundred percent of the audience loved my work when they share this. Again, one hundred percent of people say, "I loved it." At least it generated discussion, which is great.

At the end of the day, Cliff and I were happy with what we did. We put that character into a story, and into a world that she really hadn't dealt with before, and at the same time, we made her a god and we humanized her. That was another thing that we talked about beforehand. She's part of the trinity. She was always considered part of the Trinity in DC . . . I'd argue that there's Batman and everybody else. It was like, what do we have that is a Trinity? Well, there's a human being, and there's an alien, and oh, let's make her a god. That way she stands for something else. Before that, "Why was she in the trinity?" "Oh, because we need a girl."

WW: AoT | One of the things that your book explored was what it meant when she was put into the position of inheriting the mantle of God of War. You explored the idea of mercy, and her boundaries. It was very profound in terms of exploring that character that

A CONVERSATION WITH
CLIFF CHIANG

An avid comic book reader since childhood, Cliff Chiang has drawn for several DC Comics series, including *Human Target*, *Zatanna*, *Green Arrow/Black Canary*. Fans of *Wonder Woman*, however, know Chiang for the work he did with Brian Azzarello on the series' *New 52* relaunch.

In Azzarello's and Chiang's version of *Wonder Woman*, the focus is squarely placed on Diana. The duo's mission? Ground the character in realism, never mind the fact that, as Zeus's daughter, she's technically otherworldly. Chiang rendered Diana and her world in sleek, bold lines, underscoring her confidence and swagger. His crisp drawing style is simultaneously pared down and punched up, ensuring all eyes remain on Diana even when the background pops to raucous color. There's a reason his art was chosen as one of the US Postal Service's line of stamps commemorating the seventy-fifth anniversary of the character.

Under Chiang's artful eye, Wonder Woman is lean and muscle-bound. She resembles an Olympic athlete. Even her suit looks armor-ready and battle-tested. Chiang frequently illustrated Wonder Woman in action—leaping, fighting, flexing. She's rarely passive or imperiled. The master artist, who drafts digitally and still inks by hand, helped bring Azzarello's vision of Wonder Woman to vivid life. Under his pen, Wonder Woman looks confident because she is confident.

★

Wonder Woman: Ambassador of Truth | Was Wonder Woman one of the characters you tinkered with in your own sketchbook as you were developing your style? How did you approach her when you first started drawing the character professionally?

Cliff Chiang | I'd drawn her in sketchbooks trying to—and certainly with the way I was drawing at the time—trying to figure out how to draw a classic *Super Friends* kind of Wonder Woman, but with my sensibilities. A little bit of that worked its way into that book with Phil [Jimenez]. But a lot of it is just kind of learning on the job and also adapting to the story that they want to tell as well. I think because I tended towards a kind of classical interpretation of her, there wasn't really any friction there. I wasn't given a lot of notes other than just, "This is what we're doing in the books now . . . and we want you to draw this almost origin flashback story with her, filling out her history with her mother." That's what I was asked to do. And I was happy to do it.

WW:AoT | How did it feel after you wrapped your first run on her comic books?

CC | It was a great feeling. It was one of the earliest jobs that I did as well. So, just getting through a long comic—a longer comic than just an eight-page short—was a real sense of accomplishment. And then drawing her and drawing these moments from comics I had read in the past, I'd felt like I arrived in some way. And even still, of course, I was looking at it a month after I'd drawn it, thinking: "I wish I'd done that." Or, "I wish I'd drawn that better." It's a feeling like there was more you could do. It's tough. But at the time I was really happy with how it turned out. And I was happy, *really* happy, with the reception. I think people really understood things artistically where I was going with it. That it was trying to be a little bit Golden Age and a little bit Modern, but simplified at the same time.

WW:AoT | What was it like coming back to the character you'd drawn a decade earlier on your *New 52* series with Brian Azzarello?

CC | Having more experience professionally made me more confident in my own work. As a result, with Wonder Woman, I wanted to make sure it was something that really felt like us. That it was different, I think. Earlier in my career, I would have wanted to do something that everyone kind of unanimously said, "Hey! That's Wonder Woman." Something that they recognize as iconic, like Lynda Carter, or the *Super Friends* version. With Brian it

LASSO OF TRUTH

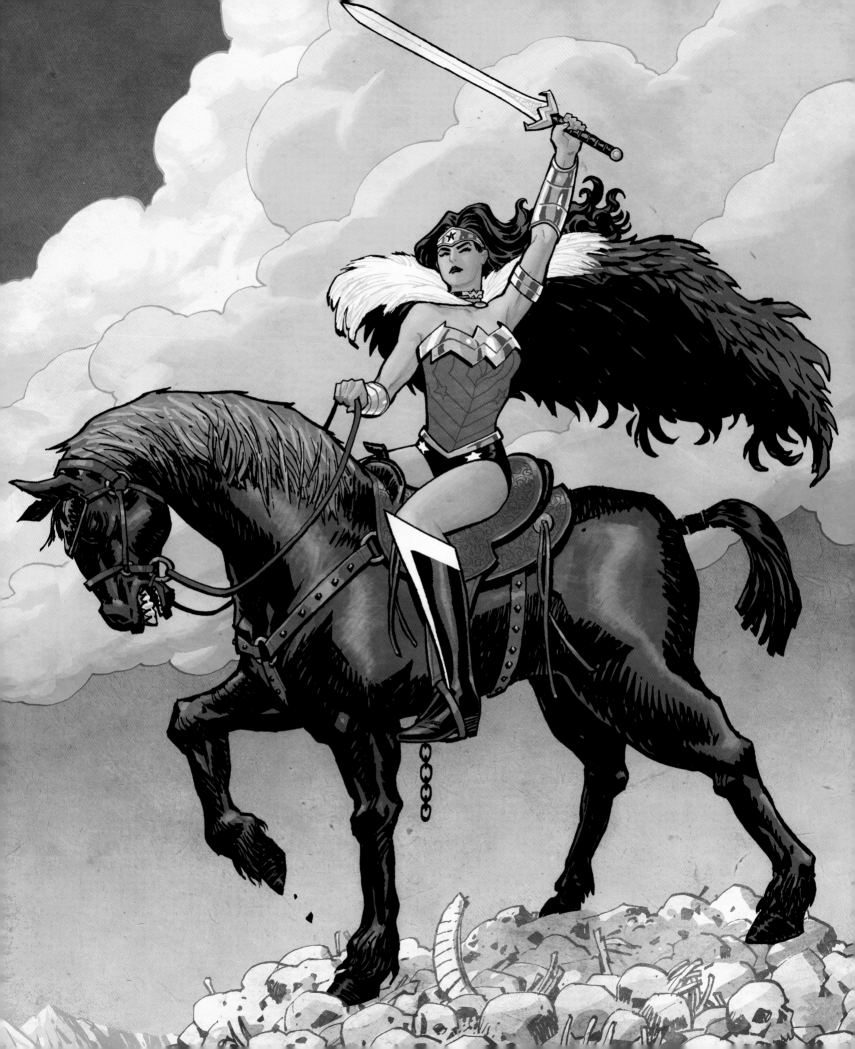

was, "How much can we change about Wonder Woman and still have it be Wonder Woman?" Like, what is it about the core concept that needs to stay? And what else can we adapt, or modify according to our story, according to the way we think she should be? To just mix it up a bit. It was partially wanting to just disrupt the concept of Wonder Woman.

People have always said, "We wanted to get into Wonder Woman, but we didn't know where to start." And then—a bunch of time ever since the *New 52*—hearing that Wonder Woman was their first comic has been really just so rewarding, to help introduce the character and the medium to them through Wonder Woman.

WW: AoT | How would you define Wonder Woman's visual aesthetic during your time drawing the character?

CC | The mythology had been done in the past, and it was classical, in togas. And there was no need for that. Certainly we wanted to embrace the strangeness and surreal quality of the gods. In order to do that in a modern way, we just broke with it. "Let's treat this more like urban fantasy than classical myth." Especially with the cast of gods that we wanted to treat more like a crime family with supernatural powers. There wasn't any piety to it. We weren't really addressing any ideas of religion, so much as the kind of unrestrained use of power.

A lot of the design of her elements came out organically from her story. The approach with Wonder Woman herself was that we knew that we wanted to take this book into almost this modern *Game of Thrones*-ish direction. Which is what prompted me to design this gladiator armor, to see how far we could push it. I wanted to send it to Brian just to show my excitement over it, and to see for myself what I could do with the traditional costume elements and change them into something that's more tuned to her abilities as a warrior. That was a lot of fun, playing with things and trying to think in practical terms for some of it, and other ways being sort of symbolic or visual hook of it.

That gladiator armor to me is *our* Wonder Woman. It encapsulates a lot of what we wanted to do with the run and kind of the shock of a different-looking Wonder Woman. What we learned later is that they had already redesigned all the characters, all the costumes for the *New 52* launch. So, using Jim Lee and Cully Hamner designs, I was trying to streamline that into something that reflected our visual sense a little bit more. The funny thing about Wonder Woman's costume is that it's so recognizable that even if you slightly change

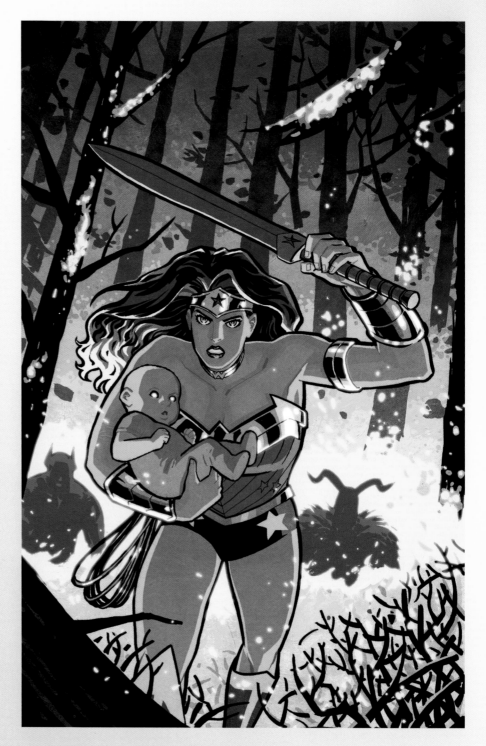

the palette—there are certain elements that you need to keep; you have to keep some kind of "W"; you have to keep the red and the blue and the stars—beyond that, you can do quite a bit with it. My version of that costume is different from the way Jim was drawing her in *Justice League* and where other artists drew her later. Everyone has their own taste to it that reflects what they want.

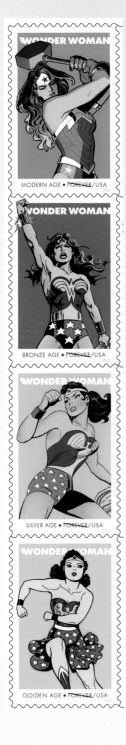

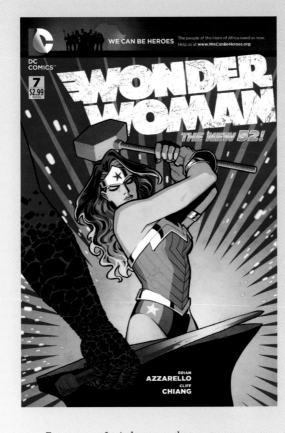

For our run, I tried to treat that costume as something active and athletic. It doesn't need to be presented as swimwear. People are always denigrating her costume like, "Oh, it's a bathing suit." Well, if your intent is to present her as a swimsuit model, then yeah, sure, it's a bathing suit. It's a one-piece. But if you think of her as an athlete, it's something that is designed for movement. If you treat it with different materials, then you can take it away from that. It's a lot about what kind of preconceptions you bring to it; when you're drawing it as well. If your goals are to ogle her or really come at it with the male gaze, then yeah, that's going to look like a swimsuit. But if you try to make her a more full-fledged character—and especially an action hero—then you can just draw these things a little bit different. It doesn't have to be oversexed.

WW: AoT | Was there a cover or an image for you that you were most proud of in that run?

CC | In terms of the story, I'm very proud with all of it. There are definitely some moments that were kind of creepy and sad. And those I loved. The issues where she goes to hell. And issue where she has to kill War. Those were really standout issues for me. Just for the comics' storytelling.

For covers, it took me a while to get comfortable, because I wasn't really sure what we were supposed to be doing with that. I think I got too caught up in trying to sell the narrative of the book with the cover, instead of thinking "compelling images." The image I'm most proud of on the cover is the one on issue #7, where she's got the hammer. It's suddenly when I felt I had her.

Our rule going into it is if you have a book with the title *Wonder Woman* splashed on top of it, you have a duty to show her in a certain light because some little kid might be looking at this, and they're going to see Wonder Woman for the first time. So, instead of where, in the sixties and seventies, you might have a lot of weird covers with her in distress, I always wanted her to be in some way in command of the situation. I wanted her to do things on the cover that were on the same footing with how you would draw Batman on the cover. If you wouldn't put Batman in the situation, I didn't want to do that with Wonder Woman. With issue #7, it just suddenly became the image that kind of embodied everything we wanted for her, for people to think of her and of the character. And for them to turn it into a stamp! What amazing, amazing luck.

WW: AoT | It's such a powerful image. And then to find out that it's become an iconic piece of art that's going to be representative of her on the US post office stamps celebrating the seventy-fifth anniversary.

CC | I was really shocked. I was contacted by one of the art directors very, very early on: like a year before they announced it. So I sent them the best art. And then completely forgot about it. . . . They were very casual about it, so I just figured it would never happen. And then when it was announced, I had gotten no wind of it. So it was a shock to me as well. I don't know if I fully understand as well—because it's my art and I always see it as something I drew, I can't really divorce my creation of it to it being all over the place. But yeah, it's been great to see other people's reactions to it.

One of my artistic heroes is José Luis Garcia-López. For him to have a stamp in the series as well as the other two, it's an incredible honor. And I guess they'll never be able to take that away from me.

A CONVERSATION WITH
GREG RUCKA

Comic book writer and novelist Greg Rucka has crafted scripts for several comic book publishers, but some of his most acclaimed in the industry have been focused on the DC Comics stable of characters. He's written for each of the Big Three: Batman, Superman, and Wonder Woman, contributing notable entries into each of their canons. Rucka first wrote for Wonder Woman in 2002, with his graphic novel *The Hiketeia*, before taking over the ongoing monthly *Wonder Woman* title. Although his end to that run came abruptly, he continued to work with DC until 2010 when he announced he was leaving the publisher to focus on his own work. But Rucka couldn't completely break free of his ties to those characters, particularly Wonder Woman. The writer returned to DC in 2016 with artist Nicola Scott to launch the *Wonder Woman: Rebirth* story line, ushering a new era for the beloved character.

★

Wonder Woman: Ambassador of Truth | When did Wonder Woman first come onto your radar?

Greg Rucka | I think it was probably TV and it was probably a combination of the Lynda Carter TV show and the Justice League cartoon. I am of an age when I was able to watch both. There's a whole bunch of people who have no idea what a Saturday morning was like. She always was the character that fascinated me most. Superman and Batman and Wonder Woman, all of them enter the pop culture subconscious so easily and so early, it's hard to say. Anybody who tells you it was a specific moment is probably lying. It's not a lie of intent, it's a lie of perception that having raised—or raising two kids, I should say—they can't find the moment where they knew who Batman was, they just knew. I just knew who Wonder Woman was.

WW:AoT | You first wrote for her character in 2002 with the graphic novel *The Hiketeia*, before taking on ongoing monthly comic for three years. What did you learn about the character from that experience?

GR | I think a *Hiketeia*, in a lot of ways, is me trying to get into Diana's head for the first time. Some of these characters are a lot easier to slip into. It's not terribly difficult to write Batman, and I don't mean to malign the many great writers who have written Batman. But Batman is not a hard character to wrap your head around. It's one of the reasons he's so successful. It's harder to write Superman, but again, not impossible. It's much more challenging because it requires a sort of core optimism that most people don't have, and I think many people who do have it are placed in a position where they are made to feel embarrassed that they feel that way.

Diana's much more difficult because she not only has some very easy touchstones, but she also has some very complicated ones. If you're going to write her honestly, then you have to really address some questions that are fuzzy in the mythology. You have to find a way to make Themyscira work as a paradise, and it has to be a viable paradise. You can't say it's not really paradise. It has to really be paradise. If it's not, then the foundation of the character is a lie. I think that's been lost over and over and over again. The primary goal of the current run that I've done [in *Rebirth*] is to make it clear what she sacrifices, because it is the equivalent of giving Superman Krypton back. You diminish the character enormously when you allow her to return home.

Diana is part of a Trinity and it's not that one of them is at the top and the others are supporting. The Trinity is one of the beauties of the DC Universe. Those three characters are always going to be the heart of the DCU. Batman's heroism is easier to identify; it's harder to articulate. You articulate by saying Bruce Wayne is a man who wants to make certain that what happened to an eight-year-old boy never happens to anybody else. He will go out every night to keep it from happening, knowing he will fail because he can't be everywhere at once. But he will do it. Superman's heroism, what his self-sacrifice is, it's harder, but again, you can get it. Here's a guy who's motivated to act for the good, despite every opportunity to act entirely selfishly.

LASSO OF TRUTH

best depictions, her chin is always up. There's always a light in her eyes and there's always hope for the future.

WW:AoT | You came back to write for *Wonder Woman* with the *Rebirth* story line that launched in 2016. Having over a decade of a break from the character, what are some of the core elements of her character you felt were important to highlight today?

GR | When the chips are down and somebody has to pick up a tank and throw it, she can do it, but that is never the first solution to the problem, nor even the second or the third. There's a moment early on in the run . . . where Cheetah has sort of gone crazy because she's in bloodlust. Part of her curse is—there's some nasty stuff in that curse—part of that curse is she's supposed to eat human flesh. She's kind of trying to destroy these things and eat them, and Diana grabs her, and the way she grabs her is that she wraps her arms around her from behind and she just hugs her. The response that I saw online was, "Oh, she hugged it out." But that was exactly what she did. Her empathy and her compassion and her capacity for love, they tend to be viewed as antidramatic. They tend to be viewed as if that's not the exciting stuff. We wanted to say, "Look, actually, her ability to love somebody and to understand them and to feel for them is, in fact, a superpower." There's no hate like a hate that was born out of love and I love the idea of this woman who has spent her whole life investigating mythology and being fascinated by the Amazons. And then here comes Diana and not only does she prove that it's all real, but then she changes the whole conception of the Universe by saying, "No, no, the gods are real too and I can prove it." It is a rare person who wouldn't look at that and want to touch that. Barbara Ann's fall from grace—in as much as she's got one—is that she's the Icarus story. She wants to touch the gods, and she does, and Diana tries to warn her. There's a line in the "Godwatch" arc, where Diana's only been in our world for three years or so and she goes to meet Barbara Ann, who's ready to go on the expedition that will ultimately lead to her becoming the Cheetah. Diana basically says, "The number of stories that end well for people who have attracted the attentions of the gods are very few, Barbara. Don't do this." And Barbara Ann says, "Well, it's gone well enough for you, hasn't it?" And Diana's response is, "My story is not yet over." I was really fond of that moment because, to me, that's a very deep cut on Diana. I think Diana suspects, "I end in tragedy."

Diana, we overlook the fact that she leaves behind immortality and everything she knows and *paradise* to come into the festering swamp that is our world with her head held high and her shoulders back, saying, "You guys are kind of fucked up. Let's see if there's a better way to do this." If you're honest to the character and what that means, then the first thing she gets hit with is "Why should we listen to you, woman?" And then she becomes even more heroic. In my opinion, in her

LEGACY

Wonder Woman wasn't the first woman in comic books. She wasn't even the first female super hero. The heroines that came before her included Invisible Scarlet O'Neil, Miss Fury, and Sheena, Queen of the Jungle, the first female comic book character to have her own title and one of the rare characters from the early part of the twentieth century to still pop up today. Few of Wonder Woman's contemporaries from the Golden Age of comic books are still around, with only Lois Lane really sharing her level of fame, and Ms. Lane doesn't even have any super powers . . . most of the time. Wonder Woman has persisted for a host of reasons that could never be catalogued in a single volume. She was a strong female character before the phrase became cliché. And she stood out from the pack, birthed as her own woman, rather than a spin-off of a popular male hero. In fact, other heroines have spun off from *her*. But Wonder Woman hasn't carried the heroine moniker on her own. She's shared it with a host of comic book characters, including DC Comics's other incredibly powered women.

If there's a "Big Three" of female DC Comics super heroes, it would have to include the counterparts of the two other members of Wonder Woman's traditional trinity—Superman and Batman—with their related characters, Supergirl and Batgirl. These two super heroines have made more media appearances outside of comics than most others in the field. In fact, Superman's cousin, Kara, carried a film long before Wonder Woman made her way to the screen. More recently, she has played the lead in her own *Supergirl* television series as part of a sort of golden age of super heroes on the small screen. Kara Zor-El has been the primary incarnation of Supergirl, a character so important to DC Comics that her death in the groundbreaking *Crisis on Infinite Earths* miniseries in the 1980s is considered by many to be among the most significant moments in comic book history. (Although, in true comic book fashion, that death didn't stick.)

Barbara Gordon as Batgirl, the daughter of Commissioner Gordon, defies her father's refusal to let her join the police force by becoming a vigilante. A member of the animated series *Justice League Unlimited*, she's a fighter, a detective, and has mad computer skills, but her character has served a much larger role in the DC Comics universe, beyond the inclusion of her in the *Batman* television series of the 1960s and her film appearances as adult and child in more recent decades. The mantle of Batgirl has been worn by several women, but Barbara Gordon is the one most associated with the character. The Joker's controversial attack on her in *The Killing Joke* may have led to her paralysis, but it also allowed her to become Oracle, a key member of the Birds of Prey and a significant contributor to the Justice League through the use of her computerized crime-solving skills. Barbara Gordon kept watch on the world, lending support to its heroes in the best way she knew how until the *New 52* saw her return to the cowl. But these are far from the only notable heroines in comics that followed in Wonder Woman's footsteps.

LEFT | Yvonne Craig as Batgirl in the *Batman* TV series (1967–68)

ABOVE | Cover art by George Pérez, *Crisis on Infinite Earths* #7 (October 1985).

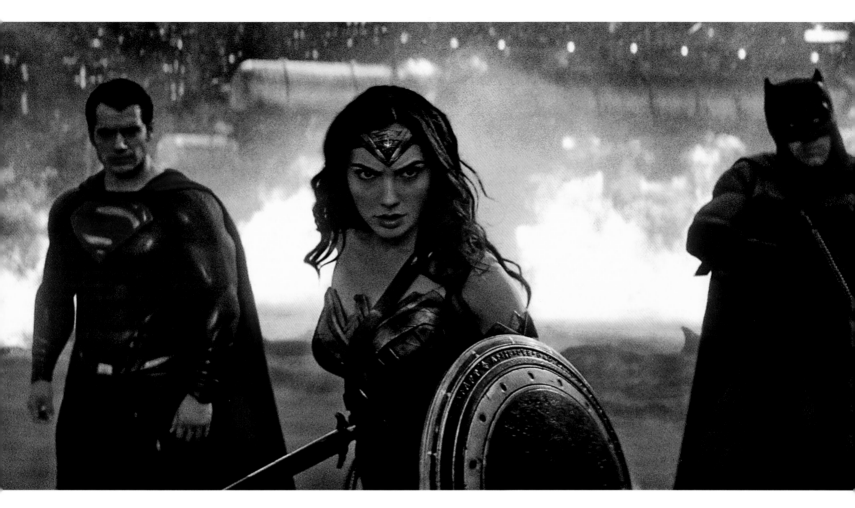

ABOVE | Henry Cavill as Superman, Gal Gadot as Wonder Woman, and Ben Affleck as Batman in *Batman v Superman: Dawn of Justice* (2016).

A songstress from Gotham, Dinah Laurel Lance took on the role of Black Canary and is renowned for her canary cry that can shatter glass and eardrums. Helena Bertinelli, the daughter of a don in Gotham's mafia, was kidnapped by a rival don and abused for years. When she escaped, she was a fierce fighter who joined the Justice League as Huntress. Another Gotham gal, Zatanna Zatara, commonly called Zee, was raised by her magician father and developed a talent for magic. Other members of the Justice League came from other planets: the mace-wielding Hawkgirl; Big Barda, who uses her superstrength to teach self-defense classes; and Maxima, who comes to Earth seeking a suitable mate and sets her sights on Superman.

An accounting of badass heroines could never be complete without Selina Kyle, also known as Catwoman, the sometimes nemesis and sometimes lover of Batman. Stories of her origin vary wildly, but her skills at gymnastics and martial arts are undeniable. The mysterious Catwoman uses her abilities in cat burglary, of course, and occasionally lends an assist to Batman. Is she a hero or villain? It's hard to tell, and the dichotomy has inspired actresses, such as Eartha Kitt, Julie Newmar, Lee Meriwether, Michelle Pfeiffer, Halle Berry, and Anne Hathaway to portray the character with wide-ranging appeal. In some versions, Catwoman uses up all nine of her lives and ends up dead, but Anne Hathaway's Catwoman runs off with Batman and they live happily ever after, sipping espresso in Paris.

Amid all these heroines in their many incarnations, Wonder Woman is the undisputed favorite and star. From the moment she appears in *Batman v Superman: Dawn of Justice* with her deflecting bracelets flashing, Gal Gadot assumes the role with ease. For sure, she can rescue Batman and save the world from the Doomsday monster. She's Wonder Woman. Every

newbie super heroine—from Catwoman and Batgirl to Wonder Girl and the DC Super Hero Girls—can trace their success back to the woman who started it all: Wonder Woman. From the moment Princess Diana donned her star-spangled suit to fight for the good of mankind, her character has been a beacon of inspiration to the women who surround her, Amazons and mortals alike, fictional characters and flesh-and-blood people as well.

WOMEN WHO KICK ASS

From an *American Ninja Warrior* contestant to fashion designer Diane von Furstenberg, women from every walk of life dream of being super heroines, capable of amazing feats. In the 1940s, when Rosie the Riveter left the kitchen and took on what was formerly a "man's job," society was primed for the rise of strong female role models. In a 1943 issue of *The American Scholar,* William Marston stated that what women really want to be is "a feminine creature with all the strength of Superman plus all the allure of a good and beautiful woman." Marston created the comic

book, and Wonder Woman became the godmother of kick-ass.

Above all, Wonder Woman is a superstar athlete who can compete and win against all the other Amazons on Paradise Island, her home. Though she has taken a lot of flak about her skimpy shorts and bustier, it can be argued that her outfit isn't sexy as much as it is practical. Her clothes don't get in the way when she runs, leaps, high kicks, and vaults. The current crop of women who participate in today's track-and-field events have pared their uniforms down to practically nothing. Compared to many of these Olympic-class athletes, the Amazon Princess is positively prudish.

Many of these athletes aspire to Wonder Woman status: Sometimes called the Wonder Woman of tennis, Serena Williams draws inspiration for many of her star-spangled outfits from the comic book super heroine. The women's UFC (Ultimate Fighting Championship) bantamweight champ, Ronda Rousey, expressed serious interest in playing the role of Wonder Woman on film. The athlete most dedicated to the

ABOVE | Animation still from *DC Super Hero Girls: Hero of the Year.*

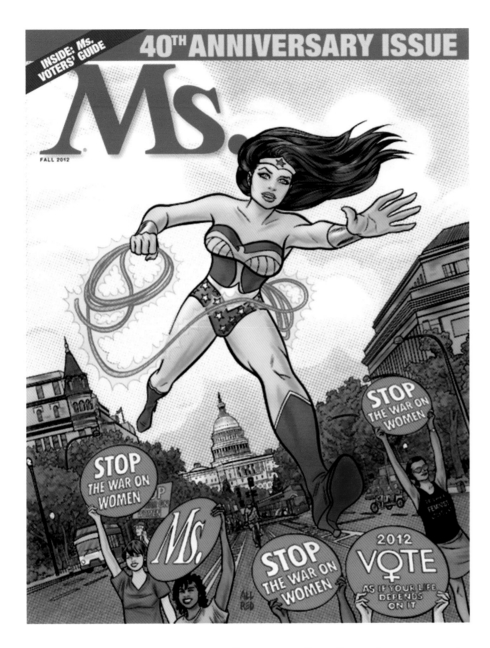

INSIDE: Ms. VOTERS' GUIDE

40TH ANNIVERSARY ISSUE

Ms.

FALL 2012

STOP THE WAR ON WOMEN

STOP THE WAR ON WOMEN

Ms.

STOP THE WAR ON WOMEN

2012 VOTE AS IF YOUR LIFE DEPENDS ON IT

ALL RED

Wonder Woman, has been cast as president of the United States in the *Supergirl* television series. In 2012, on the fortieth anniversary of *Ms.*, Wonder Woman was back on its cover, this time striding down the streets of Washington, DC amid women holding up protest signs, demanding rights for women.

Heroines with special abilities are appreciated by Kathleen Hanna, the electronic-punk feminist founder of the band Bikini Kill and by artist/author Trina Robbins. Robbins believes the Amazon Princess/demigod embodies the myth of the strong heroine. After all, Wonder Woman was molded from clay by Queen Hippolyta and had life breathed into her by Aphrodite. Trina says, "So both her parents are female. How much more feminist can you get?"

When she's not being a myth and saving the world, Wonder Woman has an appreciation for fashion and style. As Diana Prince, she sashayed through the decades with an ever-changing wardrobe appropriate for a working woman. Still, her primary outfit always came back to some version of short-shorts and bustier—a look that has been an inspiration for fashion designers. In 2001, John Galliano, working for Dior, showed a red-and-white-striped jacket over a gold bustier and tiny pants.

Diane von Furstenberg built an entire collection around Wonder Woman in 2008. When asked to choose a superpower, von Furstenberg said, "I would destroy all weapons." Though not exactly sure how this feat would be achieved, she explained that she would "just do it, while wearing a jersey dress." In the comic book von Furstenberg created with DC Comics to go with the collection, *The Adventures of Diva, Viva and Fifa*, the message was to "inspire every woman to be the Wonder Woman she wants to be." In the comic book, illustrated by Konstantin Kakanias, von Furstenberg appears in the skies along with Wonder Woman and together they give downtrodden, ordinary women super makeovers. Proceeds from the sale of the comic went to a charity to empower women.

Going from zero to hero and getting up when you're held down are not only themes for the kick-ass heroine but also sentiments expressed in Katy

myth is Jessie Graff, a professional stuntwoman, who reached the top level of competition on *American Ninja Warrior* wearing a costume that could have leapt from the pages of DC Comics.

Another arena for super women is politics. Gloria Steinem used Wonder Woman as the cover girl on the 1972 inaugural issue of *Ms.* magazine with a banner across the top that said, "Wonder Woman for President." Winning the highest office in the land is a recurring theme for this heroine. In an early issue of the comic book series, Diana Prince was elected president. More recently, Lynda Carter, television's

Perry's "Roar." With her black hair and blue eyes, Perry resembles Wonder Woman and says she likes to emulate the character's style. Other rock stars that emulate the Amazonian attire include Beyoncé, Lady Gaga, and Demi Lovato, among others. The pop star leotard, also called "bodysuit," has become the new power outfit for strong women who move fast, kick high, and hit the high notes.

Some of the actresses who have played or voiced Wonder Woman in cartoons, video games, television, and movies are: Lynda Carter, Shannon Farnon, Susan Eisenberg, Grey Griffin, Michelle Monaghan, Tamara Taylor, Keri Russell, Lucy Lawless, Maggie Q, Cobie Smulders, and Gal Gadot. Wonder Woman's influence can be seen in television and film over the decades, in both overt and subtle ways. Her costume—or a reasonable facsimile—has popped up on shows like *The Big Bang Theory, Bones, Smallville, The Wendy Williams Show,* and *The O.C.* Her mere existence has likely influenced the many other strong female characters of the large and small screens, fully developed female characters like Emma Peel, Jamie Sommers, Princess Leia, Ellen Ripley, Sarah Connor, Lara Croft, Buffy Summers, Katniss Everdeen, Imperator Furiosa, and another warrior princess: Xena.

Most importantly, Wonder Woman has influenced the countless lives of young readers—girls *and* boys, men *and* women from all walks of life—throughout her seven-decade run as one of DC Comics's most recognizable entities. Her words have inspired. Her look has been recreated at Halloween and comic book conventions, during protests and pride parades, and more casually at home by children running around in their Underoos. Today, Wonder Woman just a comic book character. She's bigger than that. However you define her—pop culture icon, symbol of female empowerment, bombshell, ambassador, movie star—there's one word that sticks: legend.

Wonder Woman is only as strong as her message. Her various creators' unwavering belief in truth, justice, and compassion—meted out by a strong, beautiful woman, no less—has the power to transform and impact the very real lives of people today. Her message is one of hope. It's a call to action. It's the simple but clear idea that the world we live in is worth protecting, the children we raise are worthy of our respect, and men and woman can work together to fight for the common good. Her legacy is ours. Let's make her proud.

FAR LEFT | Cover art by Konstantin Kakanias, *Be the Wonder Woman You Can Be: The Adventures of Diva, Viva, and Fifa* by Diane von Furstenberg (2009).

LEFT | Tom Welling as Clark Kent and Erica Durance as Lois Lane dressed in the costume of an "Amazon Warrior" as an homage to Wonder Woman in the *Smallville* episode "Warrior"

OPPOSITE | Cover art by Adam Hughes, *Wonder Woman Vol. 2 #177* (February 2002).

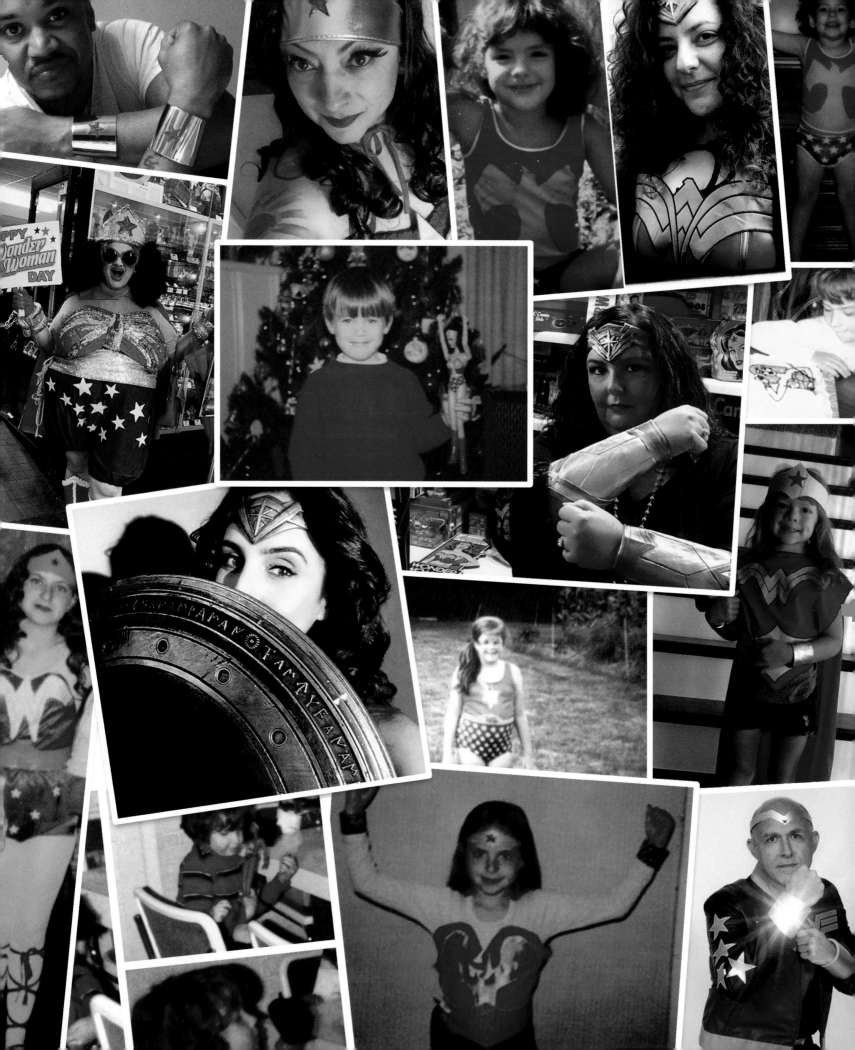

BIBLIOGRAPHY

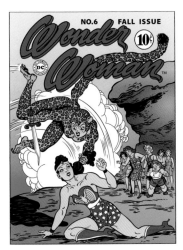

Agard, Chancellor. "A Definitive Ranking of Every *Justice League* Episode," *Entertainment Weekly,* updated February 1, 2017. Accessed February 8, 2017. http://ew.com/gallery/justice-league-ranking/25-secret-origins.

Azzarello, Brian. *Wonder Woman: Blood* Compilation, California: DC Comics, 2013. Originally published in single magazine form in *Wonder Woman 1–6,* California: DC Comics, 2011, 2012.

Ball, Jennifer, L. "The Wonder of Wonder Woman," *Ultimate History Project.* Accessed January 26, 2017. http://ultimatehistoryproject.com/wonder-woman.html.

Beedle, Tim. "Wonder Woman '77: An Interview with Writer Marc Andreyko," DC Comics, January 8, 2015. Accessed January 15, 2017. http://www.dccomics.com/blog/2015/01/08/wonder-woman-77-an-interview-with-writer-marc-andreyko

Berlatsky, Noah. *Wonder Woman: Bondage and Feminism in the Marston/Peter Comics, 1941–1948,* New Jersey: Rutgers University Press, 2015.

Bradley, Bill, "Chris Pine Shoots Down That One 'Wonder Woman' Rumor," *The Huffington Post*, October 4, 2016. Accessed February 10, 2017.

http://www.huffingtonpost.com/entry/chris-pine-shoots-down-wonder-woman-rumor-about-multiple-roles_us_57eebeeee4b0c2407cdddb4c.

Brady, Matt. "Gail Simone: Rise of the Olympian, Fall of Wonder Woman," *Newsarama,* December 23, 2008. Accessed February 2, 2017. https://www.newsarama.com/1826-gail-simone-rise-of-the-olympian-fall-of-wonder-woman.html.

Busch, Jenna."Interview: Susan Eisenberg on Being the Voice of Wonder Woman," *Legion of Leia*, November 23, 2016. Accessed February 2, 2017. http://legionofleia.com/2016/11/interview-susan-eisenberg-on-being-the-voice-of-wonder-woman.

Couch, Aaron. "Wonder Woman: Susan Eisenberg on That Batman Kiss and Other Tales from 15 Years with an Icon," *Hollywood Reporter*, October 21, 2016. Accessed February 2, 2017. http://www.hollywoodreporter.com/heat-vision/wonder-woman-susan-eisenberg-batman-940398.

Darowski, Joseph D., editor, *The Ages of Wonder Woman: Essays on the Amazon Princess in Changing Times*, North Carolina: McFarland & Company, Inc., Publishers, 2014.

DC Database. "Wonder Woman Publication History." Accessed January 18, 2017. http://dc.wikia.com/wiki/Wonder_Woman_Publication_History.

Dockterman, Eliana. "Wonder Woman Breaks Through," *Time*, December 19, 2016. Accessed January 18, 2017. http://time.com/4606107/wonder-woman-breaks-through.

Eramo, Steve. "Sci-Fi Blast from the Past—Lyle Waggoner," *SciFiAndTVTalk*, February 22, 2011. Accessed February 1, 2017. http://scifiandtvtalk.typepad.com/scifiandtvtalk/2011/02/sci-fi-blast-from-the-past-lyle-waggonner-wonder-woman.html.

Green, Catherine. "Getting the Star Treatment with Lyle Waggoner," *Los Angeles*, May 30, 2013. Accessed January 30, 2017. http://www.lamag.com/thejump/getting-the-star-treatment-with-lyle-waggoner.

Haley, Tim. *Wonder Woman Unbound: The Curious History of the World's Most Famous Heroine*, Chicago: Chicago Review Press Incorporated, 2014.

Harnick, Chris. "Wonder Woman Forever," *E! News*, October 21, 2016. Accessed January 11, 2017. http://www.eonline.com/news/803672/wonder-woman-forever-lynda-carter-on-embracing-her-legacy-and-becoming-supergirl-s-president.

IMDB. "Wonder Woman. Trivia." Accessed January 18, 2017. http://www.imdb.com/title/tt0451279/trivia.

Jenkins, Patty as told to Rebecca Ford. "*Wonder Woman's* Director Patty Jenkins: How to Make a Female Heroine 'Vulnerable,' but Not Lesser in Any Way," *Hollywood Reporter,* December 9, 2016. Accessed January 20, 2017. http://www.hollywoodreporter.com/heat-vision/wonder-woman-director-patty-jenkins-how-make-a-female-heroine-vulnerable-but-not-lesser-any-way.

Joest, Mick and Brent McKnight. "Meet Gal Gadot: 12 Things to Know About the New Wonder Woman," *CinemaBlend*. Accessed January 18, 2017. http://www.cinemablend.com/pop/Meet-Gal-Gadot-12-Things-Know-About-Wonder-Woman-64792.html.

ABOVE (TOP) | Cover art by H.G. Peter, *Wonder Woman Vol. 1 #6* (September 1943).

ABOVE (BOTTOM) | Cover art by Ric Estrada, *Wonder Woman Vol. 1 #210* (March 1974).

Keating, Lauren, "The Evolution of Wonder Woman Costumes Throughout the Years," *Tech Times*, June 15, 2015. Accessed January 12, 2017. http://www.techtimes.com/articles/57607/20150615/evolution-woman-wonder-costumes-throughout-years.html.

Lackey, Mercedes. "Introduction," in *Wonder Woman: The Circle* Compilation, by Gail Simone, California: DC Comics, 2008. Originally published in single magazine form in *Wonder Woman 14–19*, California, DC Comics, 2008.

Lang, Brent. "Gal Gadot Dishes on the New Wonder Woman Fillm," *Variety*, October 11, 2016. Accessed January 10, 2017. http://variety.com/2016/film/news/gal-gadot-wonder-woman-dc-patty-jenkins-1201884362.

Lepore, Jill. *The Secret History of Wonder Woman*, New York: Alfred A. Knopf, 2014.

Martinez, Al and Joanne. "The Spotlight Is Not Willing to Be Shared," *TV Guide*, January 20–26, 1979.

Minnow, Nell. "Wonder Woman, Feminism and Bondage," *The Huffington Post*, September, 30, 15. Accessed January 27, 2017. http://www.huffingtonpost.com/nell-minow/wonder-woman-feminism-and_b_8199126.html.

Mozzocco, Caleb, J. "The Many Loves of Wonder Woman: A Brief History of the Amazing Amazon's Love Life," *Comics Alliance*, August 28, 2012. Accessed February 2, 2017. http://comicsalliance.com/the-many-loves-of-wonder-woman-steve-trevor-nemesis-batman-superman-romance.

Nerd for a Living. "Susan Eisenberg, Wonder Woman Voice Actor." Accessed January 19, 2017. http://nerdforaliving.com/episode-75-susan-eisenberg-wonder-woman-75th-anniversary.

Pérez, George. *Wonder Woman: Gods and Mortals* Compilation, California: DC Comics, 2004. Originally published in single magazine form in *Wonder Woman 1–7*, California: DC Comics, 1987.

Robbins, Trina. *Women and the Comics,* New York: Eclipse Books, 1985.

Rucka, Greg. *Wonder Woman: Down to Earth* Compilation, California: DC Comics, 2004. Originally published in single magazine form in *Wonder Woman 195–200,* California: DC Comics, 2003, 2004.

Sergi, Joe. "Tales from the Code: Whatever Happened to the Amazing Amazon—Wonder Woman Bound by Censorship," CBLDF, October 29, 2012. Accessed January 20, 2017. http://cbldf.org/2012/10/tales-from-the-code-whatever-happened-to-the-amazing-amazon-wonder-woman-bound-by-censorship.

Stefansky, Emma. "Gal Gadot Says They Kept 'Wonder Woman' Simple. . .," *Screen Crush*, October, 11, 2016. Accessed January 10, 2017. http://screencrush.com/gal-gadot-wonder-woman-simple.

Vilkomerson, Sara. "Gal Gadot Is Wonder Woman." *Glamour*, March 7, 2016. Accessed January 18, 2017. http://www.glamour.com/story/gal-gadot-wonder-woman-cover-interview.

Wayne, Teddy. "Gal Gadot," *Interview,* July 22, 2015. Accessed January 16, 2017. http://www.interviewmagazine.com/film/gal-gadot.

Wells, John. "Crisis 20 Years Later," *Crisis on Infinite Earths: The Compendium*. New York: DC Comics, 2005.

Wells, John. "Post Crisis Events," *Crisis on Infinite Earths: The Compendium*. New York: DC Comics, 2005.

Williams, Alex. "Lynda Carter Deflects Critics of Wonder Woman," *New York Times*, December 22, 2016. Accessed January 15, 2017. https://www.nytimes.com/2016/12/22/fashion/lynda-carter-wonder-woman-united-nations.html?_r=0.

Wolfman, Marv, *History of the DC Universe*. New York: DC Comics, 2002.

Wonder Woman Collectors. "Wonder Woman Memorabilia." Accessed January 25, 2017. http://www.wonderwomancollectors.com/home.html.

Wright, Bradford, W. *Comic Book Nation: The Transformation of Youth Culture in America*, Maryland: Johns Hopkins University Press, 2001.

Yamato, Jen. "Forget Batman and Superman: Gal Gadot's Wonder Woman Is the Badass Superhero We Deserve," *The Daily Beast*, March 24, 2016. Accessed January 19, 2017. http://www.thedailybeast.com/forget-batman-and-superman-gal-gadots-wonder-woman-is-the-badass-superhero-we-deserve.

ABOVE (TOP) | Cover art by Ross Andru, *Wonder Woman Vol. 1 #137* (April 1963).

ABOVE (BOTTOM) | Cover art by Ross Andru, *Wonder Woman Vol. 1 #269* (July 1980).

ACKNOWLEDGMENTS

Many thanks to everyone who came together in the name of teamwork, dedication, and passion to create *Wonder Woman: Ambassador of Truth*. becker&mayer! editor Paul Ruditis, art researchers Farley Bookout and Chip Carter, designer Rosebud Eustace, interviewer Tara Bennett, and proofreaders extraordinaire Elizabeth Ridley and Deb Taber: Thank you for having the creative vision and know-how to realize this project. Harper Design publisher Marta Schooler, design manager Lynne Yeamans, editorial assistant Dani Segelbaum, and managing editor Dori Carlson: Ladies, you rock. To the Warner Bros. and DC Comics teams—especially Josh Anderson, Amy Weingartner, Ashley Bol, Doug Prinzivalli, Mike Pallotta, Leah Tuttle, and Stephanie Mente—my deepest gratitude for opening your archives to us, and for your tireless support. To Lynda Carter, for being an inspiration and for sharing your poignant words with us, I am eternally grateful. And, finally, a special thanks to my mother, the baddest wonder woman I know and to my son, who inspires strength, compassion, and honesty in me daily.

ABOUT THE AUTHOR

Signe Bergstrom is a writer and editor of more than thirty illustrated books, including *Suicide Squad: Behind the Scenes with the Worst Heroes Ever*, *Harry Potter: Film Wizardry*, and *The Wizard of Oz: The Official 75th Anniversary Companion*. She lives in Croton-on-Hudson, New York.

ABOUT THE INTERVIEWER

Tara Bennett is a *New York Times Bestselling* author and entertainment journalist. As an author, or co-author, she's written more than 25 official movie and TV companion books including *Outlander: The Official TV Series Companion*, *Sons of Anarchy: The Official Collector's Edition*, *Showrunners: The Art of Running a TV Show*, *The Official Making of Big Trouble in Little China*, *Fringe: September's Notebook* (an Amazon best book of 2014), *Lost Encyclopedia*, *The Art of Ice Age*, and many more. Tara is also a contributing editor for Syfy Wire.com, is a U.S. editor for *SFX Magazine* and a feature writer for *SCI FI Magazine*, *Total Film*, and *Walking Dead Magazine*. Ms. Bennett is an adjunct TV writing professor at Rowan University.

"A NEW JOURNEY TO BE STARTED.
A NEW PROMISE TO BE FULFILLED.
A NEW PAGE TO BE WRITTEN.
GO FORTH UNTO THIS WAITING WORLD
WITH PEN IN HAND, ALL YOU YOUNG
SCRIBES,
THE OPEN BOOK AWAITS.
BE CREATIVE.
BE ADVENTUROUS.
BE ORIGINAL.
AND ABOVE ALL ELSE, BE YOUNG.
FOR YOUTH IS YOUR GREATEST WEAPON,
YOUR GREATEST TOOL.
USE IT WISELY."

—WONDER WOMAN #62